Quick Snap Guide to Digital SLR Photography

An Instant Start-Up Manual for New dSLR Owners

© 2006 Thomson Course Technology, a division of Thomson Learning Inc. All rights reserved. No part of this book may be reproduced or transmitted in any form or by any means, electronic or mechanical, including photocopying, recording, or by any information storage or retrieval system without written permission from Thomson Course Technology PTR, except for the inclusion of brief quotations in a review.

The Thomson Course Technology PTR logo and related trade dress are trademarks of Thomson Course Technology, a division of Thomson Learning Inc., and may not be used without written permission.

All trademarks are the property of their respective owners.

Important: Thomson Course Technology PTR cannot provide software support. Please contact the appropriate software manufacturer's technical support line or Web site for assistance.

Thomson Course Technology PTR and the author have attempted throughout this book to distinguish proprietary trademarks from descriptive terms by following the capitalization style used by the manufacturer.

Information contained in this book has been obtained by Thomson Course Technology PTR from sources believed to be reliable. However, because of the possibility of human or mechanical error by our sources, Thomson Course Technology PTR, or others, the Publisher does not guarantee the accuracy, adequacy, or completeness of any information and is not responsible for any errors or omissions or the results obtained from use of such information. Readers should be particularly aware of the fact that the Internet is an ever-changing entity. Some facts may have changed since this book went to press.

Educational facilities, companies, and organizations interested in multiple copies or licensing of this book should contact the Publisher for quantity discount information. Training manuals, CD-ROMs, and portions of this book are also available individually or can be tailored for specific needs.

ISBN: 1-59863-187-X

Library of Congress Catalog Card Number: 2006920357

Printed in the United States of America

06 07 08 09 10 BU 10 9 8 7 6 5 4 3 2 1

Publisher and General Manager, Thomson Course Technology PTR: Stacy L. Hiquet

Associate Director of Marketing: Sarah O'Donnell

Manager of Editorial Services: Heather Talbot

Marketing Manager:

Heather Hurley

Executive Editor:

Kevin Harreld

Marketing Coordinator:

Jordan Casey

Project Editor:

Jenny Davidson

Technical Reviewer:

Michael D. Sullivan

PTR Editorial Services

Coordinator:

Elizabeth Furbish

Interior Layout Tech:

Bill Hartman

Cover Designer:

Mike Tanamachi

Indexer:

Katherine Stimson

Proofreader:

Cathleen Snyder

THOMSON

COURSE TECHNOLOGY

Professional ■ Technical ■ Reference

For Cathy

Acknowledgments

nce again thanks to the folks at Course Technology, who have pioneered publishing digital imaging books in full color at a price anyone can afford. Special thanks to executive editor Kevin Harreld, who always gives me the freedom to let my imagination run free with a topic, as well as my veteran production team including project editor Jenny Davidson and technical editor Mike Sullivan, who doesn't let more than three decades of friendship prevent him from calling me an idiot when appropriate. Also thanks to cover designer Michael Tanamachi and my agent, Carole McClendon, who has the amazing ability to keep both publishers and authors happy.

About the Author

s a roving photojournalist for more than 20 years, **David D. Busch** illustrated his books, magazine articles, and newspaper reports with award-winning images. He's operated his own commercial studio, suffocated in formal dress while shooting weddings-for-hire, and shot sports for a daily newspaper and upstate New York college. His photos have been published in magazines as diverse as *Scientific American* and *Petersen's PhotoGraphic*, and his articles have appeared in *Popular Photography & Imaging*, The Rangefinder, The Professional Photographer, and hundreds of other publications. He's currently reviewing digital cameras for CNet and *Computer Shopper*.

When **About.com** recently named its top five books on Beginning Digital Photography, occupying the #1 and #2 slots were Busch's *Digital Photography All-In-One Desk Reference for Dummies* and *Mastering Digital Photography*. During the past year, he's had as many as five of his books listed in the Top 20 of Amazon.com's Digital Photography Best Seller list—simultaneously! Busch's 80-plus other books published since 1983 include best-sellers like *Mastering Digital SLR Photography* and *Digital SLR Pro Secrets*.

Busch earned top category honors in the Computer Press Awards the first two years they were given (for Sorry About The Explosion and Secrets of MacWrite, MacPaint and MacDraw), and later served as Master of Ceremonies for the awards.

Contents

	Preface	x
	Introduction	xi
1	Exploring Your New dSLR	1
g	Typical Front Controls and What They Do	
	Typical Back Panel Controls and What They Do	4
	Typical Top Panel Controls and What They Do	
	Inserting Media	
	Using Electronic Flash	
	Inside a dSLR	12
2	Setting Up Your dSLR	15
drank	Battery Charging and Battery Life	
	Media Formatting	
	FAT Chances	
	Optimizing Compression and Resolution	
	Compression and File Format	
	Resolution	
	Making Basic Settings	28
	Changing LCD Brightness and Review Modes	30
	Other Shooting Options	
	Noise Reduction	32
	Image Optimization	
	File Numbers and Folders	
	Custom Settings	36

3	Photography: The Basic Controls	39
	Exposure Controls	40
	Tonal Range	41
	Choosing a Shutter Speed to Stop Action	42
	Selecting the F/Stop	44
	Sharpness	44
	Variable F/Stops	45
	Depth-of-Field	45
	Diffraction Distraction	
	Changing ISO	
	Aperture Priority and Shutter Priority	48
	Aperture Priority	48
	Shutter Priority	49
	Manual Exposure	
	Programmed Exposure Modes	52
	Exposure Metering and Evaluation Modes	54
	Overriding Your Camera's Exposure Settings	56
	Working with Histograms	58
	Automatic Focus Basics	60
	Automatic Focus Modes	
	Single Autofocus	62
	Continuous Autofocus	62
	Automatic Autofocus	
	Manual Focus	
á		
4	Making Light Work for You	6/
l	Quality of Light	68
	Direction	68
	Texture	
	Intensity	70

	White Balance	/ .
	Setting White Balance Manually	7
	Measuring White Balance	
	Creating Your Own Presets	
	Other Factors	
	Using Multiple Lights	
	Main Light	
	Fill Light	
	Background Light	
	Hair Light/Rim Light	
	Electronic Flash	
	Flash Sync Modes	
	Flash Exposure	
	Connecting an External Flash	
5	Choosing and Using Lenses	
	Zoom or Fixed Focal Length?	
	Lens Crop Factors	92
	Wide-Angle Lenses	
	Wide-Angle Lenses Using Telephoto Lenses	94
	Using Telephoto Lenses Using Normal Lenses	94 90
	Using Telephoto Lenses Using Normal Lenses Using Macro Lenses	94 100
	Using Telephoto Lenses Using Normal Lenses Using Macro Lenses Parts of a Typical Macro Lens	94100102
	Using Telephoto Lenses Using Normal Lenses Using Macro Lenses	94100102
	Using Telephoto Lenses Using Normal Lenses Using Macro Lenses Parts of a Typical Macro Lens	
	Using Telephoto Lenses Using Normal Lenses Using Macro Lenses Parts of a Typical Macro Lens Close-Up Accessories	
	Using Telephoto Lenses Using Normal Lenses Using Macro Lenses Parts of a Typical Macro Lens Close-Up Accessories Teleconverters Distortion, Aberrations, and Anomalies	
Co	Using Telephoto Lenses Using Normal Lenses Using Macro Lenses Parts of a Typical Macro Lens Close-Up Accessories Teleconverters Distortion, Aberrations, and Anomalies Creating a Photo	
6	Using Telephoto Lenses Using Normal Lenses Using Macro Lenses Parts of a Typical Macro Lens Close-Up Accessories Teleconverters Distortion, Aberrations, and Anomalies Creating a Photo Choosing a Theme and Purpose	
(0	Using Telephoto Lenses Using Normal Lenses Using Macro Lenses Parts of a Typical Macro Lens Close-Up Accessories Teleconverters Distortion, Aberrations, and Anomalies Creating a Photo Choosing a Theme and Purpose Selecting a Center of Interest	
(0	Using Telephoto Lenses Using Normal Lenses Using Macro Lenses Parts of a Typical Macro Lens Close-Up Accessories Teleconverters Distortion, Aberrations, and Anomalies Creating a Photo Choosing a Theme and Purpose Selecting a Center of Interest Orientation	
(0	Using Telephoto Lenses Using Normal Lenses Using Macro Lenses Parts of a Typical Macro Lens Close-Up Accessories Teleconverters Distortion, Aberrations, and Anomalies Creating a Photo Choosing a Theme and Purpose Selecting a Center of Interest	11111

	Ludan	104
	Glossary	172
	Travel Photography	170
	Sunrises and Sunsets	168
	Still Lifes	166
	Portraiture	164
	Panoramas	162
	Nature Photography	
	Night Photography	
	Moon Shots	
	Macro Photography	
	Lush Landscapes	
	Fireworks and Aerial Pyrotechnics	
	Events	
	eBay and Auction Photography	
	Concerts—Live!	
	Child Photography	
	Candid Photography	
	Architecture	
	Amusement Parks	
•	Action	
7	Great Themes	
7	Cross Thomas	121
	Framing Your Subject	128
	Using Straight Lines, Curves, and Balance	126
	Backgrounds	
	The Rule of Thirds and Other Guidelines	122

Preface

ou've unpacked your first digital SLR. The user's manual is an incomprehensible mystery. You don't want to spend hours or days studying a comprehensive book on digital SLR photography. All you want at this moment is a quick guide that explains the purpose and function of the basic controls, how you should use them, and why. There's plenty of time to learn about file formats, resolution, aperture/priority exposure, and special autofocus modes after you've gone out and taken a few hundred great pictures with your new camera. Why isn't there a book that summarizes whole collections of these concepts in a page or two with lots of illustrations showing what your results will look like when you use this setting or that?

Now there is such a book. If you want a quick introduction to focus zones, bokeh, flash synchronization options, how to choose lenses, or which exposure modes are best, this book is for you. If you can't decide on what basic settings to use with your camera because you can't figure out how changing ISO, white balance, or focus defaults will affect your pictures, you need this Quick Snap guide.

I'm not going to tell you everything there is to know about using your digital SLR camera; I'm going to tell you just what you need to get started taking great photos.

Introduction

ere I go again, inventing another niche. When digital photography began its meteoric rise in popularity and publishers were foisting dozens of "digital camera" books on the public, I insisted on writing about digital photography. Then, a host of digital photo books appeared that concentrated on how to get the effects you wanted in Photoshop, when I thought it was a better idea to show you how to get great pictures in your camera. More recently, I've been among the first to address the needs of the latest converts to digital photography: those who have found digital SLRs to be their dream camera.

While there is a growing number of books devoted to dSLRs (and I've been blamed for more than a

few of them), I see another niche opening up. There are many photographers who are new to SLRs or new to digital SLRs and are overwhelmed by their options while underwhelmed by the explanations they receive in their user's manuals. These manuals are great if you already know what you don't know, and can find an answer somewhere in a booklet arranged by menu listings and written by a camera vendor employee who last threw together a manual for a VCR.

While there are a few third-party basic dSLR function-oriented how-to books that purport to teach you how to use your camera for a few bucks, they generally deal with certain very popular models. If you own an older dSLR or a less popular model, you're often out of luck. Anyone who acquires a used Nikon D100, any of various older Kodak digital SLRs, or

models from Olympus, Panasonic, Sigma, and Fuji, the pickings are slim.

This book doesn't show you exactly how to make settings with a digital SLR camera: It tells you why you want to make them. You'll learn how to apply various controls, understand where you might find them on your particular camera, and pick up the knowledge you need to visit your camera's manual (if necessary) to locate the exact menu where a setting that does what you want is hidden. No free fish in this book; my goal is to teach you how to fish.

The book is arranged in a browseable layout, so you can thumb through and find the exact information you need quickly. The basics are presented within two-page and four-page spreads, so all the explanations and the illus-

trations that illuminate them are there for easy viewing. This book should solve many of your problems with a minimum amount of fuss and frustration.

Then, when you're ready to learn more, I hope you pick up one of my five in-depth guides to digital SLR photography. Three of them are offered by Thomson Course Technology, each approaching the topic from a different perspective. They include:

Quick Snap Guide to Digital SLR Photography. This is the book you're holding in your hands. It belongs in your camera bag as a reference, so you can always have the basic knowledge you need with you, even if it doesn't yet reside in your head. It serves as a refresher that summarizes the basic features of digital SLR cameras, and what settings to use and when, such as continuous

autofocus/single autofocus, aperture/shutter priority, EV settings, and so forth. The guide also includes recipes for shooting the most common kinds of pictures, with step-by-step instructions for capturing effective sports photos, portraits, landscapes, and other types of images.

Mastering Digital SLR
Photography. This book is an
introduction to digital SLR photography, with nuts-and-bolts explanations of the technology, more
in-depth coverage of settings,
and whole chapters on the most
common types of photography.
Use this book to learn how to
operate your dSLR and get the
most from its capabilities.

Digital SLR Pro Secrets. This is my more advanced guide to dSLR photography with greater depth and detail about the topics you're most interested in. If you've already mastered the basics in Mastering Digital SLR Photography, this book will take you to the next level.

Why dSLRs Need Special Coverage

There are many general digital photography books on the market. Why do I concentrate on digital SLRs? One reason is that I feel dSLRs are the wave of the future for serious photographers. When I started writing digital photography books in 1995, digital SLRs cost \$30,000 and few people other than certain professionals could justify purchasing them. As recently as 2003, the lowest-cost dSLRs were priced at \$3,000 or more. Today, anyone with around \$600 can afford one of these cameras. The digital SLR is no longer the exclusive bailiwick of the professional, the wealthy, or the serious photography addict willing to scrimp and save to acquire a dream camera. Digital SLRs have become the camera of choice for anyone who wants to go beyond point-and-shoot capabilities. You belong in this group if you fall into one of the following categories:

 Individuals who want to get better pictures, or perhaps transform their growing interest in photography into a full-fledged hobby or artistic outlet with a digital SLR and advanced techniques.

- Those who want to produce more professional-looking images for their personal or business website and feel that digital SLRs will give them more control and capabilities.
- Small business owners with more advanced graphics capabilities who want to use digital SLR photography to document or promote their business
- Corporate workers who may or may not have photographic skills in their job descriptions, but who work regularly with graphics and need to learn how to use digital images taken with a digital SLR for reports, presentations, or other applications.
- Professional webmasters with strong skills in programming (including Java, JavaScript, HTML, Perl, etc.) but little background in photography, but who realize that digital SLRs can be used for sophisticated photography.
- Graphic artists and others who already may be adept in image editing with Photoshop or another program, and who may already be using a film SLR, but who need to learn more about digital photography and the special capabilities of the dSLR.
- Trainers who need a non-threatening, but more advanced textbook for digital photography classes.

Who Am I?

You may have seen my photography articles in Popular Photography & Imagina magazine. I've also written about 2,000 articles for (late, lamented) Petersen's PhotoGraphic, plus The Rangefinder, Professional Photographer, and dozens of other photographic publications. First, and foremost, I'm a photojournalist and made my living in the field until I began devoting most of my time writing books. Although I love writing, I'm happiest when I'm out taking pictures, which is why I took 10 days off late in 2005 on a solo visit to Toledo, Spain—not as a tourist, because I've been to Toledo no less than a dozen times in the past—but solely to take photographs of the people, landscapes, and monuments that I've grown to love.

Like all my digital photography books, this one was written by someone with an incurable photography bug. I've worked as a sports photographer for an Ohio newspaper and for an upstate New York college. I've operated

my own commercial studio and photo lab, cranking out product shots on demand and then printing a few hundred glossy 8 × 10s on a tight deadline for a press kit. I've served as photoposing instructor for a modeling agency. People have actually paid me to shoot their weddings and immortalize them with portraits. I even prepared press kits and articles on photography as a PR consultant for a large Rochester, N.Y., company which shall remain nameless. My trials and travails with imaging and computer technology have made their way into print in book form an alarming number of times, including a few dozen on scanners and photography.

Like you, I love photography for its own merits, and I view technology as just another tool to help me get the images I see in my mind's eye. But also like you, I had to master this technology before I could apply it to my work. This book is the result of what I've learned, and I hope it will help you master your digital SLR, too.

Chapter Outline

Chapter 1: Exploring Your New dSLR

This chapter shows you the main controls and what they do, and it includes a brief discussion of what goes on inside your digital camera, too. This will get you started.

Chapter 2: Setting Up Your dSLR

If you find all the options available in your camera's manual confusing, this chapter will help you set up your dSLR, understand battery charging, learn how to format your memory cards, and choose the best resolution and file compression settings.

Chapter 3: Photography: The Basic Controls

Here you'll learn the basics of photography as they apply to a dSLR, including exposure, choosing exposure and focus modes, adjusting ISO, and selecting a scene mode

Chapter 4: Making Light Work for You

Everything you need to know about light to get started, including white balance, electronic flash, and using multiple light sources is included in this chapter.

Chapter 5: Choosing and Using Lenses

One significant difference between dSLRs and other types of digital cameras is the ability to use interchangeable lenses. This chapter gives you the basics of using telephoto and wide-angle lenses, macro lenses, zooms, plus accessories like extension tubes.

Chapter 6: Creating a Photo

Learn the basics of composition in this chapter, as you master arranging subjects in a pleasing way with interesting angles, orientations, and proportions.

Chapter 7: Great Themes

Great themes make great photos, and this chapter outlines some of the basic types of photography you may be exploring. You'll learn how to choose the right lens, setup, exposure, and focus method for each of the most popular kinds of picture taking, from architecture to sports to night photography.

Glossary

Want a quick definition of an unfamiliar word? You'll find it here.

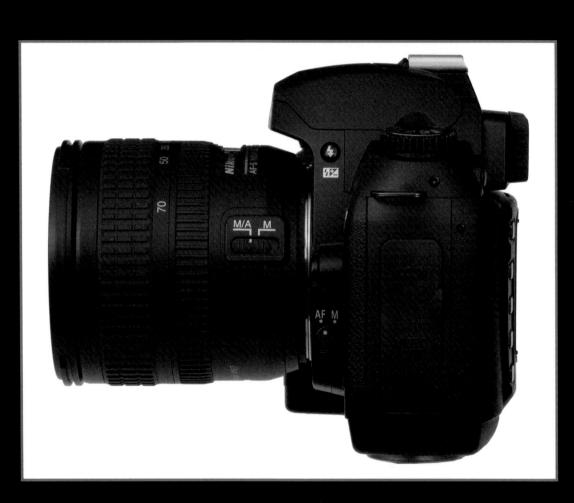

Exploring Your New dSLR

ompared to non-SLR cameras, the digital SLR bristles with buttons and controls. Believe it or not, that's a *good* thing. Most of the time, you can access the most-used features of your camera by pressing a single button and twirling a command dial or thumbing a cursor key. Once you've learned where all the main direct-access buttons reside, this way of working is usually *much* faster than jumping to a menu. The problem, of course, is getting over that hump and learning what all the controls do.

This chapter will introduce you to the key features of your digital SLR, with special emphasis on helping you understand the features and controls available with virtually every dSLR that you might not have used before if you're graduating to this more advanced camera type from a point-and-shoot film or digital camera, or a digital model with a fixed lens and an electronic viewfinder (EVF).

Although each section includes a photograph of a generic dSLR, this chapter isn't intended to necessarily serve as a roadmap for the location of a particular feature on *your* camera. Although control locations are standardized to a certain extent (that is, you'll *always* find the

shutter release button on the top panel at the right side of the camera), certain controls are shifted from place to place on the camera body, or, perhaps, relegated to a menu item, depending on a given vendor's design for the camera.

The most important part of the pages that follow is the descriptions of what these particular features do. Read the discussions of each control, find its location on your own dSLR (using my diagrams as a general guide), and then become thoroughly familiar with its use. Once you've mastered the multiple buttons, switches, and keys on your camera, you're well on the way to pixel proficiency.

My example camera used for the illustrations is the well-known Nikcanoltax 5D200*ist, assembled through the magic of Photoshop from components scavenged from various Nikon, Canon, Konica Minolta, and Pentax dSLR models, providing a suitably generic base camera that includes most of the common features found in all these models. Those of you who own Sigma, Olympus, or the late, lamented Kodak dSLRs should not be offended—assembling a hybrid that embraced all current models just wasn't possible.

Typical Front Controls and What They Do

Here are the main controls found on the front of the typical dSLR, and what they do.

Shutter Release/Power Switch

Pressing the shutter release halfway generally performs several functions. If the metering system has switched itself off, it will revive and begin measuring exposure again. A picture being reviewed on the rear-panel LCD will vanish as the camera switches from review back to picture-taking mode. The autofocus system, if dormant, will again become active. If your camera has been set to fix exposure and focus point when the shutter release is partially depressed, those parameters may be locked. (See "Single Autofocus/Continuous Autofocus and Optimizing Exposure" in Chapter 3 for more detail.) Pressing the shutter release down all the way takes the picture.

The power switch is often located concentrically with the shutter release, but may be located on the mode dial or a separate switch on the back of the camera. It powers your camera on and off. Note that most digital SLRs use so little power when turned on (because metering, preview display, and autofocus turn off after a few sec-

onds), you can usually leave the camera switched on for an entire shooting session—all day, if you like.

Sub-Command Dial

This secondary dial is found on many dSLRs to control with a quick spin a second, complementary function to the one adjusted by the main command dial (usually located on the back of the camera). For example, if the main command dial changes shutter speed, the sub-command dial might adjust f/stop. Or, the two might be matched to set exposure values for main exposure/flash exposure or another pair of functions. If your camera does not have a sub-command dial, the second function will usually be set by pressing a dedicated button and then spinning the main (only) command dial.

6 Hand Grip

The grip forms a rest for your right hand, and its bulge often serves as a compartment for your dSLR's battery. Some cameras have a built-in or optional vertical grip (not shown in the illustration) in the form of a bulging bottom plate that can be clasped when the camera is oriented for vertical shooting. The vertical grip usually includes a duplicate shutter release button, main/sub-command dials, and focus/exposure lock button.

Function Button

A few dSLRs have a user-definable function button, often placed on the front of the camera, which can activate a special feature such as an exposure, flash, or shooting mode when pressed. Usually, another button or dial must be used at the same time, to avoid accidentally triggering the special feature.

6 Depth-of-Field Preview

The Depth-of-Field button closes the lens aperture from its wide-open setting (which provides a bright view that's easy to evaluate and focus) to the actual f/stop that will be used to take the photo (based on the current automatic or manual aperture setting of the camera). Although the image on the screen darkens, this preview allows more accurate gauging of the actual depth-of-field. Not all digital SLRs have a DOF preview button.

6 Lens Mount Release

Pressing this button releases the lock that fixes the lens to the camera, making it possible to rotate the lens out of its bayonet, remove it from the camera, and replace it with another compatible lens.

PC/X Sync Connector

Some dSLRs have a connector, usually hidden by a plastic or rubber protective cover, which allows plugging in a standard cable for an external flash unit, often a manual-exposure studio flash unit. This connector is used strictly to trigger the flash when the shutter release is pressed; it provides no information to the camera about the flash itself, so you must set exposure manually or rely on the flash unit's own automatic exposure system. To retain all the features of dedicated flash units designed for your camera, you'll need to use the hot shoe on top of the camera (either by mounting the flash on the shoe or by connecting the flash to the shoe through a cable that conveys all the data for the flash/camera information exchange), or, sometimes, a multi-pin connector that accepts cables from flash units designed to work automatically with a particular camera.

Mode Dial

The mode dial is used to set exposure and scene modes (explained later in this chapter), or, with some dSLRs, to turn the camera on and off.

IR Receiver or Focus Assist Lamp

This window on the front of many cameras may serve one of several functions. If tinted a deep red (almost black), the window may cover an infrared sensor used to trigger the camera with an IR control device. If a lighter red or white, the window may instead be used with an LED that comes on momentarily to provide extra illumination for focusing in low light levels. This lamp might flash during your self-timer's countdown, using a pattern that provides a warning just before the picture is taken. A few cameras have used this lamp as a flasher that causes the subject's iris to shut down just before a flash exposure, reducing red-eye effects. However, it's more common today to have the electronic flash itself provide this pre-flash.

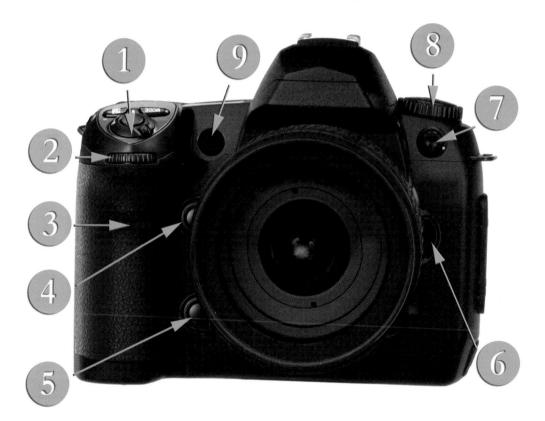

Typical Back Panel Controls and What They Do

The back panel of your digital SLR is usually the camera's command center, with most of the important controls and at least one of the key information readouts located here. Although it takes a bit of effort to learn the functions of these controls, understanding what each button, dial, or switch does makes operating your camera much faster and more efficient. Note that many cameras assign several functions to each button: In playback mode, a button might do one thing, and it might do something completely different in shooting mode.

Continuous/Sequence Shooting

This button, located on the back of the camera or on top of the camera, activates the dSLR's continuous shooting ("motor drive" or "burst") modes. Your camera may have more than one sequence mode (both low speed and high speed), and this button may also be used to activate the self-timer or another "drive" option.

Bracketing

Most dSLRs can take several consecutive photos using different f/stops or

apertures, white balance settings, or other parameters, increasing the chances that at least one of the shots in the sequence will have the correct exposure, white balance, etc. Usually the order in which the parameters are bracketed, the amount of bracketing, and the exact parameters adjusted in the sequence are set using the menu system. This button simply turns the bracketing feature on or off.

Menu

Your camera's menu system can be activated by pressing this button.

Often, a different set of menus will appear depending on whether the camera is in playback or shooting mode. The menus will be laid out in various pages and layers, grouped by type of function. One menu layer might allow you to adjust the current shooting parameters for a session; another might control semi-permanent camera settings and custom features.

O Display Info

After you've taken a photo, it can be displayed on the LCD for review. This button lets you control what types of information are displayed during the review. Perhaps you want only the picture number, date, file format, quality setting, and other basic information to be shown. Or, you might prefer to see what kind of metering

mode was used, along with shutter speed and aperture, the focal length of the lens, and so forth. The ISO setting, white balance, informational comments, or even histogram charts showing graphically how well the image was exposed, can also be chosen. Usually, these information options are displayed by pressing the Display Info button several times to cycle among them, or by holding down the button and changing the option with a cursor key or command dial.

6 Trash

When an image pops up on your screen and you know right away it's a disaster, pressing this button once or twice (to confirm) may delete it for you. Or, you can press the Delete key while reviewing a series of shots to trash the selected images.

Picture Review

Digital SLRs can usually be set up to display each image for a few seconds after it is shot. If you want to view the image again, or page through multiple images, this button puts your camera into review mode. You can then page through your shots with the multi-selector cursor pad, use the Trash key, and summon the playback menus when the Menu key is pressed.

Review/Menu LCD

This color LCD, usually measuring 1.8 to 2.5 inches diagonally, is used for reviewing images after they've been taken, and for navigating the dSLR's menu system. It can be used for evaluating pictures, choosing those to be deleted, and for selecting features and settings in the menu. Some dSLRs accompany this LCD with a monochrome LCD panel underneath that displays status information about the camera's current settings, such as ISO, exposure mode, etc.

③ USB/DC/AV Ports

Digital SLRs include one or more ports used to connect the camera to another device over a USB cable, to provide DC power to run the camera independently of the battery, or to direct the camera's LCD display output to an external monitor. These ports are most often located on the back or left side panels, and are generally hidden behind a rubber or plastic cover.

Special Feature Button

Any special features a camera might have are often activated by a dedicated switch. Konica Minolta dSLRs, for example, turn their internal antishake feature on and off using such a switch.

The multi-selector or cursor pad (usually with embedded central OK/Return button) provides navigation through the menu system as well as other "directional" features, such as setting the position of the active focus zone sensor in the viewfinder, paging forward and back through pictures being reviewed, or positioning the camera's "cropping" marks when viewing and zooming in on a specific shot.

Main Command Dial

This dial is spun to change a major feature, such as shutter release or aperture, zooming during picture review, changing ISO when an ISO button is pressed, or adjusting EV values. Cameras with only a single command dial might require pressing a second key to switch the dial into the alternate mode.

Picture Review Format/ Zoom

Some cameras have buttons like those shown here to adjust the picture review format (entire image, or six/nine thumbnails which can then be navigated with the cursor pad) and to activate zooming in and out during picture review. Or, the multiselector keys are sometimes used for this function.

Autoexposure/Focus Lock

Press this button to lock the current exposure or focus point, regardless of whether the shutter release is partially depressed.

Diopter Correction

This lever controls diopter correction that allows you to view a sharp viewfinder image.

(b) Viewfinder Window

The viewfinder is your window to the image displayed through your camera's lens. Usually surrounded by an eyecup that shields the view from extraneous light, the viewfinder window may also include a flip-down

shutter that locks out such illumination entirely, preventing it from affecting exposure when, say, the camera is mounted on a tripod and your eye is not glued to the finder.

Other Controls

Not shown in our generic image are some other buttons that may appear on the back of the camera. These include a Protect/Lock button that marks an image against accidental erasure; a Help button that displays more information about a menu setting; a Record button to activate recording of voice comments you want to append to a given image; a metering mode selector for choosing matrix, spot, center-weighted, or some other exposure option; and White Balance, Quality, ISO buttons used to adjust these parameters when pressed while the command dial is spun.

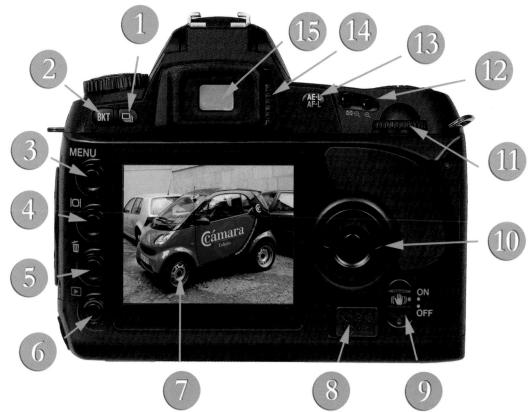

Typical Top Panel Controls and What They Do

The top panel of your digital single lens reflex camera has its own set of controls. If you're accustomed to working with recent film SLR cameras, you'll be right at home, because many of these controls and displays are carryovers from ancient times—especially those found on the lens, which are also included in this description.

Lens Hood Bayonet/Filter Thread

The front edge of your lens includes several features to allow mounting accessories such as lens hoods and filters. The lens hood bayonet is located on the outer surface of the lip of the lens, and a hood is attached by matching a dot on the hood with a dot on the lens, then rotating the hood to lock it in place. The bayonet system ensures that the lens hood is oriented properly on the lens. On the inside surface of the lens is a thread, which can be used to attach screw-in filters, lens hoods, and other accessories.

Zoom Ring

Zoom lenses have a ring that can be twisted to magnify or reduce the image.

® Focus Ring

The focus ring is twisted to bring the image into sharp focus when focusing manually, or to fine-tune focus set automatically with lenses that allow overriding the autofocus system.

Focus Scale

These markings show the current focus point, and can be used to quickly set focus manually, show approximate depth-of-field, or check the focus point set by the camera.

Other Lens Features

There are a few features found on some lenses that aren't shown on our generic model. Some lenses have an Automatic/Manual focus switch that overrides its counterpart on the camera body. Lenses with an extensive focus range (particularly macro lenses) may have a Lock switch to lock out either the most distant focusing range or the closest. By limiting the depth the lens searches for correct focus, some back-and-forth seeking (which wastes a lot of time) is eliminated, making the autofocus system operate more quickly when you're shooting either distant or close-up photos exclusively.

6 Mode Dial

This dial changes the exposure mode or programming used to calculate

exposure. Some dSLRs have so-called scene modes, such as sports, portrait, sunset, and so forth, which automatically set exposure, type of autofocus used, and parameters such as flash to best suit those shooting situations. All dSLRs will include program (the camera sets user-tunable exposure); manual (user sets both shutter speed and aperture); aperture priority, also called Av (user chooses f/stop and the camera selects a shutter speed): and shutter priority, also called Tv (user selects shutter speed and the camera chooses f/stop). Often, an auto choice will be available, which provides automatic exposure with very few fine-tuning options for the user. You'll find more on these modes in Chapter 3.

© External Flash Hot Shoe

The "foot" of an external electronic flash slides into this shoe, which provides both a mount and electrical connection to the camera. Speedlights designed to work with a specific camera exchange information with the camera. The camera may report the zoom setting of the lens so the flash can change its coverage angle to suit; the flash delivers information about things like the power setting of the unit. This information exchange allows fully-automatic flash exposure

with through-the-lens metering. The flash unit can also be used detached from the camera with a special cable plugged into the hot shoe. The shoe also may accept wireless remote control devices and generic, non-dedicated flash units.

Monochrome Status LCD

This display screen shows information about the camera's current settings, including number of exposures remaining, shutter speed, f/stop, ISO, battery status, or focus/exposure mode in use. Some cameras provide minimal information on this screen (such as number of exposures left) even when the camera is turned off.

③ Status LCD Backlight Button

Pressing this button activates a light underneath the status LCD so the information can be viewed in dim light or total darkness. The light remains switched on for as long as the button is depressed, or for a short time after it is released (typically 10–15 seconds).

EV Button

Holding down this button allows adjusting the exposure by adding or subtracting exposure values (EV) when a command dial is spun. Each EV value represents one full f/stop, doubling or halving the exposure. Typically, EV can be adjusted plus or

minus 2 or 3 EV in 1/3 or 1/2 EV increments. The EV change usually remains for subsequent exposures, so it's important to switch back to normal exposure if you begin shooting in a different setting.

© Exposure Zone/Method Selector

Holding down this button while spinning a command dial allows you to change the area used for calculating exposure. Most dSLRs default to a sophisticated matrix metering system that uses many different zones to evaluate a scene. Usually, you can switch from this method to an alternative, such as center-weighted (most of the exposure is calculated based on a central area of the scene, but the rest of the frame is also taken into account) and spot (exposure is calculated exclusively from a small area in the center of the frame). You'll find more on choosing an exposure method in Chapter 3.

Shutter Release

Pressing the shutter release halfway generally performs several functions. If the metering system has switched itself off, it will revive and begin measuring exposure again. A picture being reviewed on the rear-panel LCD will vanish as the camera switches from review back to picture-taking mode. The autofocus system, if dormant, will again become active. If your camera has been set to fix exposure and focus point when the shutter release is partially depressed, those

parameters may be locked. (See "Single Autofocus/Continuous Autofocus and Optimizing Exposure" in Chapter 3 for more detail.) Pressing the shutter release down all the way takes the picture.

On/Off Power Switch

The power switch is often located concentrically with the shutter release, but may be located on the mode dial or a separate switch on the back of the camera. It powers your camera on and off. Note that most digital SLRs

use so little power when turned on (because metering, preview display, and autofocus turn off after a few seconds), you can usually leave the camera switched on for an entire shooting session—all day, if you like.

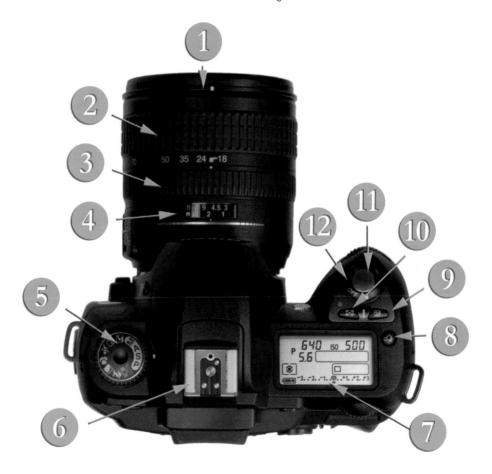

Inserting Media

Exchangeable media gives your digital SLR virtually limitless shooting capacity. When your digital "film" fills up, just remove it and replace with another memory card. The majority of dSLRs use Compact Flash solid-state memory, or hard disk alternatives, such as the Hitachi Microdrives. Some of the newest compact digital SLRs accept the smaller Secure Digital or xD cards. A few cameras have multiple slots for use

with several different formats at once, such as Compact Flash and SD, or Compact Flash and xD.

Media Slot Cover

The cover over your memory card slot can be flipped up when you want to remove or insert a card. Some dSLR models require pressing a button to open this cover. Because of the delicate electrical contacts inside, your media slot is a potential weak point. Moisture that gets inside can damage the camera, so a slot cover with

weather seals is a plus. In any case, you should be extra careful when changing media during rainy or snowy weather. Some media covers lack well-designed hinges, so you should also be careful to avoid damaging the door when it's open.

Removable Media

Your memory card goes in here. Pay attention to the proper orientation of the card (usually the label of the card faces the outer edge of the camera) and don't force it when inserting. There may be a button to press to

eject a Compact Flash card, but with SD and xD cards, pressing the media inward releases a catch, causing the card to pop out.

Handgrip/BatteryCompartment

The bulky handarip is where your camera's battery usually resides. Indeed, cameras that have optional vertical handarips often include space for two batteries, giving you longer shooting life. However, because most dSLRs can snap off 800 to 1,000 photos or more, this extra capacity is usually not needed unless you're shooting many photos or sports action sequences. It's still a good idea to have a spare battery to pop in when your main battery does expire. While batteries can be recharged many times, eventually they'll lose their ability to hold a charge, so your spare can be a life-saver when that happens.

SPEED AND CAPACITY

Your choice of memory cards will generally be limited to two parameters: speed and capacity.

Speed. The faster a memory card is able to accept data from your camera, the faster, in theory, your camera can shoot sequences of pictures. In practice, continuous bursts of images first go into a special area of memory in your camera called a *buffer*, which may be large enough to hold 10–20 pictures. Only when the buffer is full does the speed of the memory card come into play. Vendors use different terminology to represent the relative speed of their cards; some may offer Standard, Ultra, and Extreme versions, while others will sell 15X, 50X, 80X, or even 120X cards (which compare the media's writing speed with a "standard" memory card). If you feel the need for speed, you can compare apples to apples with the figures compiled at http://www.robgalbraith.com.

Capacity. The number of exposures that will fit on your memory card is likely to have a more immediate impact on your shooting. Most digital SLR owners purchase memory cards with 1GB, 2GB, or 4GB capacity. An important thing to remember is that your media just may outlive your current digital camera in terms of useful life, and you should purchase cards today with that in mind. Although those 512MB cards work fine with your 6-megapixel dSLR today, in three or four years when you replace your current model with a \$1,000, 12-megapixel model, those same cards may hold only a few dozen shots. Buying 4GB cards now can end up saving you money in the long run.

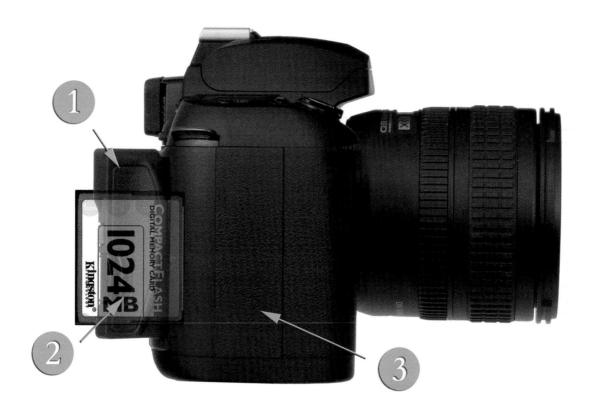

Using Electronic Flash

Electronic flash provides illumination when the available light is too dim to take a picture. It can also be used to fill in the shadows of scenes with too much contrast. One advantage of electronic flash is that its duration is so brief that it stops action in its tracks if it's the primary source of illumination, often better than all but the highest shutter speeds. Its key disadvantages are that flash can provide unattractive, glaring lighting, may produce glowing red pupils in humans ("red-eye") and has a range that may be lim-

ited to 10–12 feet from the camera. You'll find out more about flash in Chapter 4.

Most digital SLRs have a built-in, flip-up electronic flash, although some more expensive models lack this feature, on the theory that users of upscale cameras prefer to use more versatile external flash units.

LOOK FOR FLASH MODES

The most common flash setting you'll need to make involves flash mode. Your choices include:

Always Flash. Any time you flip up the electronic flash or connect an external flash, the flash will fire as the exposure is made.

Auto Flash. The flash fires only when there isn't enough light for an exposure by available light.

Fill Flash. The flash fires at a reduced illumination level, providing only enough light to fill in dark shadows caused by the contrasty main light source (which is often daylight).

Red-Eye Flash. A pre-flash fires before the main flash, contracting the pupils of your subject, reducing the chances of red-eye effects.

Rear Synch/Front Synch. Controls whether the flash fires at the beginning or end of the exposure. You'll find information about this control in Chapter 4.

Wireless/Remote Synch. This feature allows triggering an external flash that isn't connected to your camera through radio or infrared control or, sometimes, a preflashing system.

Electronic Flash Tube

The electronic flash tube is tucked behind a plastic window that directs and diffuses the light, providing illumination that covers the angle of view the flash was designed for. Sometimes the internal flash will not cover the image area of particular wide-angle lenses, or may cast a shadow from the lens or lens hood onto your subject area. While convenient, the internal flash might not be elevated enough to reduce red-eye effects (more on this in Chapter 4), and in such cases you might find an external flash (which is more powerful to boot) will do a better job for you.

Plash Mode/Flash Compensation Button

Digital SLRs will have one or more buttons used to adjust the flash mode and exposure compensation, often in conjunction with a command dial that's spun while the button is pressed down. Flash mode is one of the modes described in the previous sidebar. Flash exposure compensation will be additional or less exposure applied to override the exposure determined by your camera's flash metering system. If you discover that photos of a scene are consistently over- or underexposed, you can add or subtract EV values to increase or decrease the relative exposure. Flash EV settings are typically 2 to 3 EV (each EV doubles or halves the exposure), in 1/2 to 1/3 EV steps.

© External Flash PC/X Connector

This is a connector, often under a protective plastic or rubber cover, which accepts standard flash cables for external flash units. This connector provides only a triggering mechanism for the flash. Automated exposure and other features are available only when an appropriate external flash is attached using a connector designed for that purpose, including those that work through the dSLR's hot shoe.

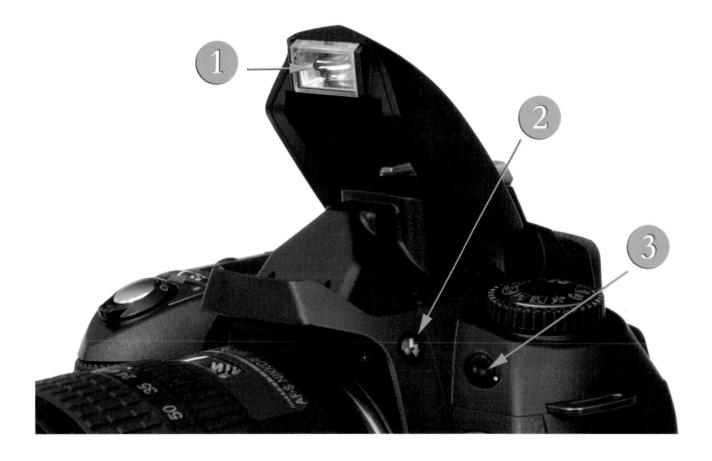

Inside a dSLR

If you've upgraded to a digital SLR from a point-and-shoot camera, you may be wondering about the innards of your camera. The first digital SLRs were film cameras with a sensor grafted onto the film plane. The newest models are designed more from the ground up as digital cameras, but still have a sophisticated combination of mechanical, optical, and electronic components that draw on both traditional and cutting-edge technological realms.

For example, the lenses used with digital SLRs may be exactly the same as those mounted on film SLRs (although some vendors have introduced lenses specially designed for sensors that are smaller than a full 35mm frame). Viewing systems in the film and digital worlds are also very similar, except for modifications made for the smaller sensors. The chief differences come with what happens when the image is actually captured and stored.

Diaphraam

The diaphragm is an iris mechanism that opens and contracts to admit more or less light. In an SLR camera, the diaphraam is generally kept wide open until the moment of exposure. providing the brightest view. Then, just before the shutter opens, the camera reduces the size of the diaphragm to the taking aperture. This aperture can be set manually or controlled by the camera's autoexposure system. Apertures are represented by f/stops, such as f/2, f/2.8, f/4, f/5.6, and f/8. Because the numbers are the denominators of fractions, the smaller numbers represent larger f/stops (f/2 is larger than f/4, just as 1/2 is larger than 1/4), and larger numbers represent smaller apertures. You'll find out more about f/stops in Chapter 3.

Lens Elements

Each lens contains multiple elements of glass or plastic that diffract, or focus the light, ideally to a position that represents the plane of the sensor. The distance of the lens elements from the sensor determines the lens' focal length, or magnification, as well as determines whether or not a particular portion of the image is in sharp focus. The f/stop chosen also affects

focus by providing more or less focus range, or depth-of-field, depending on whether a large f/stop (little DOF) or small one (more DOF) is in use. These elements also adjust the apparent magnification of the image, which is why some lenses, called zooms, can offer multiple magnifications.

6 Flip-Up Mirror

The light passing through the lens would ordinarily continue to the sensor, except that a flip-up mirror is placed in the light path to reflect the image to a viewing system that allows previewing the image prior to exposure. This mirror has its reflective coating applied to the front surface (rather than behind a film of glass or plastic) to provide the brightest, most distortion-free view. Because of this design, the mirror easily can be scratched if cleaned improperly. At the moment of exposure, the mirror pivots out of the way briefly, allowing the light to continue to the shutter and sensor. Then it flips back down. This interruption of your view may be so quick that you scarcely notice it. Some dSLRs have a mirror pre-release system, either a switch or menu choice, that allows flipping up the mirror prior to exposure to reduce the possibility of vibration caused by the mirror's movement.

This feature is generally useful only at shutter speeds from about 1/15th to 1 second in length. Digital SLRs also have a mirror lockup feature that swings the mirror out of the way and opens the shutter so the sensor can be cleaned.

Focus Screen/Pentaprism/ Pentamirror

The image bounced up from the mirror is focused on a screen of ground glass or plastic, and then bounced twice more from reflective surfaces of a pentaprism (if the component is solid glass) or pentamirror (if it is hollow with mirror surfaces), and out through a viewfinder eyepiece. All that bouncing re-orients the image so it appears to be upright rather than inverted, and not reversed left-to-right. Pentaprisms are preferred over pentamirrors (also called porroprisms) because they offer a brighter view. The magnification of this optical system determines whether the image you see in the viewfinder appears to be life-size (with a standard lens) or reduced in size. Digital SLRs generally provide 70-80 percent magnification (good) to 80-90 percent magnification (excellent).

Shutter

The shutter determines the length of time the sensor is exposed to light. A digital SLR uses a combination of a mechanical shutter, like those found in film SLRs, and an electronic shutter. The mechanical shutter is a leading curtain that opens at the beginning of the exposure and remains open until the end of the exposure, at which time a trailing curtain covers the sensor again. This mechanical shutter is used for "longer" exposures (a top speed of 1/500th or 1/250th second to 30 seconds or more). For shorter exposures, an electronic shutter turns the sensor on and off for a brief period while the mechanical shutter is all the way open. This electronic shutter is used for exposures of about 1/500th second to 1/8000th second or less.

6 Sensor

The sensor captures the image during the exposure, and is the most important component of a dSLR from a digital standpoint. The sensor determines the resolution of the image (that is, whether your camera can capture 6 megapixels or 16 megapixels); the amount of the grainy look we call noise in an image; the accuracy of the colors; the amount of detail that can be captured in shadows and highlights; and, with sensors that are smaller than a full 35mm film frame, the effective magnification of your lens.

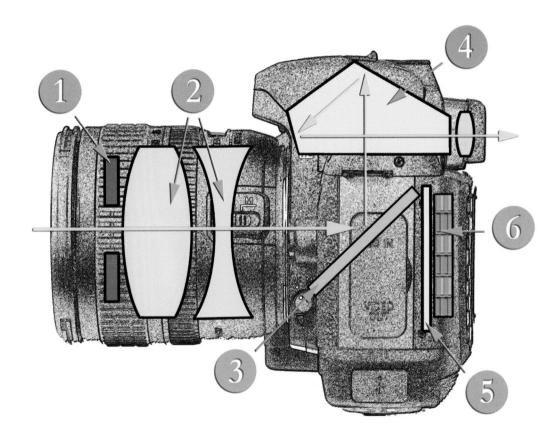

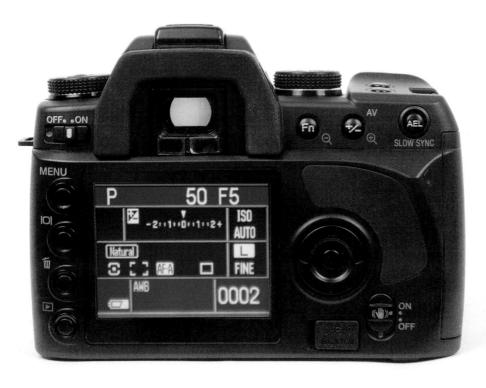

Setting Up Your dSLR

f you purchased your dSLR in a full-service camera store, it's likely that the store personnel helped you set up your camera, explained some of the key controls, and gave you a quick tour of the main features. That's one of the best reasons for buying from a local dealer, even if the price you pay is a little higher. However, many digital SLRs are bought from "big box " electronics stores and other outlets staffed by sales people rather than photographers, and all you may receive is a box and a handshake. That's okay, too, if you need a handshake more than handholding. Large numbers of dSLRs are also sold by mail order and over the Internet with very little interaction between you and the vendor.

So, it's possible that you'll spend your first hour or so with your new digital camera setting everything up and getting it ready to take pictures. If that's the case, the manual that came with your camera may be fairly helpful, but probably offers only the basics without any background that explains why you're performing the various setup tasks. This chapter provides an overview that you should find helpful when configuring your camera.

Battery Charging and Battery Life

All digital SLRs use one or more batteries of some type to provide power for the camera's various functions. One of these will be the main battery, usually a rechargeable nickel metal hydride (NiMH) or lithium ion (Li-lon) power pack that can be removed from the camera for recharging or replacement. The dSLR might also operate using standard AA batteries (alkalines or rechargeables), nonrechargeable lithium cells, or an AC adapter that can be helpful when using the camera for long periods, such as in the studio or when shooting time-lapse sequences that can last hours or days.

You might not be aware that your dSLR might also have a second "secret" battery often called a clock battery, because it powers the memory that retains various settings, including the time, when the main battery has been completely discharged or removed. Without this secondary cell, all the customized settings

you've made, as well as the current time and date, would be lost every time you changed the main battery.

AVOID BURNOUT

Don't carry a loose spare battery; make sure it's inside a pouch or container that prevents the exposed contacts from touching any conductive surface that might cause the battery to short out. It's surprising how hot a battery can get when all its energy is released unexpectedly through a short circuit.

The clock battery is usually a small button cell that's good for a number of years before it must be replaced. Unfortunately, this cell isn't always as accessible to the user as the one shown in Figure 2.1, which means you must send the camera to the vendor when the clock battery needs replacement. Often, you'll find that a

"clock" icon is flashing on your new digital SLR when you receive it. That doesn't mean that the battery is already dead; it simply signifies that the time and date need to be set for the first time.

Your camera's main battery is seldom fully charged when you receive the camera. It may have been shipped with a partial charge, or it may have lost some or all of its juice after leaving the factory (rechargeables often lose about 1 percent of their charge each day, even when the camera is not being used). So, it's helpful to recharge your batteries before attempting to use the camera. The process usually takes only an hour or two to rejuvenate a fully depleted battery. Here are some things to consider:

◆ Separate charger required.

Digital SLR batteries, like the ones shown in Figure 2.1, are usually recharged outside the camera, using a separate battery charger. Removing the depleted battery gives you the opportunity to plug in a fresh one and continue shooting

if you like. It's a better method than that used with cameras that require plugging the whole camera into a power source for recharging, or nestling the camera into a separate image transfer/power dock.

Recharge anytime. NiMH or Li-lon batteries can be topped off at any time, regardless of how much of the charge has been used, without danger of suffering from the "memory effect" that plagued earlier types of batteries (particularly nickel cadmium cells) and gradually depleted their capacity. Modern batteries are good for up to 1,000 full charge/recharge cycles in any combination; for example, if you consistently recharge when the battery is half expended, you can reasonably expect to do that about 2,000 times before needing to buy a new

Check remaining power.

Some cameras offer two ways to check the amount of charge remaining. You'll usually find an icon in the shape of a battery on the status LCD on top of the camera. The icon will gradually lose internal segments as the battery is depleted, until an "empty" battery icon represents a fully discharged

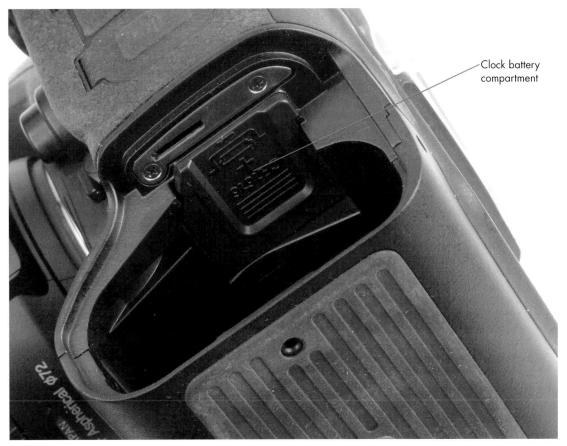

Figure 2.1 If you're lucky, your camera's clock battery will be tucked inside your camera in an accessible location.

cell. There may be a battery warning light inside your viewfinder, too. A second, often more accurate, way of determining remaining power may be found within your camera's menu system. Some dSLRs have a Battery Information screen that shows an accurate percentage of power remaining, and the number of photos taken with the current charge. (This may be a larger number than the exposures shown on your camera's status display, if you've swapped or reformatted memory cards.) Some high-end cameras with "intelligent" batteries also measure how many times a battery has been recharged and recommend replacement with a new one when needed, and track the accuracy of their gauge and call for recalibration when there is a difference between the predicted and actual number of shots you are getting.

▶ Longer life. If you've used non-SLR digital cameras before and are new to dSLRs, you may have a pleasant surprise in store. The battery life of the typical dSLR is often double or triple what you may have become accustomed to with a point-and-shoot or more advanced non-SLR digital camera. Most dSLRs can take 1,000 or more images on a single charge, and 1,500 to 2,000 exposures per cycle is not unusual.

Why do larger digital SLRs have relatively more juice than smaller, less fully featured point-and-shoot digicams? Part of the answer comes from the size factor alone: Compact consumer digital cameras may have a tiny battery that offers perhaps 600 to 700 millampere hours (mAh) of power, compared to the 1,500 to 2,000 mAh (or more) ratings of typical dSLR batteries. Snapshooters tend to use their camera's built-in flash units more, power-hungry LCDs are often switched on for long periods to compose or review images, and the camera's battery may have to handle functions like zooming—something the dSLR photographer takes care of by twisting the zoom ring on the lens.

The average dSLR, in contrast, is incredibly efficient in its use of power. The LCD can't be used for composing images, and remains off except during picture review or menu access. Autofocus and autoexposure functions consume power, but will typically be switched on only for a few seconds when the shutter release button is partially depressed.

DOUBLE YOUR PLEASURE

Some dSLRs have an optional vertical grip that holds an additional battery. One common configuration is a grip that plugs into the camera's battery compartment in place of the original battery. Then, you place the cell inside the grip's battery chamber, along with a second identical battery.

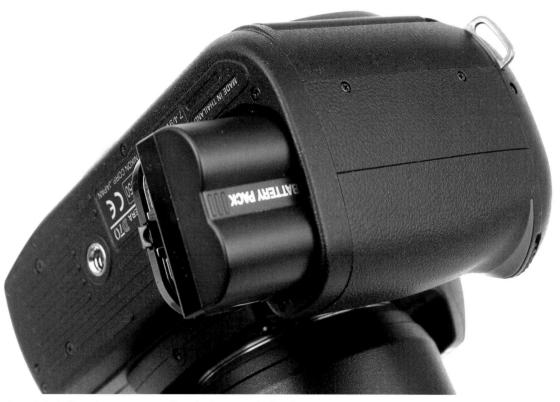

Figure 2.2 A dSLR's battery is generally tucked away in the handgrip.

Setting Up Your JSLR

Batteries for the Canon 5D, Nikon D70s, and Nikon D2X.

Serious photographers don't use flash as often as snapshooters. So, it's entirely practical to leave a digital SLR switched on for an entire shooting session (or even several days) without using much battery power. When "idling," a camera uses very little electricity at all, yet is able to spring to life instantly when the shutter release is pushed. Actually taking a picture does cause a spike in battery consumption, but, even with the diaphragm closing, mirror flipping up and down, and shutter opening and closing, the amount of current drawn isn't all that great.

Media Formatting

Your digital SLR might not have been furnished with any memory card, which is probably for the best, because there are many variations in capacity and transfer speed (how quickly the media can accept data from your camera), and the vendor probably hasn't a clue about what size or type you might really need. Why pay for a card that doesn't suit you? So, a memory card is an accessory that you either purchased at the same time as your camera, or soon afterwards. You might have already owned a card that you've used with a different camera. In either case, it's a good idea to format your card so it will be ready for use in your new camera.

It's wise to format the card (which removes all the pictures on the card) because there are several different ways of logically arranging the sectors on silicon media, and, as you'll see, it's possible that the card's current format isn't compatible with your camera. You'll know that for sure if you insert the card and receive an error message, often followed by a request on the camera's status LCD to okay an immediate reformat. However, it's also possible that your camera appears to read the card just fine, even though there are potential problems lurking beneath the surface.

These include:

♦ Hidden or protected files.

Virtually all digital cameras have an option for marking a file as read only so that the camera or your computer can view the image, but not erase or remove it. Some allow you to hide a file so that it doesn't readily appear when you access the memory card with your camera or computer. Files created on a memory card by one camera are deposited into a folder created by that camera, and may not be visible to your camera even if they haven't been intentionally hidden. When some previous use has left your media cluttered with hidden or protected files, you'll find yourself with reduced capacity. Extra space might be taken up by files that you don't want and don't even know are there. Reformatting can remove them quickly and easily.

 Bad sectors. Rewritable media eventually develop bad sectors that can't be reliably written to. The reformatting process spots these sectors and locks them out to prevent further use. • Wrong format. The device that previously used your memory card might have formatted it using a scheme that's incompatible with your digital SLR's internal software. Reformatting the media with your current camera ensures that the correct format will be used.

If you've been paying attention, you've probably drawn two conclusions from the current discussion. First, always format your digital film in your camera rather than using the Format command of your computer when the media is inserted into a memory card reader, like the one shown in Figure 2.3. The camera's Format command guarantees that the correct formatting scheme will be used. An exception to this is when you find your camera can't format a card at all for some reason. Performing a format with your computer and then reformatting in your camera can sometimes solve the problem.

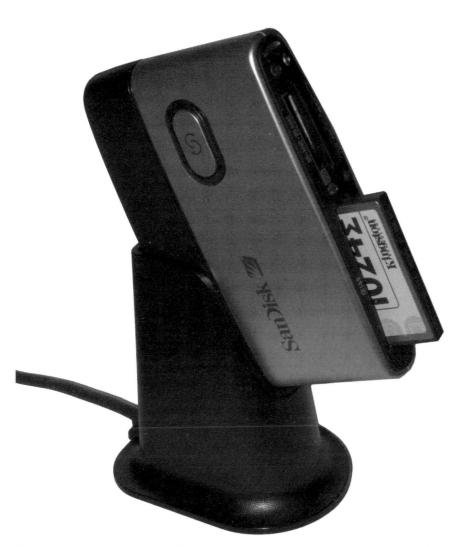

Figure 2.3 Don't format your digital film in a memory card reader. Use your camera instead, to ensure that the proper format is applied.

Second, you probably surmised that formatting is almost always a better choice than just deleting all your photos. Formatting removes hidden and protected files, and locks out bad sectors; deleting files does not do this. The only time you should delete files is when you want to remove some, but not all, of the images on your media. You can delete them one at a time, or use your camera's marking feature and then select Delete Marked (or whatever it is called) using the appropriate menu choice. Of course, if you delete all the files on your card and then immediately discover you erased the wrong files or used the wrong card, you might be able to retrieve the lost files using various utility programs available for your computer. Images removed by formatting are usually gone forever.

FAT Chances

As I've noted, you take your chances if you format a memory card with your computer. That's because there are several different schemes used to lay out the sectors on digital media, using a "table of contents" called a File Allocation Table, or FAT. The FAT allocates the smallest individual storage units of your solid-state "disk"—sectors—into easily managed groups called clusters. Each cluster is numbered, starting at 0, using a 12-, 16-, or 32-bit number. The maximum number of clusters that can be squeezed onto a digital memory card (or floppy disk or hard disk) is determined by the largest number that can be represented with 12, 16, or 32 bits.

FAT12 (12 bits) limits the capacity of media to no more than 16MB, which is not very useful, so FAT12 is used for Stone Age media like floppy disks. FAT16 allows formatting a memory card with 2GB worth of clusters, while FAT32 allows squeezing 1,024GB (a terabyte) onto one card. It will be quite a while before we see terabyte memory cards, but that upper limit is being approached by hard disk drives—which are already available in 512GB and larger capacities.

The actual conflict for digital SLR users comes with memory cards that have more than 2GB of space. Some older cameras use FAT16 formatting and, thus, are unable to use 4GB and larger memory cards. SanDisk pioneered a 4GB CompactFlash

card with a three-position switch on one edge that you can use to transform the card from a 4G/FAT32 card to two separate 2G/FAT16 volumes. You probably won't need this clumsy workaround, because newer digital SLRs all use FAT32 and can access memory cards of any size.

However, problems can crop up if your 2G-plus memory card happens to be formatted using FAT16 in a computer or digital camera. Your larger card will then appear to have no more than 2GB of capacity, which is a tragic waste of valuable silicon. That's the most important reason why you should always format your memory card in your camera.

WHAT SIZE?

Your digital SLR will use a CompactFlash (CF), SecureDigital (SD), or xD memory card—or perhaps has several slots and can accommodate more than one type of card. For dSLRs in the 6–8 megapixel range, a 1GB memory card is the smallest size you should consider; shooting 36 exposures or so before changing "film" belongs in the silver halide era, not the age of silicon. That's exactly what can happen if you're using 256MB or 512MB memory cards. If your dSLR has 10 to 16 megapixels of resolution, you probably should consider 4GB cards, especially if they cost about 4X the tariff of a 1GB version.

You can buy 4GB cards for your lower-resolution dSLR today if you expect to upgrade to a higher-res camera in the future and don't want to replace all your 1GB cards when their capacity becomes laughably small with your new machine. This can be false economy, however, because unless your upgrade is planned for the near future, it's very likely that 4GB (or larger) media will cost *less* than you're paying for 1GB cards today.

Using unnecessarily large memory cards today has one downside: Your lower-resolution digital camera can fit so many images on a single card (perhaps thousands of pictures) that you fall into the "all your eggs in one basket" trap. If you have just one basket, it's very, very important to not lose or damage that basket. Of course, it could also be said that using four 1GB cards quadruples your chance of misplacing one of them and losing some of your images—even if you're missing fewer images than if you misplaced a 4GB card.

Optimizing Compression and Resolution

Before you start taking pictures, the most important decision you must make is what compression and resolution settings to use. Both settings have an effect on the sharpness of your final image, as well as how many pictures you can fit on your memory card. Here's a quick introduction to each parameter, with some tips on choosing the setting that's appropriate for you.

Compression and File Format

To save space on your memory card, digital SLRs usually squeeze down, or *compress* the images before they are stored. Compression makes the image file smaller so that more pictures can fit on the card. Various mathematical algorithms are used to

squeeze the files down. Some are lossless, producing a file that is moderately compressed, but still retains all the basic information that makes up the image. A photo stored with lossless compression can be opened in an image editor and it will be just as sharp and detailed as it was when captured by your camera. To provide smaller files, lossy compression is used, typically using the JPEG file format. Some image information is discarded when this kind of compression is applied. The amount can range from very little to a lot. I'll show you how to choose later in this section.

The type of compression available is determined by the file format used. The most common file formats and recommended uses follow:

TIFF. This format is one of the original file formats used for images. It's a lossless format that preserves all the detail of the image, but it typically requires the most space on your memory card, and takes the most time to process. It's not uncommon to wait 15-25 seconds while a mammoth TIFF file is stored on your card. Because TIFF files are compatible with any image editor with no conversion, they are sometimes used when the photographer wants to create high-quality image files that will be used as-is, or imported into an image editor for moderate manipulation.

- RAW (uncompressed). RAW files (uncompressed and compressed) contain all the information captured by the camera after it has been converted from analog to digital format, without the application of settings such as white balance. tonal changes, or in-camera sharpening. The photographer can then import this relatively unprocessed image into an editing program through a special converter module created for that camera's RAW files, and make the adjustments at that time. Uncompressed RAW files haven't been reduced in size and are slightly larger than the compressed version (but typically half to one-third the size of TIFF files, even though they contain a great deal more editable information).
- ◆ RAW (compressed). Some dSLRs offer an option for compressing RAW files so that more of them can be squeezed onto a memory card. The size reduction is usually moderate (10–20 percent), and doesn't affect sharpness much, if at all. Use either RAW format when you want to tweak your camera's settings after the fact, realizing that you'll get fewer shots on your memory card.

◆ JPEG. The ultimate space saver in digital SLRs is the use of JPEG compression, which may reduce the size of images by 10X to 15X or more. JPEG is definitely a lossy compression method, but your digital camera will offer a choice of low, medium, and high ratios (usually with names like BASIC, NORM, FINE, EXTRA FINE). You can choose the amount of compression based on criteria similar to those applied to selecting a resolution: How sharp and detailed must your image be? Can you afford to give up a little image quality to save space? Most of the time, you'll find that the least compressed JPEG setting (FINE or SUPER/EXTRA FINE) will give you images that are almost as good as you'd get from RAW, but without the ability to manipulate the image as extensively in an image editor. The high compression/low quality ratios are a good choice when you are just taking snapshots, or will route your pictures to a low-res destination, even though you lose some image quality, as you can

see in Figure 2.4.

• RAW+JPEG. Many dSLRs let you save two copies of each image you take. One of them is a lossless RAW version that can be edited to your heart's content later on, while the second copy is a JPEG version that can be used for quick review, e-mail, or for any purpose that doesn't require the highest quality/most editable image. Your camera

may offer only a single RAW+JPEG option, or allow you to choose RAW plus any of the individual JPEG compression ratios.

Figure 2.4 Compressing a photo extensively reduces the image quality.

Resolution

In a digital camera, resolution is determined by the dimensions of the image in pixels (picture elements), and represented by the total number of pixels in the image. A dSLR that takes 3008 × 2000-pixel images (a common size), would provide a 6-megapixel image. Cameras commonly provide optional lower-resolution formats that can be useful when you don't need the full resolution of the sensor. Quality may suffer, though, as you can see in Figure 2.5.

For example, one digital SLR that shoots 3872×2592 -pixel images (10.2 megapixels) also can be set to produce 2896×1944 (5.6 megapixels), or 1936×1296 (2.5 megapixels). The available resolutions vary from camera to camera: One model's "medium" resolution mode may be higher than another camera can achieve when set at its maximum resolution. Nikon's top-of-

the-line dSLR offers a choice of 12.4, 6.8, and 3.0 megapixels, while Canon's flagship gives you 16.6-, 8.6-, 6.3-, and 4.2-megapixel options.

Why would you choose a resolution lower than the camera's highest pixel count? There are several situations where this is a smart idea

Only low resolution needed.

You're taking photos destined for low-resolution output and don't plan to do much editing of the images. For example, you might be taking pictures for your website, recording construction progress shots, capturing real estate photos, or photographing company employees for ID purposes. In all these cases, you can safely shoot at the lowest resolution your camera allows, then crop or resize them appropriately for your intended use. You might also need low-res photos when you plan on e-mailing your shots, in which case you'll also want to apply JPEG compression to make them as compact as possible.

- ◆ Your memory card space is limited. Perhaps you're on a photo outing and discover that you have only enough space on your card for another dozen photos. Drop down to medium resolution and you might be able to double or triple the number of pictures you can take before the card fills. (You can also increase compression of the images, as I've already explained.)
- A lower resolution adds **speed.** Some digital SLRs operate faster when resolution is reduced. because they are able to process images and store them to the memory card more quickly. After an image is captured, it resides in a special area of memory called a buffer until it can be written to the removable memory card. When the buffer fills, the dSLR is unable to take any more photos until some of the images are offloaded to the card. Inexpensive digital SLRs (as well as some older models) may have only a small amount of buffer space available, making it impossible to shoot more than three or four full-resolution photos in a row before it's necessary to wait a second or two as the buffer is gradually emptied. Drop down a notch

in resolution, and you might be able to double the number of sequence shots you can take. Nikon actually turns this quirk into a useful feature: Its D2X camera is capable of shooting about five images in a row at its full 12.4megapixel resolution, but using a so-called "high-speed crop" mode, the same camera increases its burst speed to eight 6.8-megapixel frames per second. In this case, the D2X reduces resolution by actually ignoring (cropping out) part of the frame; the smaller target area is shown in the viewfinder.

Digital SLRs typically allow you to change the resolution in one of two ways. There may be a button on the camera (labeled Size or Qual) that is pressed while spinning a command dial or pressing a cursor/multiselector switch. Or, you may have to visit a menu to adjust resolution. Many cameras offer a choice of either method.

Figure 2.5 Do you really need a 6-megapixel image (top)—or will a 3.3-megapixel version do?

Making Basic Settings

There are several basic settings you should make or double-check each time you begin shooting. These include ISO (sensitivity), white balance (color rendition), autofocus mode (how the camera chooses focus settings), exposure mode (the scheme used to select the correct combination of shutter speed and f/stop), and metering mode (how the camera measures exposure). These values generally remain in place from shooting session to shooting session, so if you've made a significant change in the settings you usually use by default, not confirming them when you start can lead to photos that are overexposed, badly focused, or imbued with bad color. This step is a little like the pre-flight checks pilots use to make sure their craft has sufficient fuel, oil, and coolant; the radio is working; and all the doors are closed and latched. A little attention now can avoid unpleasant surprises later.

I'll cover most of these in more detail on separate pages in Chapter 3, but here are the important checks to make before you begin shooting:

◆ ISO. ISO determines the sensitivity of the sensor to light. Lower values require more exposure, but often produce better results. Higher values let you take pictures in dimmer conditions, but may reduce quality and increase the noise levels in photos. One trap new dSLR owners sometimes fall into is to set ISO to Auto, as is usually done with pointand-shoot cameras. Don't do it! Serious photographers need to make the decision about sensitivity and grain tradeoffs themselves. In bright sunlight, manually select the lowest ISO setting (usually ISO 100 or 200). Some cameras have a "low" setting, as well as an "extra low" setting (such as ISO 50) that you might want to save for special circumstances (check Chapter 3 for more information on these). In dimmer light, you might want to select a mid-range "high" setting, such as ISO 400 or ISO 800, and reserve the highest settings for the most extreme lighting situations.

◆ White Balance. Setting white balance to Auto is usually safe. White balance adjusts for the color of the light source you're using: Indoor illumination tends to be warmer or redder, and outdoor illumination is cooler or bluer. Manual settings for a specific type of light, such as daylight, incandescent, or fluorescent illumination can ruin your photos beyond fixing in an image editor if you are shooting JPEG images and select the wrong light source. Your pictures may end up far too blue or too orange to repair. If you're shooting in RAW format, you can always adjust the white balance when the photo is

Figure 2.6 Customized white balance can be used as a creative effect, adding a golden glow to this building.

- imported into an image editor. The camera white balance is recorded as the "As Shot" setting, but the RAW file can be manipulated to any WB setting you want. You can even use customized white balance as a creative effect, as in Figure 2.6.
- * Autofocus mode. Choose single autofocus unless you have a reason to do otherwise. Select the center focus zone, or allow your camera to choose the focus zone itself. With single autofocus, the camera locks focus when the shutter release is partially depressed; it is a good choice for subjects that aren't moving rapidly. Continuous autofocus allows the camera to set focus when the shutter release is partially pressed, but continues to refocus if the subject moves or the image is reframed. This mode is better for action and sports photography, but does use more battery power.
- ◆ Metering mode. Most digital SLRs offer a choice of matrix, center-weighted, or spot metering. Most of the time, matrix metering—which evaluates many different areas of your image to intelligently choose what exposure to set—is best. Center-weighted and spot metering can be used when you want to calculate exposure based on specific areas in an image.

◆ Exposure mode. You're safe if you choose programmed exposure. The camera will use the Matrix metering mode and match up the exposure results with a built-in database of picture types and arrive at the best combination of shutter speed (to stop action) and aperture (to provide a sufficient zone of sharp focus). Use shutter priority to choose the shutter speed yourself and allow the camera to select the aperture; aperture Priority mode gives you control over the f/stop and the camera has

when each is a better choice. Entry-level dSLRs also have scene modes, like those shown in Figure 2.7, programmed to handle specific shooting situations (such as portraits, landscapes, museums, or night scenes). These are great when you don't have time to make decisions yourself, but serious photographers usually eschew scene modes once they've become familiar with their cameras.

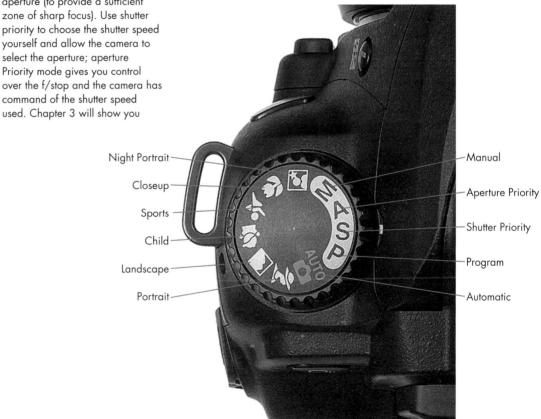

Figure 2.7 Some dSLRs have "scene" modes tailored to specific shooting situations.

Changing LCD Brightness and Review Modes

The ability to review your images after the shot and make immediate corrections is one of the top advantages of digital cameras over the film variety. By the time you have your film processed and prints made, it's usually too late to go back and re-shoot all those blurry pictures you took with the shutter speed set to 1/15th second. With a digital camera you can have instant feedback and correct exposures, errant shutter speeds or white balance settings, and other potential problems after you've taken only a few pictures.

Here are the settings you should be most concerned with:

◆ LCD brightness. New digital camera owners may not even be aware that the brightness of the back panel LCD, like the one shown in Figure 2.8, can be adjusted. Outdoors, you might want to crank up the brightness so

you can view the LCD in direct or indirect sunlight (although shading the screen with your hand is an option). An extra-bright setting can drain your dSLR's battery more quickly, so you won't want to maximize brightness all the time. Indoors, you might want to crank down the brightness below midlevel, particularly when shooting in dark surroundings (say, at a concert). The low level is easier to view and won't distract those close to you. (Avoiding being a pest at a concert is always a good thing.)

♠ Review period. You can set your camera to show the most-recent picture for a set period (usually about two seconds), or define a longer duration as a default.

Or, you can set the display so it doesn't automatically show the image at all. Turn the review feature off if you won't be checking each shot after it's taken. This will avoid the short delay that occurs when you involuntarily pause to look at your photo, whether you needed to or not. (With most dSLRs, you can dismiss the

reviewed picture and return to metering mode by partially depressing the shutter release.) No review mode also can save on battery power. You can always summon the most recently taken picture by pressing the Review button on your camera. (It's frequently a green triangle pointing to the right.)

 Information displayed. Digital SLRs offer a choice of information displayed by default during picture review. Most of the time the information is just the basics, as in Figure 2.9: the photo itself and picture number. However, you can elect to have a great deal more info displayed in various combinations, such as file format or compression ratio used, time and date, metering and exposure mode, shutter speed/aperture, amount of any EV compensation, zoom lens focal length setting, flash information, ISO, white balance, sharpness, saturation, and other data. Some

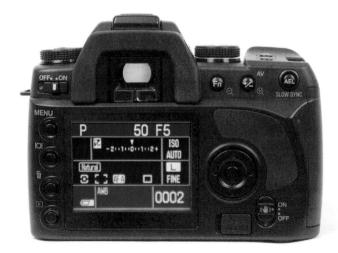

Figure 2.8 A bright LCD can make viewing menus and images easier under bright lighting.

cameras will even show you the focus zone used for an image and display a histogram that shows the distribution of tones in your picture, as you can see in Figure 2.10.

 Autorotation. Digital cameras have a setting called autorotation that can be useful if you (as you should) use a healthy mixture of vertically and horizontally oriented shots. Your camera has a little hanging device inside that swings from one position to another when the camera is tilted between portrait and landscape orientations. The relative position of the camera can be included right in the image file and used by compatible image editing software to determine how the photo should be oriented when loaded. Your camera's software, too, can use this information to display vertically oriented photos upright on the LCD screen. The downside is that a vertical picture shown in its correct orientation on a horizontal LCD looks smaller, and details are more difficult to judge. If you find this to be the case, turn autorotation off in your camera's menu system.

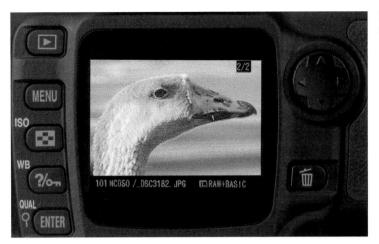

Figure 2.9 Basic information includes the file name and other data.

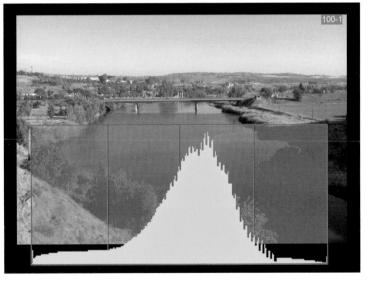

Figure 2.10 A histogram chart, used for judging exposure, can also be included in the picture review display.

Other Shooting Options

There are a number of other options you can set that affect how your pictures are shot. These are fairly specialized choices that must be selected from menus. Here's a checklist of the key items you might want to check before you start shooting.

Noise Reduction

Noise is a pattern of random graininess that infuses your image under a number of different conditions. These include:

- High ISOs. To increase the apparent sensitivity of a sensor, your camera may amplify the original signal to retrieve information from murky shadows. Unfortunately, the process also magnifies any random electrical interference in the signal, producing noise.
- ◆ Long exposures. The electrical charge that sensitizes your camera's imaging chip also heats it up slightly. As the length of the exposure increases, so does the heat build-up, so that any exposure longer than about 1/15th second may suffer from noise induced by interference with the signal due to the excess heat. Long exposure noise can be produced at any ISO setting if the exposure is long enough, but when you combine it with high ISO noise, the speckles become even worse.

Your digital SLR has built-in noise reduction (NR) algorithms that can reduce noise somewhat. The most common way to do this is to follow the original exposure with a second, blank exposure, and then compare the two. Any artifacts that appear in the "dark" frame and also in the actual exposure can be assumed to be noise and removed. The process is not 100 percent accurate, so noise reduction can also reduce the amount of detail in your image, and should be used only to the degree necessary. Some dSLRs have only an option for turning NR on or off. Others have normal, high, and low settings, and might allow using NR only for high ISOs, only for long exposures, or for both.

Image Optimization

Most digital SLRs have an assortment of image tweaks you can turn on or off. It's important to keep track of which enhancements you're using, because no particular adjustment is right for every photograph.

Your choices may include:

◆ **Sharpness.** Adjust sharpness when you want to add a little acuity to every image you're shooting, or want to soften images slightly. A sharpness boost might be useful if you need a little extra detail in a group of images and don't want to sharpen each one manually in your image editor. Portraits can sometimes benefit from setting the sharpness level to a softer level.

Figure 2.11 Your camera's noise reduction feature can reduce the amount of grain from long exposures and high ISO settings

Quick Snap Guide to Digital SLR Photography

- - Hue. Some dSLRs let you adjust the hue. This is a different setting than color balance, and changes all the colors in an image by shifting them in one direction around an imaginary color wheel (see Figure 2.12).
- ♠ EV. Exposure Value settings override the setting of your camera's exposure meter, usually to correct for measurements that are "fooled" by the current lighting conditions (such as backlighting or sidelighting), or to deliberately under- or

Figure 2.12 Hue alters colors by rotating around an imaginary color wheel, shown by the edges of this shape.

- overexpose a photo for a creative effect. It's important to make certain you've "zeroed" the EV settings when beginning a new session, to avoid unintentionally over- or underexposing your pictures. Most dSLRs have an EV indicator in the viewfinder, but it's easy to overlook.
- ◆ Saturation. Saturation is the richness of the color, and can turn, say, an ordinary red into a faded pink or brilliant crimson, as you can see in Figure 2.13. You can boost saturation as a special effect or to brighten gloomy days outdoors. Reducing saturation produces a subtle pastel look in your photos.
- Color filters. Some digital SLRs have special effects filters, such as sepia, black and white, cyanotype (bluish), or specific colors like red, green, or blue.

File Numbers and Folders

You can choose how your digital SLR applies file numbers, and designate which folders your files are deposited into on your memory card. Usually, you'll want the camera to continue numbering images consecutively each time

existing pictures are copied to your computer and the memory card is reused. That avoids having several pictures with the exact same name. However, you can also direct your camera to start numbering images from zero again each time a new card is used. You might do that if you have your own filing system and want to have each batch of photos numbered consistently. If you were a school photographer, for example, you might want to have your photos numbered from 000 to 999 for each school, so you could match the photos with a numbered class list. It would then be up to you to remember to put West Elementary files into one folder on your hard disk, East Elementary photos into another, and North and South Elementary schools' pictures in their own folders

Your camera may also allow you to chose your own prefix for each file number (say, welemxxxx.jpg instead of imgxxxx.jpg or dscxxxx.jpg) or define the folders on your memory card where the images are deposited.

Figure 2.13 Boosting saturation enriches the colors of an image.

Custom Settings

Digital SLRs have many more customization options than you'll find in the typical point-and-shoot camera, and you can use these options to direct your camera to behave in the way you prefer.

Usually, you'll make these settings once and then leave them alone until your preferences change.

Here are some of the most important choices you might have to make.

♦ Beep/no beep. Your camera may make a sound when it turns on and/or when certain functions are carried out. In some instances, such as at concerts or in museums, you might prefer a more "silent" mode that doesn't draw attention to your camera. However, keep in mind that there is no disguising the shutter click and the sound of your camera's instant-return mirror (back in the olden days, the SLR mirror of some camera models would remain up until the film was advanced), so it's unlikely that a beep will be much of a problem. The main application of silencing

- the beep is to let you remain in stealth mode *until* you actually take that first picture.
- No memory card. Your digital camera may be able to exercise all its functions even when there is no memory card loaded. This is sometimes called "play" mode, and can be helpful when you want to demonstrate how a camera operates, but don't want any pictures taken. Play mode can be dangerous if you forget it's on and actually try to take pictures when no memory card is mounted. Most users use a menu choice to lock the camera's functions when the memory card is removed.
- ◆ Viewfinder grid. Many dSLRs have a line grid in the viewfinder, like the one shown in Figure 2.14, that can be used to align images. It's useful for making sure your camera is level and lining up the horizon or architectural images. Some people find the grid distracting and turn it off most of the time. However, if you become used to it, there is no harm in leaving the grid visible at all times.

- ◆ Increments. Many settings, such as white balance, ISO, EV adjustments, and bracketing, are set in specific whole number or 1/2 or 1/3 step increments. Some photographers prefer the larger increments, which are often faster to set, while others like using smaller
- increments, which allow more precision. Your choice. Each type of adjustment may have its own increments setting.
- Control functions. Many buttons and dials can be user-customized.
 For example, if your dSLR has

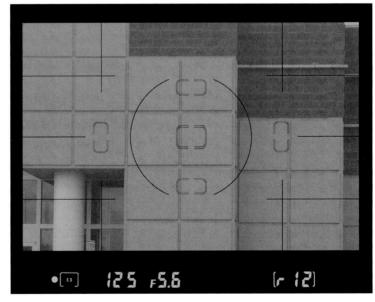

Figure 2.14 Line grids in the viewfinder help you line up architectural elements, or straight lines like horizons.

more than one command dial, you might be able to swap the main command dial with the secondary dial, so each now has the others' functions. You might be able to define whether you scroll through pictures using the left/right or up/down keys on your camera's cursor control pad. If your camera has a Func button, you can assign a specific feature (such as a particular shooting mode or action) to that button

 Bracketing options. Bracketing is the process of shooting several consecutive photos using different settings, in hopes that one of the settings is best for that photo, as you can see in Figure 2.15. Your camera may allow bracketing exposure, electronic flash exposure, white balance, or other parameters either alone or in combination with other adjustments. (Perhaps you want to bracket exposure and white balance.) Bracketing options may also let you specify the order in which multiple bracketing parameters are applied (exposure first, followed by white balance, or vice versa), the increment used for each of the pictures in the set, and the number of bracketed pictures you want to take (often three to five).

Flash modes. There are many options you can apply to your electronic flash (in addition to the obvious ones for flash exposure and synchronization modes: see Chapter 4 for more on those). Your options may include the shutter speed used to synchronize your flash unit with the shutter (higher speeds reduce the amount of ambient light used for the exposure, which can reduce ghost images); whether your flash's "modeling lamp" feature is used (assuming your camera offers this feature); and things like power level (from 1/2 to 1/128th power, commonly), automatic or manual exposure calculation, and options for using an external flash unit.

Figure 2.15 Bracketing allows you to take several consecutive pictures using different settings, such as exposure or white balance.

3 Photography: The Basic Controls

ust as it's possible to get a driver's license without knowing how to use a stick shift, you can take great pictures with your digital SLR even if you don't know the finer points of using all your camera's individual controls. The dSLR's "automatic transmission" will do a good job of whisking you off to a pretty good picture with little more effort needed on your part other than knowing what to point the camera at and when to push the shutter release.

However, it's likely that you purchased your dSLR with the thought of bypassing this point-and-click mode of photography, and, instead, exercising a great deal more control over what goes into your photograph. You aim to go careening down some figurative mountain roads of photography (or, perhaps the real thing), shifting gears as you shoot, tweaking the way your camera responds, and adding your personal creative touch to the way an image is framed, exposed, and focused. If you're new to dSLR photography, having all this control over your images can be daunting. Certainly, you can choose how your camera should react to a particular situation, but do you really know which controls should be used to apply this influence, and how they should be used? This chapter provides the basic information you need to know when it's time to tell your camera who's the boss.

Exposure Controls

In a perfect world, digital cameras would be able to capture all the detail in an image that our eyes can see. The sensor would pull in information from inky shadows and grab detail from the brightest highlights, while representing all the rich tones in between with exquisite accuracy. But that's not the case with digital imaging, just as it was not true with film. In the case of a digital camera, some exposures will allow too few photons to reach the individual pixels of the sensor, rendering that part of the image black. A particular exposure might channel far too many photons to register the brightest parts of the image, causing them to "blow out" and turn white or. worse, spill over onto adjacent pixels to produce a "blooming" effect. The tricky part is that a sinale exposure may do both, providing an image in which the shadows are too dark and the highlights are too bright. A digital sensor's dynamic range is its

ability to capture bright and dark details.

The job of a camera's exposure controls is to find a compromise exposure that does the best job of preserving as much detail in the shadows and highlights as possible, given a particular sensor's dynamic range. Often, compromises must be made; we give up some shadow detail to preserve detail in the highlights, or vice versa, as you can see in Figure 3.1. Your dSLR's autoexposure system does a commendable job of calculating the optimum exposure, but there are still times when you need to provide guidance about what parameters should be used.

Perhaps you want to tell the camera to calculate exposure based solely on a small area in the center of the picture, where you know the most important detail is. Maybe you'd like to "weight" the exposure for the area in the mid-

Figure 3.1 The selected exposure allowed some of the white features on the eagle's head to wash out in order to preserve detail in the shadows.

is O

dle of the frame, but you want the subject matter at the edges taken into account, too. Often, you'll want to use a particular f/stop to optimize sharpness or control the amount of depth-of-field. You might need to use a fast shutter speed to stop action and would like the camera to select an exposure that favors higher shutter speeds.

The basic settings for adjusting exposure are the shutter speed, f/stop, and ISO (sensitivity) controls. Each of these three will be addressed on the following pages. Later on, I'll show you how you can apply further controls to choose how the three main settings are used by selecting the exposure mode (how exposure is measured), exposure evaluation mode (how the camera calculates the exposure based on the information collected), exposure priority (what parameters are given precedence), and exposure measurement time (exactly when the camera takes its exposure readings). Subsequent sections in this chapter cover all of these.

Tonal Range

Digital cameras are digital (rather than analog) devices because the continuous range of tones from absolute black to the brightest possible white are represented by discrete values, just as a digital clock shows whole seconds, minutes, and hours rather than a continuous sweep of time you see on the face of an analog clock. The more individual tones an image is divided into, the more accurately an image can be rendered without needing to

convert "in between" tones to some other value.

Although digital cameras typically capture 4,096 different tones (or more) per color, the raw information is preserved only in the camera's native, or RAW file format (hence the name). By the time you finish working on an image in your editor, it is usually reduced to a mere 256 different tones per color, or 16.8 million colors (256 × 256 × 256). The darkest tone is assigned a value of 0 (no brightness), while the

lightest is assigned a value of 255 (maximum brightness). Every tone in between, from an almost-black dark tone to an almost-white super-light tone, must be represented by one of the other 254 numbers between 0 and 255. In Figure 3.2, I've broken down this scale into ten tones, so you can clearly see the steps between each value. If a sensor is unable to capture all the available tones, some are lost, as in Figure 3.3.

Figure 3.2 When a tonal scale is reduced to only ten tones, the steps between them are clearly seen.

Figure 3.3 A sensor that is unable to capture all the available tones loses some.

Choosing a Shutter Speed to Stop Action

The shutter speed you select for a given photo affects two key parts of your image: the overall exposure (when mated with the ISO and f/stop parameters) and the relative sharpness of your image in terms of how well subject or camera motion is stopped. A high shutter speed will freeze fastmoving action in front of your camera, and potentially negate any shakiness caused by camera movement. If a shutter speed is not high enough to stop this movement, elements in your image will be stretched and blurred. Creatively, you might actually want this blur in order to add a feeling of motion to your image. So, it's important to choose the right shutter speed to stop action when you want to freeze a moment in time or to allow your subject to "flow" when that's what you're looking for.

To maintain the most control over the amount/lack of blur in your photographs, you need to understand that components in your image are subject to this blurring to varying degrees. Indeed, it's possible to have one image with several subjects, each with a different amount of blur.

- Camera shake is an equal opportunity destroyer. As a practical matter, a shaky camera blurs all of your photograph to more or less the same degree. Objects closer to the camera may, in fact, appear to be blurrier than those located farther away, but the distinction is seldom important. Unless you have a creative purpose for camera shake, you'll want to use a high enough shutter speed to stop it, or steady your camera with a tripod, monopod, or other support. Of course, don't discount the possibility of using camera shake as a creative element, as in Figure 3.4.
- ◆ Motion across the frame is fastest. Motion that occurs in a plane that's parallel to the plane of the sensor will appear to move more quickly than motion that's headed toward or away from the camera. So, a racecar speeding from one side of the image to the other or a rocket taking off straight up will appear to be moving the fastest and will require the shortest shutter speed to freeze.

Figure 3.4 Camera shake during a one-second handheld exposure was used deliberately to add a pattern to these holiday lights.

Photography: The Basic Controls

- Motion toward the camera is slowest. Motion coming toward the camera appears to move much more slowly. If that racecar or rocket is headed directly toward you, its motion won't seem nearly as fast (but it's still a good idea to get out of the way).
- "Slanted" movement is in between. If a subject starts out on one side of your frame, and approaches you while headed to the other side, it will display blur somewhere between the two extremes.
- Distance reduces apparent speed. Subjects that are closer to the camera blur more easily than subjects that are farther away, even though they're moving at the

same absolute speed, because their motion across the camera frame is more rapid. A vehicle in the foreground might pass in front of the camera in a split second, while one hundreds of feet away may require three or four seconds to cross the frame.

◆ A moving camera emphasizes or compensates for
subject motion. If you happen to
be moving the camera in the same
direction as a subject's motion (this
is called panning), the relative
speed of the subject will be less,
and so will the blur. Should you
move the camera in the other direction, the subject's motion on the
frame will be relatively greater. An
example of stopping action with
panning is shown in Figure 3.5.

The correct shutter speed will vary based on these factors, combined with the actual velocity of your subject. (That is, a tight end racing for a touchdown in an NFL game is very likely moving faster [and would require a faster shutter speed] than, say, a 45-year-old ex-jock with the same goal in a flag football game.) The actual speed you choose also varies with the amount of intentional blur you want to impart to your image, as in Figure 3.6.

For example, if you want to absolutely stop your subject in its tracks, you might need 1/1,000th to 1/2,000th second (or faster) for the speediest humans or speeding automobiles. You might apply 1/500th second to a galloping horse to allow a little blur in the steed's feet or mane. Shutter speeds as slow as 1/125th second can stop some kinds of action, particularly if you catch the movement at its peak, say, when a leaping basketball player reaches the top of his or her jump and unleashes the ball.

Figure 3.5 Panning the camera in the direction of movement can stop action at a relatively slow shutter speed, while imparting a feeling of motion.

Figure 3.6 Because different elements in an image move at different speeds, you can select a shutter speed that will freeze some parts of your subject, while letting other parts blur in an interesting way.

Selecting the F/Stop

Like shutter speed, the aperture affects both exposure and other important pictorial factors, including sharpness and relative depthof-field. So, the f/stop you select for a given picture can depend on more than simply how it affects your exposure. You don't want your images to be under- or overexposed, but you don't want to achieve the optimum exposure at the expense of sharpness or focus depth.

Here are some things to think about:

Sharpness

Every lens has an optimum aperture that produces its sharpest, best-corrected image. That's generally about two f/stops smaller than the maximum aperture, but the true optimum lens opening can vary depending on the particular lens. This ideal f/stop produces the best image in terms of

resolution (subjects at the plane of focus have the most detail, compared to smaller or larger f/stops) and also in terms of correction for some common lens defects, which are reduced when a lens is stopped down.

So, unless you need to use one of the largest apertures to get a correct exposure, you might prefer using an f/stop that's as close as possible to the optimum for your lens. It's not necessary to perform any formal tests: Just close down two f/stops and you'll be close enough. For example, with a prime lens with an f/2 maximum aperture, your "best" f/stops would be f/5.6 or f/8; a zoom or prime lens with an f/4 or f/5.6 maximum aperture would do its best work at about f/8 or f/11.

Of course, some lenses are designed to produce good sharpness at certain f/stops. So-called

"fast" or "low-light" lenses, such as 28mm, 35mm, 50mm, or 85mm f/1.4 or f/1.8 optics are intended to provide excellent resolution and correction of distortion wide open, as you can see in Figure 3.7. In longer focal lengths, the "fast" versions, such as 400mm or 300mm f/2.8

lenses, or 80–200mm f/2.8 zooms, are also designed to be useable wide open. You probably can gain additional sharpness by reducing the aperture by a stop or two, but will find the performance wide open quite acceptable.

Figure 3.7 The 85 mm f/1.8 lens used for this shot is sharp when used wide open, making it possible to grab a compelling image at 1/160 th second and f/1.8.

Variable F/Stops

Many zoom lenses change their relative aperture as you zoom in or out. A lens with an f/4.5 maximum aperture at its wide-angle setting could be an f/5.6 or f/6.3 lens at the telephoto end. Lenses that don't change the effective value of their f/stops are called constant aperture lenses and usually cost a lot more because of the additional complexity needed to make them perform in this way. Remember that as the maximum aperture shifts, so does the optimum aperture for a given lens and zoom setting: The best f/stop for an f/4-f/5.6lens might range from f/8 to f/11 as you zoom in.

Depth-of-Field

The aperture of a lens affects depth-of-field, too. The larger the lens opening, the less depth-offield at a particular subject distance. As the aperture is reduced in size, depth-of-field improves. So, when you want to use selective focus to isolate your subject, a large aperture will help (even if it costs you a bit of sharpness), but when you need to have as much of the image in focus as possible, a smaller f/stop will do the job. (This also can cost you some sharpness, as you'll see shortly.) As with any trade off, you'll need to decide whether sharpness or depth-of-field is most important to you, and choose your aperture accordingly.

For most subjects at ordinary distances, f/5.6 to f/11 will provide the best combination of sharpness and depth-of-field. If you're shooting close-ups, you might prefer to extend the amount of depth-of-field with a smaller f/stop. Figure 3.8 shows a close-up image taken at f/5.6. The part that is in focus is sharp, but there isn't nearly enough depth-of-field.

Diffraction Distraction

Once you stop down more than a couple f/stops smaller than a lens' optimal aperture, another kind of optical malady, called diffraction, strikes. The effect may be small, but the reduction in sharpness is real, so you'll want to avoid using the smallest

f/stops available with a given lens if you possibly can.
However, you might need those smaller stops in certain exposure situations (when the light is very bright or you want to use a longer shutter speed), or require the extra depth-of-field the smaller aperture offers.

Figure 3.8 The jug at the back is plenty sharp, but f/5.6 simply doesn't offer enough depth-of-field to allow both ceramic pieces to be in focus.

Changing ISO

The third main parameter that controls exposure is the sensitivity of the sensor, as determined by the ISO setting. ISO stands for International Organization for Standardization, a group that determines the basic yardsticks for a host of things (including how to abbreviate its name), ranging from quality standards (ISO 9000, etc.) to the sensitivity of film and digital sensors.

Increasing the ISO setting adjusts the sensitivity upwards, which allows the camera to capture a picture using a briefer shutter speed or a smaller aperture, as shown in Figure 3.9. Reducing the ISO setting lets you use a longer shutter speed or a larger aperture, which might be the case when the light is very bright or you want to increase the shutter speed or size of the lens opening for creative reasons.

As with the other two exposure parameters, changing the ISO value has an effect on your images. In this case, boosting ISO provides an increase in the amount of visible grain (called noise) in digital images. Noise is created when blips in the digital signal that do not represent captured photons are mistaken for image data and recorded as such by the sensor. The higher the sensitivity, the more likely that spurious information will show up

in your picture as noise. (Noise can also be caused by long exposures, from 1 second to 30 seconds or more, regardless of ISO setting used.)

Noise is random and, as such, may occur at any pixel position, so that noise speckles may be recorded as red, green, or blue spots. Some photographers like the texture that noise adds to an image under certain circumstances, but most of the time it is considered a defect, and something to be avoided, as in Figure 3.10. So, your goal will be to use the lowest ISO setting possible that also lets you use your preferred f/stop and shutter speed

Figure 3.9 Raising the ISO setting makes it possible to take good photos at night and in other low-light situations.

Figure 3.10 Noise appears as grainy speckles in images shot at increased ISO settings.

combination. In other words, you'll often increase or decrease ISO sensitivity a notch or two to allow you to apply your lens' optimum aperture, or the lens opening that produces the depth-of-field you want. Or, you can adjust ISO to let you use a faster shutter speed to stop action, or you can use a slower shutter speed to generate desired motion blur effects. Note: Some cameras have an optional feature that will adjust ISO for you, if necessary.

Use with caution, as its no fun to think you're shooting creamy-looking photos at ISO 400, and then discover your camera has bumped sensitivity up to ISO 1600 with only a bright flashing LED (oops! You missed that!) to inform you of the change.

Digital SLRs have a minimum ISO setting that is usually in the ISO 64 to ISO 200 range. The maximum sensitivity setting is often ISO 800 or ISO 1600, although

REDUCING NOISE

Your digital SLR has a feature called Noise Reduction that can partially compensate for random noise. NR is usually activated from a menu option. Some dSLRs have separate Long Exposure Noise Reduction and High ISO Noise Reduction. Both use a process called Dark Frame Subtraction to reduce noise. When the feature is turned on, the camera takes a second, blank frame, and compares the information with your original picture so that grainy speckles common to both can be deemed to be noise and thus removed. Some dSLRs let you specify High, Normal, or Off settings for NR.

The viewfinder remains blank during the noise reduction process, so 30-second exposures stretch into 60-second pauses while the camera's algorithms do their stuff. If you find you don't like the wait, or want to customize the amount of noise reduction you apply, you can also perform NR tasks with image editors like Adobe Photoshop, cut noise when importing RAW files using Adobe Camera RAW or other RAW utilities, or use noise zapping programs like Noise Ninja (www.picturecode.com), which is also incorporated into the latest version of Bibble Pro, a RAW converter with image manipulation features (www.bibblelabs.com).

some cameras can use ISO 3200 or higher. You'll get the best quality (least noisy) image at ISO 64–200, while grain will often become bothersome at ISO 800–1600, and probably objectionable at ISO 3200 or higher (depending on the noise characteristics of your particular camera). A few dSLRs allow changing the ISO setting only in whole "stop" increments (that is, ISO 100, ISO 200, ISO 400, or ISO

800, with no intermediate steps), or in half- or third-stop increments (such as 100/125/160/200...). As a practical matter, there is not much difference in terms of noise levels between ISO settings that are close to each other, so many digital photographers find it convenient to dial in a little less or more sensitivity to fine-tune exposures (particularly in Manual exposure mode) without changing the f/stop or shutter speed.

Aperture Priority and Shutter Priority

Digital SLRs have four main shooting modes, commonly known by their traditional initials: MASP, for Manual, Aperture Priority, Shutter Priority, and Programmed. Many entry-level dSLRs also have an additional set of modes called Scene modes, with names like Landscape, Portrait, Night Scene, or Children. These are highly automated settings fine-tuned for specific types of photography— "no brainer" modes that make basic settings and may even lock out particular options, such as the use of certain shutter speeds or your camera's internal electronic flash. As photographers gain experience, they usually eschew Scene modes, as well as a mode called Auto, which may be even more restrictive of options, while not flexible enough to handle common shooting situations.

For most of us, MASP does the job. We can choose M (Manual) to set exposures (usually based on exposure information supplied by the camera), Aperture Priority

(you set the f/stop, the camera chooses the shutter speed),
Shutter Priority (you set the shutter speed, the camera selects the f/stop), or Programmed (the camera sets shutter speed and f/stop through a sophisticated metering algorithm, but you retain the freedom to customize exposure at your whim).

Aperture Priority

This is the mode to choose when you want to choose a specific small aperture to maximize depth-of-field, or a large aperture to reduce depth-of-field so you can apply selective focus, as shown in Figure 3.11. The shutter speed doesn't matter to you (within reason), so you're content to allow the camera to choose it for you.

Or, you might select aperture priority (usually marked as A or Av on your camera's mode dial), when you do want a high shutter speed under changing lighting

Figure 3.11 Use Aperture Priority mode when you want to use a specific f/stop to control depth-of-field.

conditions, but prefer to keep the camera from using an aperture that you deem to be too wide. So, you set the camera to aperture priority and select an f/stop that allows a shutter speed in the range you're looking for. Your aperture will remain constant at the value you select (say, f/5.6), but the shutter speed will vary a little as the available illumination allows, perhaps alternating between 1/500th and 1/1,000th second as appropriate. If you were to use shutter priority and set the camera to 1/1,000th second, your f/stop might change from f/5.6 to f/4 or even wider if conditions dictated.

Shutter Priority

Use Shutter Priority mode (usually marked S or Tv on your camera's mode dial) when the shutter speed in use is most important to you. This mode is commonly used for sports photography (see Figure 3.12). Set your camera for a high shutter speed and then fire away. The correct f/stop will be selected automatically. The "reverse mode" trick also works for Shutter Priority: If you want a

relatively large or small f-stop for depth-of-field reasons, but don't mind if it varies by a stop in either direction, select Shutter Priority and set whichever shutter speed corresponds to roughly the f/stop you prefer. If the light changes a bit more or less, compensate.

With both Aperture Priority and Shutter Priority, you may need to adjust the setting selected, or increase/decrease the ISO sensitivity, if the aperture or shutter speed you've selected won't allow a good exposure. For example, in Shutter Priority mode,

if you've chosen 1/500th second, and the exposure system decides there isn't enough light for a shot at that speed with the lens wide open, you can reduce your preferred shutter speed to 1/250th second, or double the ISO.

Figure 3.12 Shutter Priority mode allows you to specify a fast shutter speed for stopping action.

Manual Exposure

A manual exposure mode isn't as retro as you might think. Even though you're setting the shutter speed and aperture yourself, you can still use your camera's built-in exposure meter to determine whether or not the exposure you've selected is within the realm of reason. Your dSLR probably has a flashing LED, or a plus/minus scale in the viewfinder that tells you when the exposure is right. There are several reasons for using manual exposure:

- ◆ Special effects. Maybe you'd like to underexpose an image deliberately to produce a shadow or silhouette look. The fastest way to do this may be to set exposure manually, review your results on your dSLR's LCD, then shoot again until you have the exact special effect you want.
- External or manual flash. Perhaps you are shooting in a tricky lighting situation and your internal flash just isn't reading the exposure properly. Or, you're

- using an external flash without automatic features, or one that isn't compatible with your camera's TTL flash metering system. Set your camera to Manual and choose the exact exposure you want.
- ◆ Zoned out. You love famed photographer Ansel Adams' Zone
 System of exposure and want to work with a handheld light meter.
 Or you need to make some precise exposure calculations. Perhaps you want to work with an incident light meter, which measures the incoming light at the subject position, in order to establish a precise ratio between main light and fill light. Manual exposure lets you tweak your exposure settings to your heart's content.
- ◆ Older lenses. It's possible you want to work with older lenses that don't couple with your camera's exposure mechanism. There are some fine manual focus, manual exposure lenses out there at bargain prices. If you switch to Manual exposure, you can use a handheld meter or just guesstimate exposures, fine-tuning your settings after reviewing a few shots on your dSLR's LCD.

Figure 3.13 Use manual exposure when you want to underexpose significantly to create silhouettes or other special effects.

Manual exposure is particularly comforting for film SLR veterans who are working their way into the highly automated digital photography world. For many years and thousands of photos, I used several SLR film camera bodies that had no light meter at all. A handheld meter, manual exposure settings, and, perhaps, some judicious bracketing (shooting several pictures at slightly different exposures to get at least one optimum picture) worked just fine. The most important byproduct of this mode of photography was that I learned quite a bit about exposure and lighting, simply because I worked manually. You can learn a lot, too, with your camera set on Manual. Figures 3.13, 3.14, and 3.15 show several examples of situations that work best with manual exposure.

Figure 3.14 If your automatic electronic flash exposures are incorrect, try setting your f/stop manually to get a properly exposed photo like this one.

Figure 3.15 Most cameras can't make time exposures of several minutes' duration, like this one, so manual exposure is your only option.

Programmed Exposure Modes

Digital SLRs usually have several programmed (small p) exposure modes, usually consisting of Programmed (capital P), plus Auto. These both select the shutter speed and aperture for you, but in P mode, you can override the camera's settings. In Auto (automatic) mode, the camera's settings can't be modified. This is the mode you'd use when you ask a stranger on tour with you to take a picture of you and your family posing in front of the Great Pyramid. Even photographic fumble-fingers won't be able to mess up the settings or press the wrong button.

Both P and Auto use complex algorithms to analyze your scene and compare the information with an internal database derived from thousands of photos. The crunched numbers then suggest an appropriate f/stop and shutter speed, based on current conditions. For example, the camera may decide that you're shooting sports and try to use a relatively

high shutter speed to subject motion, but switch to lower shutter speeds only under very low light conditions. Or, the camera may discover that the picture you're shooting very much looks like a landscape, and it will apply the exposure emphasis to the distant scene rather than the foreground you used to "frame" the picture, as in Figure 3.16. The combinations of best f/stop and shutter settings are built into the camera by the vendor.

Figure 3.16 Programmed metering algorithms can quickly identify this photo as a landscape and expose for the distant subject while ignoring the foreground used to frame the image.

Photography: The Basic Controls

Although fully programmed exposures can do a decent job, serious digital photographers might use the P mode only when they first get their dSLRs, and will soon switch to Aperture or Shutter Priority, or even Manual mode once they learn exactly how much fun it is to tweak settings. Your dSLR may also have a few Scene modes, like those shown in Figure 3.17, which adjust settings based on the needs of particular types of pictures, such as sports, landscape, or portrait photos. While some point-and-shoot models have upwards of 25 Scene modes, digital SLRs generally have only five or six, tops, usually ignoring the silly ones such as Food (increased saturation to make the food look better) and Museum (locks out the flash even in low light, so you won't get kicked out of the venue). Scene modes make some settings for you, and may limit the other settings you can make by blocking out overrides for focus, exposure, brightness, contrast, white balance, or saturation. Here are some of the common Scene modes found in digital SLRs (you can see that an experienced photographer can achieve the same effects with MASP):

- Portrait. Uses a large f/stop to throw the background out of focus and activates red-eye reduction in the flash.
- Night. Reduces the shutter speed for exposures in low-light levels, to allow longer exposures without flash, and to allow ambient light to fill in the background when flash is used. You'd probably have to use a tripod with this Scene mode.
- Night Portrait. Uses a long tripod-assisted exposure, usually with red-eye flash, so the backgrounds don't sink into inky blackness.
- Beach/Snow. Adds some exposure to counter the tendency of automatic metering systems to underexpose when faced with very bright settings.
- ◆ Sports. Uses the highest shutter speed available to freeze action, and may choose spot metering to expose for fast-moving subjects in the center of the frame.

- ◆ Landscape. This mode chooses a small f/stop to increase depth-offield, improving your chances of having both foreground and distant objects in sharp focus. With some cameras, this mode also increases the saturation setting to make the landscape more vivid.
- Macro. Some cameras have a close-up Scene mode that shifts over to macro focus mode and tells the camera to focus on the object in the center of the frame.

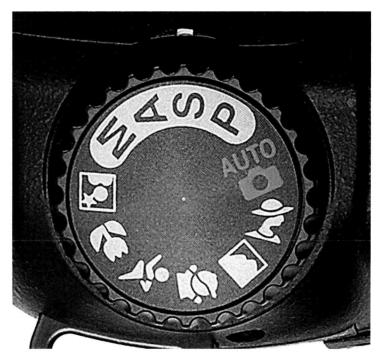

Figure 3.17 Digital SLRs have only a minimum number of Scene modes, compared to point-and-shoot cameras, which may include several dozen.

Exposure Metering and Evaluation Modes

Exposure metering controls fall into two different categories. Metering mode is the method the camera uses to *gather* the information it uses to make exposure decisions. Evaluation mode determines the rules used to *calculate* the correct exposure from the information that has been collected

All digital SLRs measure and calculate exposure based on light-sensitive sensors inside the camera that measure the light that has passed through the lens and is reflected upwards to the viewfinder. This through-the-lens (TTL) metering means that the camera automatically takes into account any filters you've placed over the front of the lens, and any additional exposure that might be required because of close-focusing aids (such as extension tubes or bellows) that have been used.

One key option is to specify exactly what portions of the frame should be used to measure exposure.

• Multipoint or Matrix metering. This is the default metering mode for digital SLRs. The camera collects exposure information from many different positions in the frame (from a few dozen to more than 1,000 locations). This method is best for most subjects, which may have the brightest and most important portions of the image anywhere within the frame. (See Figure 3, 18.)

Center-Weighted metering.

The center portion of the frame is afforded 80 percent or more of the emphasis in calculating exposure, although the brightness of the remaining portions of the image is also taken into account. This mode is best suited for compositions in which the most important subject matter is in the center of the frame. (See Figure 3.19.)

15 CC (288)

Figure 3.18 Matrix metering samples multiple zones within a frame (shown here in yellow) to arrive at the correct exposure.

 Spot metering. This method gathers exposure information only from a very small central portion of the frame (sometimes user definable) and is usually measured in either degrees or the size of the metering circle in millimeters (for example, 6mm or 8mm). It's the best mode when your main subject is in the center of the frame and surrounded by areas that might mislead a Matrix- or Center-Weighted metering system. A spotlit performer on a stage is a typical subject that lends itself to this kind of metering. (See Figure 3.20.)

After the camera's metering system has measured the amount of illumination passing through the lens, the system switches to Evaluation mode to determine the correct exposure. The camera tries to decide what kind of image has been framed, so that the exposure can be determined for the main subject while balancing that exposure for the settings needed to capture other detail in the frame.

Working with Histograms

A histogram is a graphical display in the form of a bar chart that shows the number of pixels at each of 256 brightness levels. The chart has both x and y axes. The values in the x axis (horizontal) represent the brightness levels from 0 (black) at the left side to 255 (white) at the right side of the histogram. The y axis (vertical) represents the number of pixels at a particular brightness level. So, a very short bar at a particular position means that very few pixels have that value; a tall bar means that a larger number of pixels have that brightness.

Histograms tend to look like a mountain range, as you can see in Figure 3.22. In most images, the majority of the pixels reside in the midtones, producing a tall clump in the middle of the histogram. Fewer tones are present at the darkest and brightest

areas, so the histogram "mountain" tends to tail off at either end. Ideally, the histogram should show some tones at every brightness level.

From an exposure and tonal standpoint, problems crop up when some brightness levels are not represented as you might expect. If the foothills of the mountain don't extend to both the black (left) and white (right) sides of the graph, some brightness levels are wasted. Worse, if the toes of the curve run off either side. then the image is probably overor underexposed. Figure 3.23 shows an image in which the left side of the curve is clipped off, producing an underexposure. Figure 3.24 shows an image in which the right side of the curve is clipped, indicating an overexposure.

When viewing a histogram during picture review after the shot is taken, you can try to fix the overor underexposure by adding or subtracting Exposure Values. If an image is underexposed according to the histogram, add EV; if it

is overexposed, use the EV adjustment to subtract exposure. Start with a small EV value, take another photo, and then compensate if the image is still not correctly exposed.

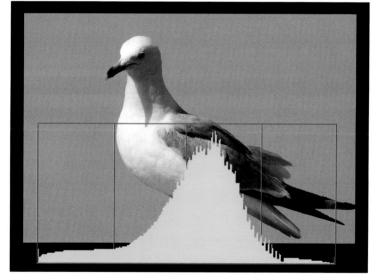

Figure 3.22 In a properly exposed image, most of the detail is in the midtones, trailing off to the highlights on the right and shadows on the left.

Figure 3.21 With bracketing, you can take several consecutive shots at different exposures, automatically, and then choose the one you prefer.

Overriding Your Camera's Exposure Settings

Sometimes you'll want to modify the exposure your camera would choose, either because the automatic exposure is not quite right or because you want to change the exposure for creative effect, say, to produce a silhouette or extra-bright high key look.

Digital SLRs have a number of tools to let you change the exposure from the camera's calculated value to one that better suits your image. These controls include:

◆ Exposure lock. You can lock in the current exposure setting so that the camera won't change it. You could, for example, take a reading up close to your subject, then step back to actually frame the photo the way you want. (Zooming in with a zoom lens, then backing off to a wide-angle setting would have the same effect.) One way to lock the exposure is simply to partially depress the shutter release button. However, that can be clumsy when

you're trying to zoom in and out or reframe your image. See if your camera has an AE-L or exposure lock button or switch. When activated, the current exposure is locked in until you take a photo or press the lock button a second time. Some cameras may allow you to lock both exposure and focus with this button, or to set it so that only one or the other is locked when the button is pressed.

Bracketing. Before cameras became so automatic, bracketing to capture several images in a row at different exposures was fast and easy. All you did was take a picture, move the lens aperture ring or shutter dial one click, take a second picture, then turn the ring or dial again for a third image. Today, the process is even faster and easier. You can set up your camera to bracket consecutive exposures for you automatically, changing the exposure each time by an amount you specify, for the number of frames you'd like to include in your bracketed set. It's

simple to take three, four, or more shots, each with one-third, one-half, or a full stop more exposure, as quickly as you can press the button (see Figure 3.21). Even better, you can combine exposure bracketing with bracketing for white balance, flash exposure, or other parameters, or use them alone.

- ◆ Changing combinations. Most digital SLRs let you change exposure combinations without changing the actual exposure. For example, if the camera is set for an exposure of 1/250th second at f/11, you can spin a command dial or press some other control to change to a preferred equivalent exposure, such as 1/500th second at f/8 or 1/125th second at f/16.
- Applying EV compensation. Exposure Value settings are an easy way to add or subtract exposure. In the camera realm, +1EV means doubling the amount of exposure, while -1EV represents cutting the total exposure in half. In EV terms, it doesn't matter whether the change was accomplished by

opening the lens one f/stop or halving the shutter speed (to add 1EV), or by closing down the lens one f/stop or doubling the shutter speed (to subtract 1EV). EV compensation is generally applied by holding down an EV button and spinning a command dial or moving some other control to add or subtract an EV amount. Usually, EV increments are one-third, one-half. or a full EV, and your camera probably allows you to specify the size of the increment, EV compensation can also be used with electronic flash (flash EV), and in either case is especially useful when used in conjunction with a graphical representation of tonal values called a histogram, discussed next.

Figure 3.19 With Center-Weighted metering, most of the exposure emphasis is on the center of the frame, shown in yellow, while the rest of the image may count for less than 20 percent of the overall exposure calculation.

The evaluation system varies from camera to camera. For example, some cameras, when set to Center-Weighted metering, may calculate exposure based on an average of all the light falling on a frame, but with some extra weight given to the center. Others may use a modified spot system with a really large, fuzzy spot, so that light at the periphery of the frame is virtually ignored.

Spot metering, too, can be used in different ways, depending on the camera's design. You might be able to select the size of the spot, or move the metering spot around in the viewfinder to meter the spot of your choice. That option can prove to be especially useful for backlit subjects or macro photography.

Matrix or *Evaluative* metering is the most sophisticated metering

Figure 3.20 Spot metering, indicated by the yellow circle, calculates exposure solely by the information collected from a small area in the center of the frame.

system. The camera can examine the frame and determine that the upper half is brighter than the bottom half, and then assume from its built-in database that a landscape photo is being shot, and expose appropriately. The same algorithms can determine whether you're attempting to shoot a portrait, a snow scene, or other common type of image. More than just the measured amount of light can form the

basis for a calculation. For example, a subject that's positioned at infinity (as determined by the autofocus system) is more likely to be a landscape. For pictures taken at closer distances, the camera may safely decide that the object that appears to be closest to the autofocus system is the center of interest, and then base exposure on that subject, even if there are brighter objects elsewhere in the frame.

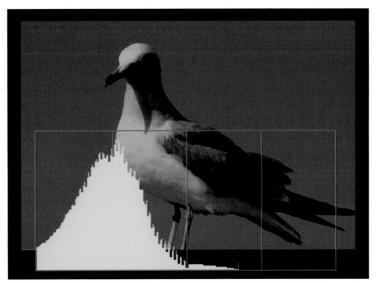

Figure 3.23 With an underexposed image, tones at the left side of the histogram are clipped off.

Figure 3.24 Tones at the right side of the histogram are clipped off when an image is overexposed.

Automatic Focus Basics

Automatic focus can be one of the most confusing aspects of the digital SLR to a new owner who hasn't used an SLR before, because focus systems used in point-and-shoot cameras are a great deal simpler, with fewer options. However, once you've sorted through the controls and understand what the various autofocus modes and settings do, you'll find these features to be among the most valuable capabilities a digital camera can offer.

A dSLR's autofocus system uses sensors embedded in the viewfinder that measure the contrast of individual focus zones. When the portion of an image measured by a particular zone is low in contrast, that zone is out of focus; when the contrast is highest, the zone is properly in focus. Digital SLRs have from five to about a dozen focus zones (although at least one pro camera boasts 45 individual focus points).

When the autofocus system is active, the camera uses a motor to adjust the focus position of the lens, and then evaluates the contrast of the zones to determine when correct focus is achieved. At any given time, it's likely that some zones will be in focus, while others are out of focus. It's impossible, of course, for every part of an image to be in sharp focus simultaneously. The key to the success of an autofocus system is to determine which zones should be sharply focused and which are allowed to be out of focus. In making these decisions, the autofocus mechanism takes into account many different factors:

◆ Is the subject moving? The camera can determine, based on the changing state of the image area within the focus zones, whether the subject is moving. Most digital SLRs can apply this information to produce predictive autofocus; that is, adjust the focus point so that a moving subject is still in focus at the position it's going to be at when the shutter release is finally pressed all the way.

- ◆ Is the subject the closest object to the camera? As focus information is collected, the camera can determine the relative distance of a subject in any particular focus zone, and thus determine whether a given object is the closest subject matter to the camera (and, consequently, likely to be the center of interest).
- ♦ Which focus zones should take precedence? The camera can use the focus zone you select manually (which may be a very good idea, because only you know exactly which of several objects in the frame is your main subject). Or, the camera can select a focus zone on its own based on the closest subject or some other parameter. Some cameras can be set to use only a single focus zone in the center of the frame, and ignore all others.
- How many zones should be used? The camera can use a single focus area that doesn't change (useful when your main subject will always be in the center of the frame), or switch among several zones if the subject moves (great for sports or photographing kids).

- Other cameras work with a group of zones, usually by measuring just one zone, but taking into account the readings from adjacent sensors. This works well when your subject may be moving around within a limited area of the frame, and you want the autofocus system to track it efficiently. (See Figure 3.25.)
- ◆ When should focus be locked in? It would be an extravagant waste of power to have your camera focus and refocus for as long as the camera was switched on. Instead, your dSLR doesn't begin to seek the correct focus point until you partially depress the shutter release (or press an optional Focus button). At that point, focus can be locked in, or it can change continually as you frame your image or your subject moves while the shutter release is partially depressed.

You'll need to explore your dSLR's manual thoroughly in order to understand the settings you need to apply to change between the various focus zone options.

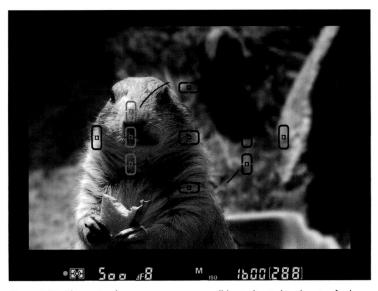

Figure 3.25 The active focus zone or zones will be indicated in the viewfinder.

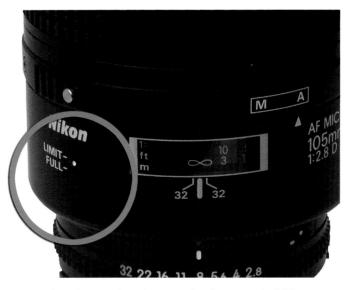

Figure 3.26 A focus limit switch can keep your lens from using the full focus range.

FOCUS FEATURES

There are several useful autofocus features found in some digital SLRs. These include:

- Focus override. This is a feature that allows fine-tuning an autofocus setting manually, without switching the lens or camera out of Autofocus mode.
- Focus limit lock/lockout. A few lenses, particularly macro lenses, have a provision for locking the lens into or out of close-up focus range. Then, when you're shooting macro photos, your camera won't waste a lot of time seeking focus all the way out to infinity. Or, if you're shooting at normal focus distances, the lens won't try to focus extra close, because the macro range has been locked out. (See Figure 3.26.)
- Autofocus assist lamp. Many digital SLRs have an LED that turns on to provide helpful illumination when attempting to focus in low-light situations. The LED lamp provides enough light to improve contrast sufficiently for the autofocus system, although assist lamps are rarely helpful for subjects farther than a few feet away.

Automatic Focus Modes

Choosing the proper automatic focus mode isn't as difficult as it might seem, because the main options are just two: single autofocus and continuous autofocus, and there are clearly defined types of photo situations in which each is the better choice. Some cameras have a third mode that is a combination of the two others. Here's a quick summary:

Single Autofocus

In Single Autofocus mode, when you press the shutter release down halfway, the autofocus system is activated, sets the focus, and then locks it in until the shutter release is fully depressed, taking the picture, or until you release the shutter button without taking a shot. This setting is usually your best choice for non-moving subjects, and not your best option for sports photography. It uses less battery power because the autofocus mechanism is typically active only for a second or two as focus is locked in.

Continuous Autofocus

With Continuous Autofocus mode, when you press the shutter release down halfway, the autofocus system sets the correct focus, but remains active and monitors your subject. If your subject moves or you reframe the image, the lens will be refocused as required. This mode is best for action photography (see Figure 3.27), because your subjects won't remain in one place, and the system compensates for that movement or any changes in framing you make. There are disadvantages to this autofocus mode. It uses more battery power, of course, because the autofocus system is on whenever the shutter release button is partially depressed.

But more importantly, Continuous Autofocus can be "fooled" by a fast-moving object passing momentarily in front of your main subject. If you've focused on, say,

Figure 3.27 Continuous Autofocus is best for fast-moving subjects, including most sports.

the quarterback, Continuous Autofocus will dutifully refocus as the team's field general moves around the gridiron (which is good). But if a wide receiver 10 yards closer to you than the quarterback suddenly darts into the frame on a passing route, the camera will refocus on the interloper and may not fix back on your original subject quickly after the receiver leaves the frame. Some advanced dSLRs let you dial in a delay so that when you're using continuous autofocus, a momentary diversion won't cause the camera to instantly refocus on the new subject matter.

Automatic Autofocus

This setting, found in some newer cameras like the Nikon D50, is actually a combination of the first two. When selected, the camera will examine a scene and then switch to either Continuous Autofocus or Single Autofocus as appropriate. It's a good choice when you're shooting a mixture of action pictures and less dynamic shots and you want the camera to make the focus mode choice for you.

RELEASE PRIORITY/FOCUS PRIORITY

One very important autofocus parameter that you should understand is the difference between "release priority" and "focus priority," especially since they are implemented in different ways in different digital SLRs. Both parameters simply describe what happens when you press the shutter release while the autofocus system is still actively focusing your image. With release priority, the camera will go ahead and take a photo even if the autofocus system has not locked in. It is possible to take a photo that's slightly out-of-focus, which may be what you want when, say, you're capturing a decisive moment in a sports competition and you'd rather have a picture taken right now, even if it's not in perfect focus, rather than a really sharp version taken a second later when the moment has passed. Many dSLRs apply release priority to their Continuous Autofocus mode, but that's not true of all models, even within the same product line. For example, the Nikon D70s uses release priority in its AF-C (Continuous Autofocus) mode, but sibling Nikon D50 does not.

The alternate mode is called *focus priority*, which means that if you fully depress the shutter release while the camera is focusing, the picture will not be taken until sharp focus is achieved. That can provide some frustrating delays, or even result in your camera refusing to take a picture at all when pointed at a subject that's difficult to focus on. A bird flying in a cloudless sky (see Figure 3.28) might give your autofocus system fits because most of the image lacks sufficient contrast for the focus system to lock in on. Focus priority reduces the number of out-of-focus pictures, and is most commonly implemented in Single Autofocus mode.

Figure 3.28 A bird in a cloudless sky can confuse your autofocus system, and if your camera uses focus priority you may not be able to take a picture at all.

Manual Focus

Once you get the hang of autofocus, you'll probably want to use nothing else. Or will you? There are some situations where manual focus can be very handy. You don't have to worry about the camera understanding exactly what object in your frame is your main subject. Just twist the focus ring on the lens until you visually see that your subject is in sharp focus. You're not entirely on your own, either. With many dSLRs, a focus indicator LED will illuminate when the image within the default focus zone is in sharp focus. Here are some of the pros and cons to manual focus:

◆ Works with manual focus lenses. D'oh! If you happen to have a great manual focus lens, you can still use it with your digital SLR if you're willing to focus the image yourself. I own a couple lenses that are so manual that I not only have to focus them myself, I have to set the aperture on my own, and then stop the lens down from wide open to the taking aperture just before I press the shutter

- release (it's called a *pre-set* lens). That's a lot of work, but my favorite example is a sharp 400mm f/6.3 lens that I paid a whopping \$50 for.
- ♦ Take your time. Focusing manually is slower, and may not be your best choice for sports or any fastmoving subjects. But if you're shooting things that sit still, manual focus is hardly a handicap. I use an older 55mm f/3.5 manual focus macro lens for many of my close-up photos. I also own an autofocus macro lens in a 105mm focal length. I end up switching the autofocus macro to manual focus because I find that focusing closeups manually allows for more precision in choosing the point of sharpest focus. For these kinds of subjects, manual focus is not a drawback, and may even be your best choice. (See Figure 3.29.)
- ◆ Focus difficulty. You may have a bad memory for names, but your brain is even worse in remembering whether your subject was sharper a fraction of a second ago, or is actually sharper right now. That's why you jiggle the focus ring back and forth a few times using smaller arcs when man-

 $\textbf{Figure 3.29} \ \, \textbf{Close-up photography often lends itself to methodical and careful manual focusing techniques}.$

- ually focusing. For subjects that lack contrast, manually focusing can be a trial-and-error experience with lots of trial and even more errors.
- Accuracy. It's easy to focus accurately by manual means if your subject is bright and contrasty. A lens that's easy to focus manually is one with a large maximum aperture (and, thus, little depth-of-field) and a longer focal length (again, because of shallow depth-of-field). More challenging are scenes that are dim and murky, viewed through lenses with smaller maximum apertures (say f/3.5 or smaller), and of the wide-angle persuasion. Focusing under such conditions is challenging for an autofocus system, too, but the extra speed your AF system has and its perfect memory for whether the image contrast is increasing or decreasing means you'll frequently get better results, more quickly, by letting your camera take care of focus.
- ◆ Following action. Your dSLR is smart enough to use predictive focus to track moving subjects and keep them in focus as they traverse the frame. You're not. You might be able to manually focus on a point where you think the action is going to be, and then trip the shutter at the perfect moment. But, then again, you might not. (See Figure 3.30.)

Figure 3.30 Sure, he's just sitting there now, but do you think you're fast enough to follow-focus this fellow if he begins scampering around? Or is automatic focus a better choice for wildlife photography?

Making Light Work for You

culptors work in marble and other materials. Painters work with pigments. Musicians craft sound waves. Photographers create their images by capturing and manipulating light. Interesting subject matter is all around us, and while angles and timing and other factors are important, what makes the difference between a great photo and a mediocre one is how light is used. The better you understand your raw material, the better you'll be able to use it to shape your photographs.

Light comes in two forms: continuous and electronic flash. Continuous lighting consists of the constant illumination around us, whether it occurs naturally (such as daylight, moonlight, or firelight), or is created by humans in the form of lamps and other kinds of artificial illumination. Electronic flash is a special kind of artificial light, produced by a gas inside a glass tube that glows brightly for an instant when given a powerful electrical charge.

For photographers, continuous and electronic flash each have advantages and disadvantages. Continuous lighting allows you to visualize exactly the highlights and shadows the light source will produce when the picture is taken. However, you'll need to depend on a fast shutter speed to freeze action, and constant lighting may not be bright enough for the exposure you need.

Electronic flash, on the other hand, makes it more difficult to visualize the lighting effect you'll get, but can be very bright without providing discomfort to your subjects in the form of heat. Electronic flash's very brief duration is excellent for stopping action, too.

This chapter provides a concentrated dose of what you need to understand to work with light in either form.

Quality of Light

Light isn't just a bunch of photons bouncing around aimlessly. In practice, the illumination you use to make photographs has characteristics of its own, including direction, intensity, color, and something you can think of as texture. You need to understand and manage each of these attributes to shape your images with light. Color is a worthy topic of its own, so we'll look at the other three attributes first. All of these apply both to continuous lighting and electronic flash

Direction

The direction from which light approaches your subject affects the three-dimensional qualities of your image as well as its mood. You can make some dramatic changes in your images just by altering the direction from which light approaches. When you're shooting subjects that aren't flat such as people—the direction of light determines how shadows form and how they affect your image. The relative balance between shadows and the lighter areas of your photo is also important. I'll explain more about shadows and what you can do with them in "Using Multiple Lights," later in this chapter.

The directionality of the light you use can affect the mood of the photo. When light comes from behind the subject with very little light falling on the front, you get a backlit or silhouette effect. which can be mysterious because we can't really see details of the subject on the side facing us. Lighting from the side can be dramatic, because only part of the subject is well lit, and the rest is either de-emphasized or left to our imaginations. Figure 4.1 shows an image that's side lit to increase the dramatic look. A subject lit evenly from the front can be bland because there are no interesting shadows to show shape and form, or it can represent honesty and forthrightness, with nothing to hide. Light placed

very low below the subject can change our perceptions drastically, because in the natural world, such lighting is not the normal state of affairs. Low lighting of a human face can produce a "monster" look.

When shooting photos, you can manage the direction of light by moving your subject or, if the lighting is artificial, by moving the lights themselves.

Figure 4.1 Lighting from the side can produce a dramatic look.

Texture

Okay—light doesn't really have texture. What I describe as the texture of light is actually another aspect of its directionality and intensity, which, depending on how the light reflects from the subject, reveals or disguises its texture. This aspect is mostly determined by whether the light appears to come from a small, concentrated point, or from a larger, more diffuse surface. As you can see, this quality of light is actually just another aspect of its directionality. With a pointsource light, the illumination arrives at the subject from the same direction, with not much of it spilling into adjacent areas, such as shadows, producing a harsh, glaring look. With a "softer" light source, the light appears to come from slightly different directions, and some of it spreads out to fill in shadows and edges in the subject for a gentler form of illumination. Figure 4.2 shows what I mean.

Figure 4.2 Notice how the harsh shadows in the upper picture make this a contrasty image; in the lower picture, a more diffused light source fills the shadows with light.

Texture is also something you can modify as you take photos. With natural illumination and a moveable subject, you can relocate to a place where the light is less harsh or more so, depending on your needs. Sometimes going from direct sunlight to the shade, or vice versa, can do the trick. Light can be modified by using reflectors such as pieces of cardboard or umbrellas. A soft white reflecting surface creates diffused light. A bright, shiny surface can be used to increase the contrast of the light.

Intensity

The absolute intensity of the light we use doesn't intrinsically change the appearance of our subjects in the same way that the direction of the light and its texture do. That's because your digital SLR can compensate for the relative brightness (or lack of it) by increasing the exposure or boosting the sensor's sensitivity. In practice, the intensity of light has an indirect effect on your photos: If there is too little light, you must use a slower shutter speed (which can cause blur), use a larger

aperture (affecting depth-of-field and, perhaps, sharpness), or increase the ISO setting (which can add noise or grain to the image). Too much light, and you may lose creative control over intentional blur caused by moving subjects or selective application of depth-of-field.

There are a variety of ways of controlling intensity, including adjusting the output of the lights themselves (especially with electronic flash, which may have adjustable power levels), or using light-reducing filters on your lenses. Close-up photos that call for lots of depth-of-field work best with high light levels, even if that light is soft and diffuse.

White Balance

The "white" light that we see consists of a continuous spectrum of colors, but, for the purposes of photography, humans have segregated those colors into the same three primaries that our eyes detect: red, green, and blue. Unfortunately, the relative quantities or balance of each of those three colors varies, depending on the kind of illumination you're using. That ratio is commonly called color balance or white balance. For most types of continuous lighting and electronic flash, the white balance is measured in degrees Kelvin, because scientists have a way of equating temperature with the relative warmness and coolness of the light. (That's why white balance is also called color temperature.) Common light sources range from about 3,200K (warm indoor illumingtion) to 6,000K (daylight and

electronic flash). Fluorescent light doesn't have a true color temperature, but its "white balance" can be accounted for nonetheless.

While digital cameras can make some good guesses at the type of lighting being used and its color temperature, it's often a good idea to explicitly tell your camera exactly what kind of light it is working with. That will produce pictures with more accurate colors and less correction required in your image editor. Figure 4.3 shows two sample images with the white balance gone terribly wrong. Digital SLRs, like all digital cameras, have an adjustment that allows you to specify the white balance manually or to actually measure it on the spot, as I mentioned in Chapter 2.

Setting White Balance Manually

Your digital SLR may have a button that can be held down while white balance is adjusted using a command dial or the cursor pad. Or, you might have to take a trip to menu-land to accomplish the feat. In either case, you'll be presented with preset values that you can choose instead of the default Auto. The number of choices may vary, but you'll have the first four as a minimum, and probably some or all of the others. Look for self-explanatory options including Daylight/Direct Sunlight, Incandescent, Electronic Flash. Fluorescent, Cloudy, and Shady. Your camera might offer several different Fluorescent settings for the different kinds of fluorescent lights (cool white, warm white, etc.) as well as an option to dial in the exact color temperature in degrees Kelvin.

It's also common to have a "finetuning" option that allows you to dial in some extra warmth or coolness—usually plus or minus, say 10—from the nominal neutral value.

TIP

If you're in the habit of using your camera's automatic white-balance feature, it's an especially good idea to take some time now and learn each of the ways you can tweak white-balance settings manually. You won't want to take the time to figure it out when you're busy shooting under difficult lighting conditions.

Figure 4.3 Oops! Automatic white balance sometimes doesn't detect fluorescent lighting, giving you greenish photos; when color balance is set for incandescent lighting, you'll get blue results shooting outdoors.

Measuring White Balance

You can measure white balance of continuous light sources yourself. The option will be located in one of the setup or shooting menus. Once the camera is ready to measure white balance, you take a photo of a neutral surface (such as a white or gray wall). White balance will be set to render this subject without a color cast.

Creating Your Own Presets

Your digital SLR may have an option for storing the measured white balance in a memory slot as a preset. The feature might also include the ability to provide a label or name to the preset (such as Madison Square Garden), so you can retrieve the setting at a later date. Many dSLRs also allow adopting the white balance of an existing image on your memory card, so that can be applied to your current shooting session or stored as a preset.

TIP

If your camera doesn't allow you to save as many white-balance presets as you'd like, dedicate a small-capacity memory card for holding sample images with various white balances. When you need one of them, insert that memory card and tell your camera to use the appropriate example as its current white-balance setting.

Other Factors

If you shoot RAW, you can adjust the white balance when the image is imported into your image editor, changing it from the "as shot" value to any other value available in the conversion program, like the one shown in Figure 4.4. This may be your best opportunity to tweak electronicflash white balance. Flash color temperature can vary slightly, depending on the duration of the flash. The dedicated flash units designed from some dSLRs can actually "report" to the camera the exact color temperature of each image, so the "as shot" value in the RAW file is likely to be very accurate.

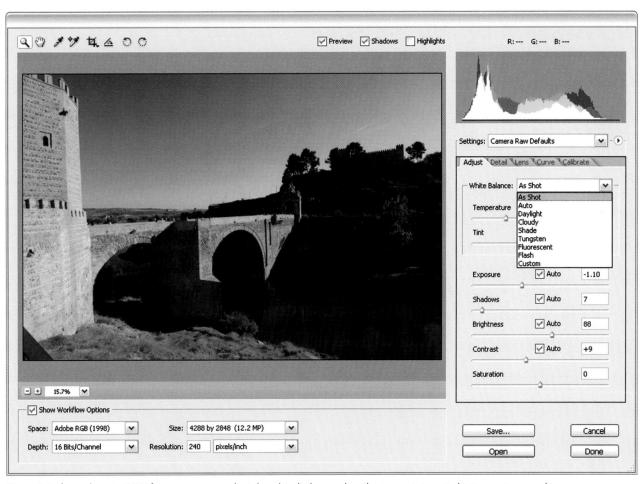

Figure 4.4 If you shoot in RAW format, you can adjust the white balance when the image is imported into your image editor.

Using Multiple Lights

Sometimes it takes more than one light source to do a subject justice. Perhaps you're shooting a large room indoors and want to get light into every corner, nook, and cranny. Or, more likely, you're concentrating on a single subject, such as a person, and want to use several lights to create a flattering look. Indoors or out, multiple lights can let you bring out character, disquise defects, or emphasize the best points of your subject. Here's a quick introduction to the most common multiple light sources photographers use. Any of these light sources can be either electronic flash or continuous illumination. For this discussion, I'll assume you're shooting a portrait, but each of these kinds of lighting can be applied to any kind of single subject, whether it's a human, pet, or bowl of flowers. Figure 4.5 shows the arrangement of the four general types of lights used in a multiple-light setup.

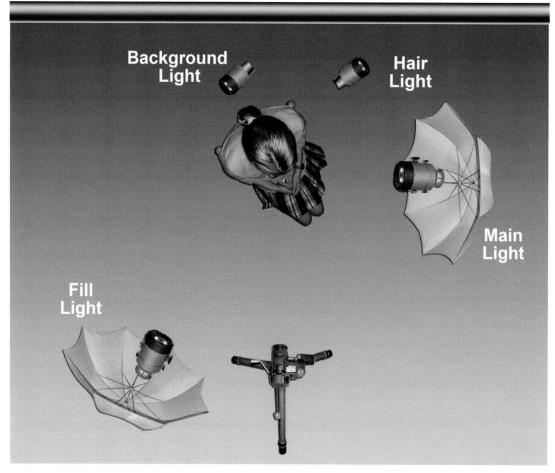

Figure 4.5

Main Light

This is the primary and strongest light source used to illuminate your subject. It can be placed to the side to produce a sidelighting effect; behind, to create backlighting; or in front of your subiect on one side of the camera or the other. The main light is usually at your subject's eye level or a little higher. If the subject is not facing directly into the camera, and is looking off to one side, this source can be placed so that it illuminates the near side of the subject. (This is often called broad lighting because the illumination falls on the widest part of the face.) With the main light illuminating the far side of the subject, the result is short lighting.

You'll find that broad lighting tends to make faces look wider (and is thus good for thin faces), while short lighting makes wide faces look thinner. Figure 4.6 shows short lighting and broad lighting.

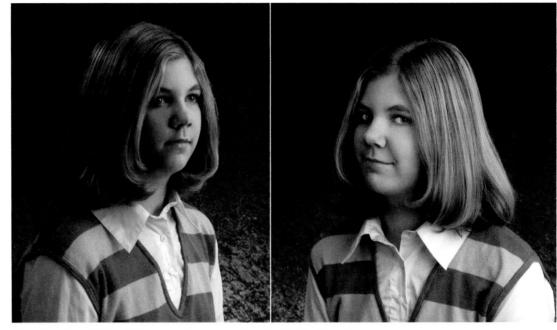

Figure 4.6 Short lighting (left) narrows faces; broad lighting (right) widens them.

Fill Light

Any portion of your subject facing the camera that is not illuminated by the main light will be in shadow. The darkness of that shadow area will depend on how much stray light (ambient light) is bouncing around. With a very bright main light and little ambient light (outdoors in direct sunlight, or indoors with a single

bright light source), the shadows can be inky black indeed. The fill light is used to brighten those shadows. This provides a more balanced lighting effect in which the main light continues to provide most of the illumination, but the fill allows detail to be seen in the shadow areas.

Fill light doesn't need to be a separate light source. Fill can be added by simply bouncing some of the light that spills over from the main light back into the shadows with a reflector. Outdoors, you can counter a strong sun that's serving as a main light with a reflector or your dSLR's built-in flash (adjusted to a lower power setting, if necessary, so that it doesn't completely fill in the shadows). With a more formal portrait lighting setup, the fill light can be

a second light source set to lower power so it provides less illumination. If the fill light is relatively strong (say, half as powerful as the main light, for a so-called 2:1 lighting ratio), the shadows are very bright. Reduce the power of the fill to say, one-quarter that of the main light, and you get a more dramatic 4:1 lighting ratio. Figure 4.7 shows fill lighting at work.

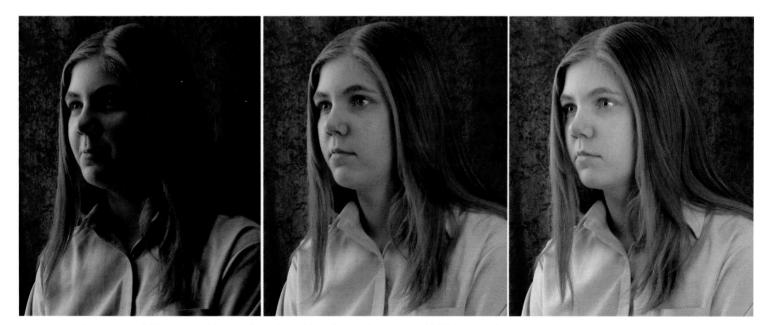

Figure 4.7 Lighting ratios of 4:1, 3:1, and 2:1 can be achieved by adjusting the amount of fill light in the shadows.

TIP

If your fill light doesn't have the capability of changing power levels, just move it farther away from your subject. Increasing the distance by roughly 50 percent cuts the light level in half (1 f/stop); moving it 100 percent farther away (say, from 4 feet to 8 feet) reduces the light level by 2 f/stops.

Background Light

A background light can be used to illuminate the area behind your subject, providing separation between your subject and the background. This light can be just strong enough to provide a tonal difference between the edges of a subject and the background, or can provide a more dramatic difference. The brightness of the background light will depend on the darkness of the background and your subject matter: A dark subject will call for a lighter background; a light subject will look best against a darker background.

Hair Light/Rim Light

A hair light or rim light is an optional light source used to illuminate the edges of your subject to add a little life to an area that otherwise tends to be excessively dark in a photo. A spot-type light is the easiest source of illumination to use as a hair light. It can be arranged high above and behind your subject, shining down on the top edge. With a human, you should adjust the light so it just spills over onto the face, and then move it back a little so it concentrates on the hair.

Electronic Flash

Electronic flash is a convenient form of illumination that can provide the light you need to take a picture in areas where the existing light isn't strong enough for an exposure using a reasonable shutter speed and aperture. Not all digital SLRs have a flash unit built in. Some of these cameras, generally the higher-end models such as the Nikon D2X and all the Canon models from the Canon EOS 5D up to the EOS 1-Ds Mark II, don't even have a built-in flash. Most others have a pop-up flash like the one shown in Figure 4.8.

As with all forms of illumination, it obeys what photographers call the *inverse square law*, which can be summed up: When the distance between the light source and your subject is doubled (2X), the amount of light needed to provide an exposure is quadrupled (4X). In photographic terms, that means you need two extra stops worth of light each time you double the distance.

TIP

When using manual flash exposure, keep a clean handkerchief handy. Drape it over the pop-up flash to diffuse the light. You'll reduce its intensity at the same time, which can be important if you've moved in close to your subject. Built-in electronic flash sometimes cannot be reduced in power enough when shooting close-ups.

Fortunately, your digital SLR can calculate the correct exposure for you if you use the built-in flash unit, or an external dedicated unit designed especially for your camera and usually attached to the shoe mount on top of the camera. Usually, the appropriate exposure is achieved by reducing the amount of light issued by the flash. When the camera's exposure system determines that sufficient light has been received by the sensor, the remaining electri-

cal charge in the flash will be "dumped" and not emitted by the flash tube.

No matter what the duration of the flash, it generally occurs only when the camera's shutter is fully open. With most SLR cameras, the mechanical focal plane shutter consists of two curtains that follow each other across the sensor frame. First, the *front curtain* opens, exposing the leading edge of the sensor. When it reaches the other side of the sensor, the rear curtain begins its travel to begin covering up the sensor. The full sensor is exposed when the flash is tripped. If the flash went off sooner or later, you'd see a shadow of the front or rear curtains as they moved across the frame.

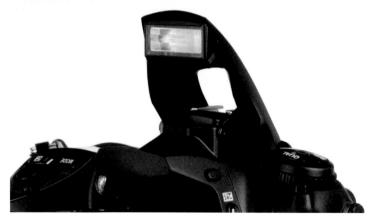

Figure 4.8 A built-in flash pops up ready for use at a moment's notice.

With the digital SLRs, the sensor is completely exposed for all shutter speeds from the longest up to a top speed called the *maximum sync speed*, which can range from about 1/180th second to 1/500th second, depending on the camera model. Here are some important things to know about using flash:

- ◆ Action stopping. The flash occurs for an instant when the shutter is fully open, so the shutter speed itself has no effect on the flash's action-stopping power. A 1/1,000th second flash will freeze action at 1/2 second in exactly the same manner as at 1/250th second, as you can see in Figure 4.9.
- ◆ Ghost images. While flash will freeze action even at slower shutter speeds, if there is enough ambient light to produce an image, you'll get a second exposure that can cause a ghost image if your subject is moving. For that reason, it's usually a good idea to use the highest shutter speed that will sync with your flash when taking flash pictures of moving subjects under high levels of illumination.

- Hurry up and wait. The electronic flash must recharge after an exposure, usually one to two seconds, depending on how much of the charge was used for the last shot. For that reason, your dSLR won't let you use its burst/sequence shooting mode with flash.
- ◆ Depth of light. Flash provides optimum exposure at only one distance. Anything in front of that distance will be overexposed; anything behind it will be underexposed. The relative "depth of light" will be shallow. This means that if you want to shoot a group of four people, you're better off with a line-up, at least from a flash perspective. Use flash with, say, a couple on a dance floor, and it's likely the background behind them will go completely dark.

Figure 4.9 Electronic flash can freeze action in its tracks.

Flash Sync Modes

Your digital SLR will offer several different ways of synchronizing the electronic flash with the camera's shutter, thanks in part to the requirements of shooting flash photos with a focal plane shutter, described in the last section. Your options include front sync, rear sync, slow sync, and combination modes. Choosing the right sync option is easy: Select front sync or front sync with red-eye prevention, unless you need one of the other choices for a specific reason. I'll outline the exceptions next.

◆ Front sync. The flash fires at the beginning of the exposure when the first curtain has reached the opposite side of the sensor and the sensor is completely exposed. The subject is imaged sharply. Then, the rear curtain starts to close. If there is enough ambient illumination to make a second exposure during the time it takes for the shutter to completely close, you'll get a ghost image. If the subject is moving, the ghost image will be

- recorded in the direction of movement (that is, in front of the subject). That's not very natural: If you shot an automobile at night, you'd get a sharp image of the car, and then streaks from its headlights in front of the image. Or, to use a different example, the valiant carousel steed is chasing his ghostimage streaks in Figure 4.10
- Rear sync. If you are going to have ahost images in your photo, a more natural look will be achieved by switching to rear sync mode. When the first shutter curtain reaches the far side of the sensor, the flash exposure is not made at that time. Instead, the shutter remains open for the allotted period, and, if your subject is moving, the ghost image forms. Then, when the exposure is over, the flash is triggered, recording a sharp image of the subject at the end of the ghost streak. At this point, the rear curtain closes. Your automobile is pictured with its headlight/taillight streaks behind it. In Figure 4.11, a merry-goround horse is properly trailed by its ahost image.

Figure 4.10 Front sync produces ghost images that streak in front of the object that produces them.

- ♦ Slow sync. This mode uses the ghost-image effect in a positive way to provide brighter backgrounds in flash photos at night or in other relatively dark venues. The object here is to prevent streaky ghost images by mounting the camera on a tripod to hold it steady and photographing a non-moving subject. Slow sync combines slow shutter speeds with flash to produce two different images (one from the flash, the other from the ambient light) so that your flash pictures have a background that isn't completely black.
- ◆ Combination modes. Most digital SLRs have flash sync options that combine a specific mode with other features. For example, you may be able to choose front sync with added red-eye reduction (a preburst from the electronic flash or focus assist lamp causes the subjects' eyes to contract enough to block red-eye), or combine slow sync with rear-curtain sync. In the latter case, if you happen to get ghost streaks, at least they will be the natural-looking kind.

Figure 4.11 Use rear sync to place the ghost images in a trailing position.

Flash Exposure

Your digital SLR and its flash unit may allow you to select from several different automatic exposure schemes, and a couple manual exposure compensation methods. This explanation of each of the most common flash exposure modes and when you should use them may help sort out some of the confusion over these options.

 Balanced TTL. Various camera vendors call their most sophisticated flash exposure system by different names, but what they all do is similar. When used with dedicated flash units made specifically for your camera model, balanced TTL exposure reads the light bouncing off your subject as it passes through the lens (hence TTL) and tries to balance the flash with the ambient illumination to create the best exposure. The rich vein of information available to your camera's computer may include the distance between your camera and the subject (supplied by the autofocus mechanism), the coverage angle of the flash (many external flash units can "zoom" to provide more or less coverage when your lens changes from wide angle to telephoto positions and back

- again), or even the color temperature of the flash. If you can use this mode, you'll get the best exposures.
- ◆ TTL. Some camera systems have a second mode (or this might be their only mode), which calculates exposure based only on the light reflecting from the subject and passing through the lens. The camera does not try to balance flash exposure with ambient light. If this mode is optional, you can use it when you want to ignore ambient light, or are using a high enough shutter speed that ambient light shouldn't have any effect on exposure.
- AA (Auto Aperture). If you're using an external automated flash that doesn't support either TTL option, this mode can be used to calculate exposure in the flash unit. The camera tells the flash unit what ISO value is set in the camera, and the f/stop in use. Then, a light sensor on the flash measures the light reflected by the subject and adjusts the flash's output accordingly. You'll want to use this option only when your flash unit doesn't work with TTL, as it tends to provide decent exposure, but is not as accurate as through-the-lens flash metering.

- ◆ A (Automatic). Older flash units and those not built for your camera can't communicate with the camera. So, you'll have to manually enter the ISO setting of the camera and the current aperture into the flash unit yourself. Then, the flash will measure the amount of light reflected by the subject and adjust its output accordingly.
- Manual. In manual mode, you adjust the output level of the electronic flash (generally from full power to 1/128th power) and then set the f/stop of your camera to an appropriate value, determined by guesstimate (and then

adjusted after you review your results on your camera's LCD), by calculation (using an archaic system called Guide Numbers), or, best of all, by use of a handheld flash meter. Use manual exposure when you have flash units that have no automatic features at all (such as studio flash), or when you want to calculate flash exposure yourself because the automatic systems are being fooled (say, by a subject that has components that reflect more or less light and throw the auto exposure off), or when you want to use the very lowest power setting to freeze action, as in Figure 4.12.

GUIDE NUMBERS

If you want the joy of calculating flash exposures manually (or, more likely, you simply want an indication of how powerful your flash is relative to other units), you can work with Guide Numbers, which are values given in pairs for any particular ISO setting, one for meters and one for feet. To use a Guide Number (GN) to calculate exposure, divide the guide number by the distance to produce the f/stop. For example, if the flash's GN at ISO 200 is 110, and your subject is 10 feet away, then 110 divided by 10 is 11, and you'd use f/11. If the subject were 20 feet away, your result would be 5.5, and you'd use f/5.6. Guide Numbers are clumsy to manipulate, and don't take into account how much light your subject reflects, but they can be useful in a pinch.

Another way of controlling flash exposure is through Flash Exposure Value adjustments. Each flash EV setting increases or decreases the amount of flash exposure given to your subject, overriding the exposure determination of the TTL system. Your digital SLR should allow you to specify whether you want to make these adjustments in 1/2 or 1/3 stop increments. The 1/2 stop increments can be added or subtracted more quickly, but the smaller increment allows more precision.

To use Flash Exposure Values, take a test picture or two and decide whether your images are too light or too dark for your taste. Then press the flash EV button or control (or activate it with a menu choice), and use the command dial/cursor pad or other adjustment control to add or subtract exposure for the next shot. Adjust by only one increment each time.

Figure 4.12 Manual exposure can be used to reduce power to its lowest setting for action-stopping close-ups like this one.

Connecting an External Flash

Built-in electronic flash isn't always your best choice. The internal units in other digital SLRs might not be powerful enough for the job at hand. A flip-up flash is often so close to the interchangeable lens that red-eye effects are almost unavoidable, and might even cast shadows of the lens or lens hood on your subject. The flash that comes with your camera might not provide enough coverage for wide-angle lenses. External flash units often solve all these problems, and provide additional capabilities to boot.

Add-on flash units can be attached to the hot shoe on top of the camera, where their extra height helps reduce red-eye. They can be swiveled to bounce light off various surfaces, and fitted with color filters, dome diffusers, and other accessories. These strobes can "zoom" their coverage automatically to match that of your lens. Some have a bright focus assist lamp to replace the one built into the camera, and can wirelessly control other flash units.

But, most importantly, external flash units can be removed from the camera and pointed in any direction you like, so their illumination can come from the side or above your subject. Operated wirelessly or as a slave unit, an add-on flash can be placed anywhere in your scene. But, if the strobe is not mounted on the camera, how does it connect? There are six ways of linking an external flash unit to your camera.

- Hot Shoe Cable. This kind of cable has a fitting that slides into the camera's hot shoe. The external flash slides into a shoe at the other end of the cable. All the electrical connections provided by the hot shoe are conveyed to the flash unit, so all the automated functions of the dedicated flash are retained.
- Proprietary Connector. Midlevel and advanced dSLRs often include a proprietary connector that accepts a plug with a halfdozen to a dozen contacts (see Figure 4.13). Electronic flash can be plugged into this connector, as well as remote control units and other accessories. The link is

- designed to provide complete communication between dedicated flash units and the camera, again preserving all the features you paid for
- PC/X Connector. This is a simple two-conductor connector used to trigger a flash unit. (See Figure 4.14.) The only communication between the camera and the flash

occurs when the camera gives the signal to fire. Automatic exposure, if it's possible, must be of the A (Automatic) variety I described earlier, with the electronic flash itself calculating exposure using the ISO and f/stop information you entered manually. This kind of connector is useful if you're working with studio flash or other manual strobes

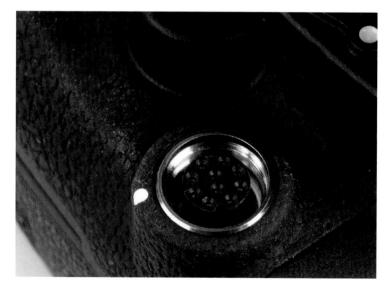

Figure 4.13 A proprietary accessory connector.

Substitute PC/X Connector.

What do you do if you want to connect a flash that is compatible only with a PC/X connection, and your dSLR doesn't have a PC/X socket? All dSLRs have a hot shoe, so you can slide an adapter that has its own PC/X socket into the shoe and then plug your flash into that. Flash units that use a triggering voltage that is too high for your

- camera's circuitry can be connected to an adapter like the one shown in Figure 4.15 that has its own isolation function, shielding your camera from innards-frying bursts of electricity.
- Wireless Trigger. Some cameras have a wireless mechanism that can trigger off-camera flash units that are built to sense the signal. You can then place the flash any-
- where you like (within its distance limitations) with no need for a wired connection. Advanced wireless systems allow the flash and camera to communicate fully (exchanging information about what f/stop, zoom setting, or focus point on the camera is in use), just as if they were physically connected, so you can retain automatic exposure and other features.
- ◆ Slave Trigger. A slave sensor detects the burst from other flash units and triggers its own strobe in response, quickly enough to contribute to the current exposure. External flash units that don't have their own slave sensor can often be fitted with an outboard unit. No camera/flash communication exists.

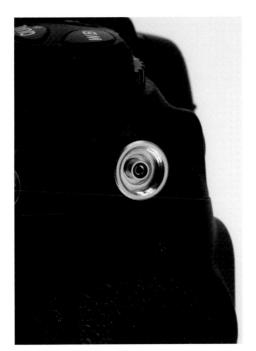

Figure 4.14 A standard PC/X sync connector.

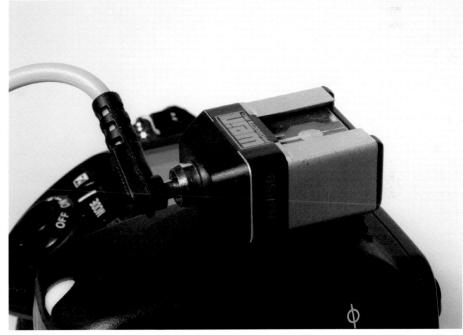

Figure 4.15 Adapters can add a PC/X connector though the hot shoe.

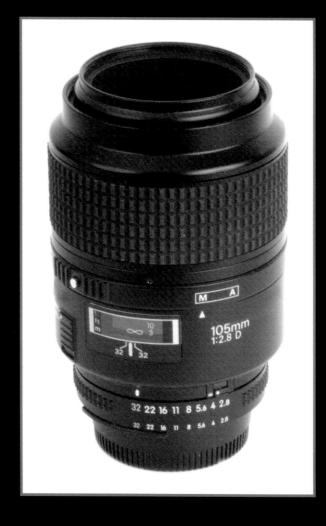

Choosing and Using Lenses

n of the chief advantages of the digital SLR camera is the ability to change lenses. Newcomers to dSLR photography often think in terms of simply exchanging one lens for another one with a wider or narrower field of view: They're thinking only in terms of wide-angle and telephoto lenses (or zoom positions). However, there's so much more that add-on lenses can do for you.

Yes, you can mount a wider lens on your camera when your back is against a wall and you need a lens with a wider perspective. Wide angles are great for interior photos, pictures outdoors in crowded surroundings, and for those times when you want to take advantage of the wide-angle lens's perspective "distortion." Telephoto lenses bring things closer, reduce depth-of-field (so you can use selective focus), and compress the relative distance between objects, which are all valid creative tools.

But you also have macro lenses that let you focus as close as an inch or two from the front of the lens, and lenses with larger maximum apertures, relative to their focal lengths, that let you shoot in lower light levels (say, an f/1.4 lens), or use faster shutter speeds (such as a 300mm f/2.8 lens used for sports). Some lenses offer extra sharpness for critical applications where images will be examined closely or enlarged. Some have special features, such as vibration reduction (also called *image stabilization*), sliding elements that offer a degree of perspective control (for shooting architecture without that weird "falling backward" effect) or provide intentionally distorted fish-eye looks.

This chapter provides a quick overview that will help you choose the optical artillery best suited for common picture-taking opportunities.

Zoom or Fixed Focal Length?

Most digital SLR photographers start out with a zoom lens or two. Such lenses are small, light, faster to use, and usually quite sharp. Most digital SLRs can be purchased with an 18mm–70mm (or 17mm–55mm) zoom lens that

makes an excellent "walking around" lens that covers everything from moderate wide angle to short telephoto. Other photographers favor compact lenses like one vendor's 28mm–200mm optic, shown in Figure 5.1, which

Figure 5.1 Choosing a set of zoom lenses with minimal overlap is a smart move. The lens at left covers 170mm–500mm, whereas the one at right encompasses a 28mm–200mm zoom range. Use the shorter zoom as a "walking around" lens, and reserve the longer optic for sports and wildlife photography and other long-distance chores.

measures just 2.7 by 2.8 inches, weighs only 13 ounces, and focuses down to 1.2 feet. It is a good all-purpose lens when a longer telephoto reach will be more valuable than extra-wide-angle perspective. There are larger "do-everything" lenses in the 18mm–200mm range, too. The chief drawback of these lenses is that they are slow (f/5.6) at the telephoto position.

Things to consider when choosing a zoom lens:

- ◆ Size. Zooms require additional internal lens elements to provide the zoom factor, correct for optical aberrations, and correct for optical problems introduced by the corrective elements. So, many zoom lenses are considerably larger than their non-zoom, fixed focal length equivalents at the same magnification. You'll need to decide whether the extra size or weight is worth the added convenience.
- Speed. Zoom lenses typically have smaller maximum apertures: An f/2.8 zoom is expensive.
 Moreover, the f/stop is likely to

- change as the lens is zoomed to the telephoto position, narrowing from, say, f4.5 at the wide-angle position to f/5.6 or f/6.3 at the long end. Zooms with an unchanging, constant maximum aperture are more expensive.
- ◆ Sharpness. Zooms may sacrifice a little sharpness to gain a longer range or a wider aperture. The offerings from some vendors may vary in sharpness (or even quality of construction) within the same model number. If you can, test the actual zoom lens you'll be buying before you make your purchase.
- ◆ Autofocus. Automatic focusing capabilities vary among zoom lenses. Some offer slower autofocus than others. Others shift optical focus as you zoom, forcing the camera to refocus constantly. Zoom lenses with small maximum apertures may not be usable with digital SLRs that require at least an f/5.6 lens opening for proper operation of the autofocus mechanism.
- Zoom creep. Watch out for zoom lenses that extend themselves when the camera is pointed downwards. Zoom creep is both inconvenient and annoying.

Choosing and Using Lenses

Lenses are also available as prime lenses, which have fixed focal lengths. These are a good choice when you need the best sharpness or lens speed. If a large f/stop is your need, most vendors offer lenses with an f/1.4 maximum aperture in focal lengths of 28mm, 50mm, and 85mm, all of them guite sharp when used wide open. There are 100mm f/2 telephoto lenses, longer optics with f/2.8 maximum apertures and 300mm or 400mm focal lengths, and even a few 500mm or 600mm f/4 lenses that are huge, heavy, and burdened with huge and heavy price tags to match. Fixed focal length lenses are suitable when you have freedom of movement and can get closer or back away from your subject to keep the frame filled.

Figure 5.2 A zoom lens can give you a wide perspective... or take you in very close, as this pair of shots taken with the same lens from roughly the same distance, but slightly different angles shows.

Lens Crop Factors

If your digital SLR has a sensor that is smaller than a 24mm × 36mm film frame (which includes virtually all dSLRs sold for \$3,000 or less), then you have to contend with the lens crop factor, which is often referred to erroneously as a lens multiplier. The phenomenon is the result of the field of view of lenses being cropped to fit within the area of the sensor (see Figure 5.3). Depending on the size of the sensor, the image may include only

50 percent to 77 percent of the lens's traditional field of view. However, the *effect* of this cropping is to "multiply" the apparent focal length of the lens: A telephoto or zoom lens at 100mm when used with a camera having a 1.3X, 1.5X, 1.6X, or 2X cropfactor (all available from Canon, Nikon, Olympus, and others) has the equivalent field of view of a 130mm, 150mm, 160mm, or 200mm lens.

Of course, no multiplication is being done. The depth-of-field and aperture of the lens remain exactly the same, just as they do when you crop a picture in your image editor. The crop factor does have several real-world effects that you need to keep in mind when using your lenses.

◆ Telephoto lenses offer a tighter image. That 100mm lens really does offer a cropped view similar to a 150mm telephoto (with a 1.5X crop factor at work), and your 300mm lens is now magically a 450mm super telephoto. This can be a great benefit to sports and wildlife photographers who can't afford the true longer lenses and would have had to crop anyway. The camera does it for you.

- ◆ Wide-angle lenses are less wide. An 18mm ultra-wide lens becomes a moderate 27mm wide angle when a 1.5X crop factor is applied. To achieve a true ultrawide angle look, you'll need a more expensive 10mm to 12mm lens
- ◆ Depth-of-field is "increased."

 Your 450mm super tele (or zoom position) has the same apparent depth-of-field as the 300mm lens it really is; your 18mm ultra-wide angle (after 1.5X crop factor is applied) has the near-infinite depth-of-field of the 12mm lens you're actually using. Most of the time, this added depth-of-field won't be a problem, unless you need less depth-of-field for a selective focus effect.

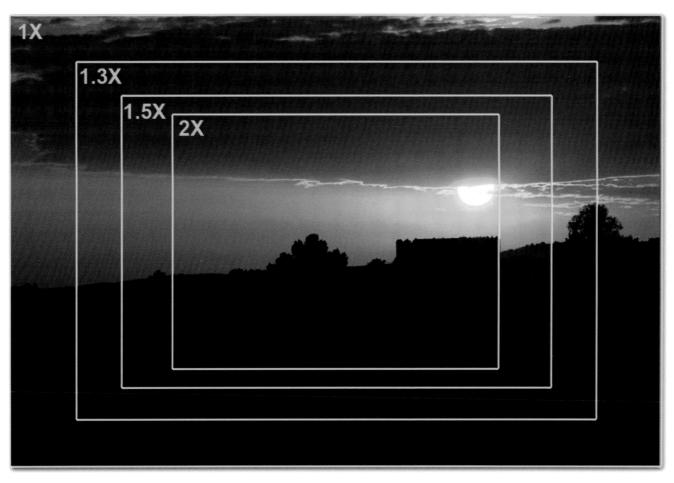

Figure 5.3 Crop factors offer dramatically different viewpoints of the same scene. The 1X (full-frame) view is typical of what you'd get with a wide-angle lens on a Canon EOS 1D or Canon EOS 1Ds Mark II. The 1.3X crop is similar to what you would see with a Canon EOS 1D Mark II N, while the 1.5X crop is typical of many different digital SLRs, including the Nikon D2X, D200, D70s, and D50, as well as cameras from Pentax, Fuji, and Sony (formerly Konica Minolta). Olympus and Panasonic offer digital SLRs with a 2X crop factor, as does Nikon with its optional High Speed Crop mode in the D2X (which crops the original 12.4-megapixel image to a smaller 6.8-megapixel size, increasing the crop factor from 1.5X to 2.0X). Sigma and Canon also offer digital SLRs with 1.7X and 1.6X crop factors (respectively), which are very similar to the 1.5X factor shown.

Wide-Angle Lenses

A wide-angle lens or wide-angle zoom setting provides a dramatically different perspective compared to normal or telephoto lenses, which tend to simply bring things closer. Here are the advantages of using a wide-angle lens:

- Increase working space. If space is tight indoors, you don't want to back up against a wall or go outside and shoot through a window! Outdoors, you might want to include all of a city building without stepping into the street, or you might like to snap a picture of Lindsay Lohan from a few feet away without giving her fans a chance to crowd around her and obstruct your view. A wide-angle lens or zoom setting allows you to fit more in the frame from a reduced distance.
- ◆ For added depth-of-field. As a practical matter, wide-angle lenses offer more depth-of-field at a given aperture than a telephoto lens. Of course, the fields of view and perspective differ sharply, but if lots of depth-of-field is your goal, a wide-angle lens is your best bet.

- ◆ For emphasis or distortion. A wide-angle lens applied to a landscape subject will emphasize the foreground details while moving the distant scenery farther back from the camera. A snowy slope with distant mountains might look dramatic. Or, you can get extra close to your subject and create a distorted wide-angle look.
- To gain a wider field of view. The mountain range is wide and dramatic. The only way you can take it all in is with a wide-angle lens.
- ◆ For an interesting angle. Get down on the ground and shoot up at your subject. Or, climb a ladder or other high vantage point and shoot down. You'll find the perspective refreshing even while it sparks your creative viewpoint. Or, try turning your camera sideways and shoot a wide-angle vertical shot, as in Figure 5.4.

Wide-angle lenses have a few things to beware of when you use them, too:

- ◆ Watch straight lines. Your wide-angle shots are likely to have lots of horizontal and vertical lines in the horizon or outlines of structures. If the back of the dSLR is not parallel to the plane of your subject matter you can end up with perspective distortion. If the camera is rotated slightly, the vertical and horizontal features won't line up. To help you align your camera properly, consider using the grid that many cameras add to the focusing screen (usually turned on through a menu option).
- ◆ Avoid unintentional size distortion. Subjects closer to the camera will appear disproportionately large compared to objects that are farther away. When shooting human subjects up close, you might find that noses look immense and ears look flattened and comical. Unless you're looking for a special effect, back away from such subjects or use a longer lens if you need the same image size—but without distortion.
- Compensate for optical defects. Wide-angle lenses often suffer from barrel distortion at the edges of their frames, with straight lines seeming to bow outwards. You might even have darkening or vignetting in the corners (make sure it's not your lens hood!) or purple fringing around backlit subjects from chromatic aberration. You can disquise barrel distortion by keeping subject matter with straight lines away from the edges of the frame, and fixing vignetting (and sometimes chromatic aberration) in your image editor.
- Avoid uneven flash. Your camera's built-in flash unit probably doesn't cover the full frame of your widest lenses. You can often fix this by using a diffuser on the flash to spread the light, or by switching to an external flash unit that offers wider coverage, or that can be adjusted to change its coverage angle. Bouncing the external flash off a ceiling can also widen a flash's spread. If all else fails, use a slightly less-wide zoom setting and take a step backwards to capture the same image area using your existing flash.

Figure 5.4 A wide-angle lens offers an interesting perspective when you get down low below your subject, as in this shot, or up high and shoot down.

Figure 5.5 Wide angles give you a wider field of view, but make it important to watch that the straight lines in your images are properly aligned.

Figure 5.6 A wide-angle lens's depth-of-field encompassed everything on this antique steam engine from the mid-point on the boiler back to the wheels. The size distortion of the close vantage point lifted this photo from the mundane, too.

IMAGINARY DEPTH-OF-FIELD?

Of course, pedants will say this added depth-of-field is illusory, because if you photograph the same subject from the same distance with both wide-angle and telephoto lenses, then crop and enlarge the wide-angle photo to provide the same image size, the depth-of-field will be the same. But who does something insane like that? Most of us happily benefit from the "deception."

Using Telephoto Lenses

Don't fall into the trap of thinking that telephoto lenses have only one purpose: to magnify distant objects. Although the change in perspective provided by a tele lens isn't quite as dramatic as that offered by a wide angle, there are a lot of creative things you can do with these optics. Here are a few of the tools at your disposal:

- Use selective focus. A telephoto lens or zoom setting offers less depth-of-field so you can use selective focus to make your subjects stand out distinctly from their backgrounds (see Figure 5.7).
- Bring distant subjects closer. Interesting wildlife such as deer, hummingbirds, or tree frogs can become skittish when humans approach, whether the distance is 5 feet (for smaller critters) or 50 yards (for larger creatures). Of course, it's not a good idea to approach animals that aren't particularly frightened of you (wild bears come to mind). You'll often

- want to photograph inanimate objects up close and personal, too. A telephoto lens can bring these distant objects nearer to you.
- ◆ Enter the huddle or scrum. Telephoto lenses are a valuable tool for getting you into the middle of sports action, too, without the need to don a uniform and attend exhausting practices (see Figure 5.8). Even sports that can be photographed from fairly close, such as basketball or soccer, can benefit from a telephoto perspective.
- ◆ Flatter your portrait subjects. While wide-angle lenses make humans look their worst, a moderate telephoto lens can help your portrait subjects look their best, by providing a flattering perspective with noses, ears, and other body parts portrayed in their best proportions. An 85mm to 105mm lens (35mm film camera equivalent), which is roughly the same as a 55mm to 70mm zoom setting on cameras with the typical crop factor, seems to provide the best rendition.

Of course, telephoto lenses, like wide angles, have characteristics that must be compensated for. Here's a checklist of the things you must watch out for.

Boost those shutter speeds.

The magnification provided by telephoto lenses also magnifies any camera shake. A basic rule of thumb says that you should use, as a minimum, the reciprocal of the focal length of the lens or zoom setting. So, a 200mm lens would require a shutter speed of 1/200th second—or shorter; a 400mm lens would call for 1/400th second or briefer. Very long, clumsy lenses can set up a rocking action of their own and might require a higher shutter speed. If you plan on enlarging your image, increase the shutter speed, too. A tripod or monopod is often a good idea for telephoto shots.

- Maximize depth-of-field.
- Selective focus is a cool tool, but sometimes you want to have more of your subject in focus than your telephoto lens allows at your current f/stop. The solution is to use a smaller aperture, even if it means you have to use a tripod to allow the lower shutter speed required.
- Address atmospheric and lighting problems. Telephoto lenses often exhibit flare when illumination from light sources outside the picture area enters the lens and bounces around within that long tube. Use your lens hood! In addition, photographing distant subjects means the light that makes your image has to pass through a lot more of the atmosphere, which, if it contains dirt or moisture, can reduce the contrast and saturation of your images. A haze filter can sometimes help. Be prepared to brighten up your photo in your image editor.

Figure 5.7 The reduced depth-of-field of telephoto lenses lends itself to selective-focus techniques, making it simple to throw a distracting background out of focus.

- 6
 - ◆ Watch for anemic electronic flash. If you're photographing distant subjects with electronic flash, you'll discover that few built-in units are much good beyond 20 feet, and more powerful add-on flash seldom is effective much beyond 30 feet. Plan on using multiple flash units with telephoto lenses or eschewing flash photography altogether.
 - ◆ Use compression. Telephoto lenses aren't free from distortion. Lenses longer than about 200mm tend to flatten human faces, making them appear wider than they really are. Very long lenses can compress the apparent distance between objects, so a line of automobiles will appear to be bumperto-bumper when they are actually 20 feet apart. Telephoto compression can be a creative effect or a bane, depending on your intention. In Figure 5.9, the effect was used to enhance the excitement of the face-off between batter and pitcher.

Figure 5.8 A telephoto lens can bring you right into the thick of the action.

Choosing and Using Lenses

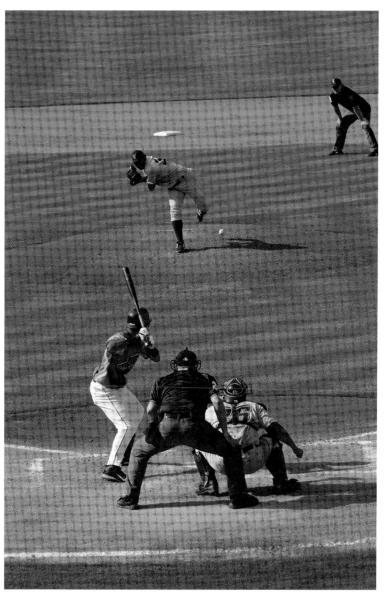

Figure 5.9 Telephoto lenses compress the apparent distance between objects, in this example drastically reducing the distance between the pitcher's mound and home plate.

Using Normal Lenses

Before zoom lenses became so popular, SLR cameras were commonly sold with a so-called fixed focal length "normal" lens. The normal part is derived from the diagonal measurement, in millimeters, of the image frame. For a full-frame digital SLR, that works out to be about 45mm, although anything from 50mm to 55mm is considered normal for such cameras. For a camera with a 1.5X crop factor, a normal lens would be about 32mm. The precise focal length has relevance only when you're looking for a normal lens for your camera, or want to know what focal length approximates normal with your zoom lens.

Normal lenses and normal zoom settings provide a perspective that's neither wide angle nor telephoto. They're good for interior or external photography when your subject is not too close, and for picturing humans when you can back up and shoot a 3/4 or full-length portrait (see Figure 5.10). For a zoom lens,

the normal setting is just another position on the zoom scale. With a fixed focal length or prime lens, normal lenses have some distinct advantages.

- ◆ Extra speed. Because the lens designers don't have complex zoom optics to worry about, normal lenses are generally much faster than even the best-designed zoom lenses. Most vendors and several third parties offer 28mm, 30mm, 35mm, or 50/55mm f/1.4 lenses. You'll find f/1.8 or f/2 lenses in those same focal lengths, too. If you need a large maximum aperture for shooting in dim light, a normal lens can be just the ticket.
- ◆ Economical price. Prime lenses of all types can be relatively inexpensive—frequently running \$500 or less-compared to complicated speedy zoom lenses that can cost \$1,300 or more. That often means you can find a lens that falls into your camera's normal focal length bracket for as little as \$150, and generally no more than a few hundred dollars if you'll find an f/2 to f/2.8 maximum aperture acceptable. Stretch the definition of normal a little, and you can find a 50mm f/1.8 lens for less than \$100.

Figure 5.10 A normal lens makes a good portrait lens for 3/4 portraits of individuals, or group portraits.

- Super sharpness. Again, because they are easier to design, normal fixed focal length lenses can be significantly sharper than zoom lenses that provide the equivalent magnification.
- Portability and simplicity.

Using a normal lens as your single, "walking around" lens is a great way to learn photography, because the fixed focal length and mundane field of view forces you to visualize the photos you're taking carefully to accommodate the "limitations" of your lens. At the same time you can travel light and may find that being able to photograph subjects without toting around a heavy zoom lens can be liberating.

Figure 5.11 The extra speed of a fast normal lens makes it possible to shoot good pictures by available light without the need to boost the ISO setting to noise-producing levels.

Using Macro Lenses

Macro lenses are special lenses that focus more closely than conventional optics (see Figure 5.12). In addition, they are often designed to provide enhanced sharpness at close-focusing distances. Macro lenses come in two varieties: prime or fixed focal lenath lenses and macro-zooms that focus closely over a range of focal lengths. (You can also sometimes use your "regular" lenses for close-up photography if you use one of the gadgets described under "Close-Up Accessories" in the next section.)

You should know that inexpensive macro-zooms might possibly be ordinary zoom lenses that happen to focus fairly close, with no special optical legerdemain applied to ensure top-quality images. And, regardless of

STEADY Macro photography magnifies camera shake dramatically. The relatively small f/stops often used in macro photography to gain depth-of-field force you to use longer shutter speeds, too. In both cases, a tripod can help steady your camera to sharpen those close-up images. Use a shutter release cable or IR remote or the self-timer to trip the shutter to eliminate camera shake caused by your trigger finger. If your camera offers mirror pre-release (mirror lockup), that can help damp the vibration that can be caused by the mirror flipping up prior to exposure.

whether your macro zoom is the genuine article or not, it's easier to design prime lenses to focus closely and still provide optimum sharpness. So, you'll want to evaluate a macro zoom you plan to purchase even more closely than you examine a prime macro lens.

Here are the things to keep in mind when choosing a macro

♠ Magnification. With non-macro lenses, the specification you're most concerned about is the closefocusing distance, whether it's 24, 12, or 6 inches. With macro lenses, the magnification is most important. After all, a 50mm lens that focuses down to four inches from the sensor will give you exactly the same size image as a 100mm lens that focuses as close as eight inches from the sensor. Macro magnification is expressed in ratios, such as 1:2 (half lifesize), 1:1 (life size), or 2:1 (twice life-size" magnification will produce the same-size image on the sensor as in real life; that is, a 10mm-wide object will

Figure 5.12 Depth-of-field is limited in macro photography: Focus on the object in front, and the one behind is likely to be out of focus, unless you use a small f/stop.

cover 10mm of the sensor width. Macro lenses should offer at least 1:2 magnification with no additional attachments, and, preferably, 1:1 (1X) magnification.

- Focal length. The longer the focal length of the macro lens, the farther you can be from your subject and still achieve the same magnification. So, a 60mm macro lens (or zoom setting) might be best for small objects you can conveniently photograph from a few inches away. Objects that are best photographed from more distance (say, skittish insects) might do well with a 100mm to 150mm macro lens (or zoom setting). There are 200mm and longer macro lenses for subjects that require even more distance. Many photographers prefer a macro zoom with a longer range because of the flexibility they provide in choosing a shooting distance.
- ♦ Minimum aperture and depth-of-field. You'll need lots of depth-of-field when shooting close ups, so the ability to use a small f/stop is key. A minimum aperture of f/22 or f/32 (or even smaller) can be useful. Remember that at such small apertures you'll probably be losing some detail to diffraction effects (caused by incoming photons being deflected by the edges of the aperture), but that's often an acceptable price to pay.

Parts of a Typical Macro Lens

These are the most common features and controls found on macro lenses; not all macro lenses have all these controls, and a macro-zoom lens will also have a zoom ring.

- Lens thread. Can be used with lens hood, filters, reversing ring, or additional close-up attachments.
- Focus ring. Adjusts focus when manual focus is used.
- Auto/manual focus control.
 Switches between manual and automatic focus.
- Focus scale. Shows distance of current focus in both meters and feet, as well as rough depth-offield.
- Limit switch. Locks out near or distant focusing so autofocus doesn't seek back and forth within a distance range that isn't needed.
- Aperture ring. Sets f/stop manually.
- Aperture lock. Locks lens f/stop at smallest opening so the camera can switch to other apertures automatically.

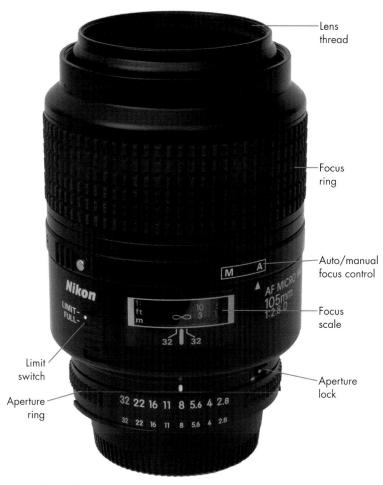

Figure 5.13

Close-Up Accessories

There are several different macro accessories that can help you focus closer with a macro lens or macro zoom, or even press your existing lenses into service as acceptable macro optics. Here are the most common accessories you'll want to consider:

- Close-up lenses. These aren't stand-alone lenses but, rather, are filter-like attachments that screw onto the front of your camera's lens to enable it to focus closer (see Figure 5.14). These inexpensive accessories are labeled by their relative magnification in diopters. For example, a 50mm lens focused at 3 feet would focus down to 20 inches with a +1 diopter, 13 inches with a +2 diopter, and 10 inches with a +3 diopter. These lenses can be combined to increase their strength: A +2 and a +3 would yield the same magnification as a +5-diopter attachment. You lose some sharpness with close-up lenses, but they are convenient and don't reduce exposure. Look for better-quality two-element diopter lenses called achromats.
- Extension tubes. These are empty tubes in various lengths that increase the distance between your lens and the sensor, allowing the lens to focus more closely (see Figure 5.15). You can use them singly or in combinations, and they are available in lengths from 10-12mm to 50mm. The better quality tubes have linkages to preserve the autofocus, autoexposure, and autoaperture functions of your original lens. Unlike diopter attachments, extension tubes don't reduce the image quality, but they do force you to increase exposure to compensate for the additional distance the light has to travel.
- ♠ Reversing rings. These are a lens mount flange that attaches to the filter thread of your lens, so you can flip the lens around so the camera-mount end is facing the subject, while the end with the filter thread is attached to the camera, extension tube, or bellows (see Figure 5.16). This configuration provides extra magnification and often improves sharpness. Many photographers use a reversing ring to press their normal lenses and wide angles into macro duty.

◆ Bellows attachments. These are accordion-like variable length extensions that function like an extension tube, but with continuous adjustment of the lens/sensor distance (see Figure 5.17). Bellows are usually more expensive than extension tubes and often provide no linkage between the camera and lens, so you'll need to focus manually, meter and set exposure using your camera's manual mode, and even stop down the lens to the taking aperture yourself.

Figure 5.14 A close-up lens attachment can turn any lens into a serviceable close-up lens.

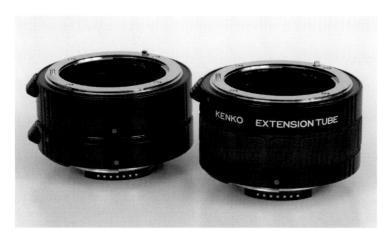

Figure 5.15 Extension tubes in several different lengths allow a lens to focus more closely.

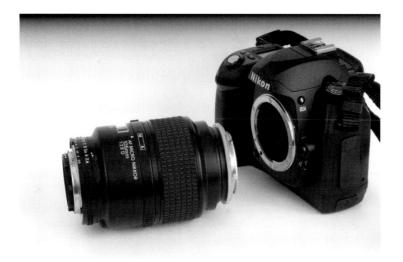

Figure 5.16 A reversing ring allows flipping a lens so the front end attaches to the camera, increasing magnification and often improving sharpness.

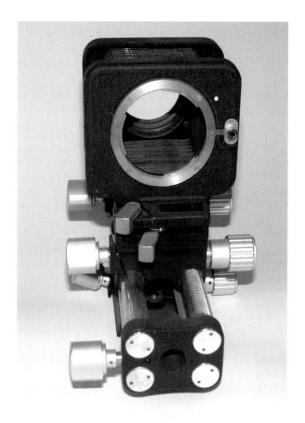

Figure 5.17 A bellows attachment provides the most extension over a continuous range.

Teleconverters

Teleconverters are optical attachments that fit between your prime or zoom lens and your camera's body, providing additional magnification. They resemble extension tubes, but have optical elements that increase the lens's effective focal length. Teleconverters are available from third parties such as Kenko and Tamron, as well as from digital camera vendors. Both Nikon and Canon offer good-quality converters. (Canon calls them "extenders.")

The best-quality teleconverters offer conservative magnifications in the 1.4X to 1.7X range, topping out at 2X. A few third-party vendors also offer 3X teleconverters, but they often reduce sharpness too much to be practical. Teleconverters also reduce the amount of light reaching the sensor. Unlike your camera's crop factor, a teleconverter does multiply your lens's focal length by its rated factor, so depth-of-field is slimmed down to match.

Here are the most important things to know about teleconverters:

- F/stop loss. Teleconverters reduce the amount of light reaching the sensor. A 1.4X converter costs you half an f/stop; a 1.7X converter reduces the light by 1.5 f/stops; a 2X by 2.0 f/stops; and a 3X by a whopping 3 f/stops. If your lens has a small maximum aperture to begin with, the light loss penalty might be too much. It's one thing to convert a 180mm f/2.8 lens into a 540mm f/5.6 super-telephoto with a 3X converter. But a 400mm f/6.3 lens transformed into a 1,200mm f/18 lens that must be stopped down to f/32 to get acceptable sharpness is no bargain. In bright daylight you'd need to boost your dSLR's ISO setting to ISO 1,600 to shoot at 1/400th second at the equivalent of f/32. Even with the camera locked down on a tripod, that might not be enough to eliminate camera/lens shake.
- Bye-bye, autofocus. Some cameras require an f/stop of f/5.6 or larger for the autofocus mechanism to work. With a 3X converter, your main lens will need to have a maximum aperture of f/2.8 to

- ensure proper autofocus. Even if autofocus does operate properly, teleconverters tend to reduce the contrast of the image, and contrast is what your autofocus system uses to zero in on correct focus. You might find that a given teleconverter can autofocus only with a limited number of non-zoom lenses. Should you choose to focus manually, you'll find the dimmer image difficult to focus with, too.
- Lost sharpness. All teleconverters cost you some sharpness. If the optics aren't first rate, you'll lose a little in the extra glass placed between your main lens and the

sensor. More sharpness is lost because, with reduced light, you'll end up using an f/stop that may not offer the best resolution with your particular lens. If your camera isn't steadied with a tripod, more sharpness will be lost from camera shake. It's not uncommon to find that shooting an image without any teleconverter at all and then cropping in an image editor produces a better image. If you elect to use one of these attachments, you're better off with a high-quality 1.4X or 1.7X converter with at least four or five elements and special coatings to reduce flare.

Figure 5.18 Inexpensive teleconverter lenses may be suitable if you stop down the lens an extra stop or two.

Figure 5.19 A 2X teleconverter transforms your 105mm f/2.8 telephoto lens into a 210mm f/5.6 optic with twice the magnification.

Distortion, Aberrations, and Anomalies

Lenses can be plagued by a variety of optical aberrations, distortion, and anomalies, not all of which are the fault of the lens. Many of these can be fixed up nicely in Photoshop, or worked around with some clever compositional techniques. Here are the most common maladies and some tips for countering them.

- ◆ Barrel distortion. This kind of distortion results in lines that are parallel to the edges of the image bowing slightly outward (see Figure 5.20). It's commonly found in wide-angle lenses, and can often be corrected in Photoshop using the lens Correction filter.
- Pincushion distortion. This is the opposite of barrel distortion, and appears as lines that are parallel to the edges of the image curving inward towards the center (see Figure 5.21). It's most commonly found in telephoto lenses, and can often be corrected using Photoshop's Lens Correction filter.

Figure 5.20 Barrel distortion in wide-angle lenses causes lines parallel to the edges of the frame to bow outward.

◆ Vignetting. This is the darkening of the corners of an image, as seen in the pincushioning example (Figure 5.21), and can result from mechanical, optical, and natural causes. Mechanical vignetting most often occurs when a lens hood is used that has too narrow a view for the focal length of the lens, especially if the lens is a zoom. A

hood that properly shields the lens from extraneous light at the telephoto setting may intrude on the image when the lens is zoomed out to its wide-angle setting. A filter that is too thick for a lens (particularly a wide-angle lens) can also show up in the frame as vignetting. Optical vignetting is a property of any lens produced by illumination

fall-off at the edges of the image. This effect is strongest when the lens is opened up to its maximum aperture, and when the subject matter is relatively contrasty.

Natural vignetting is also caused by lens design, and afflicts wideangle lenses, which use a special arrangement of elements to allow them to focus on a sensor placed

- at a greater distance than their focal length. You can prevent vignetting by using the proper lens attachments, stopping down the lens to a smaller f/stop, and by using a tool like the Lens Correction filter in Photoshop.
- Chromatic aberration. This is a kind of distortion caused by the inability of a lens to focus all the colors of light at the same point. This defect produces fringes of color around objects, and is most easily seen around backlit subjects. There are two kinds of chromatic aberration: axial (or longitudinal), in which the colors don't focus in the same plane and produce a colored halo around the subject, and transverse (or lateral), in which the colors are shifted to one side (see Figure 5.22). Preventing this kind of distortion, which is especially noticeable in telephoto lenses, is best tackled by the lens designer, but photographers can reduce axial chromatic aberration by stopping the lens down. Transverse chromatic aberration can sometimes be fixed by modules included with image editors like Photoshop. (You'll find this tool in Adobe Camera RAW as well as the Photoshop Lens Correction filter.)
- Perspective distortion. This is not a lens defect but, rather, an effect produced when the camera is tilted up, down, or to one side to capture all of a tall or wide subject.

Figure 5.21 This image has pincushion distortion (lines that bow inward).

The portions of the subject closest to the lens appear larger than the portions that the camera is tilted to include. When photographing buildings and other structures, perspective distortion can cause the subject to appear to be falling backwards (see Figure 5.23).

Bokeh. This is a term used to describe the aesthetic qualities of the out-of-focus parts of an image, with some lenses producing "good" bokeh and others offering "bad" bokeh (see Figure 5.24). Boke is a Japanese word for "blur," and the h was added to keep English speakers from rhyming it with broke. Out-of-focus points of light become discs, called the circle of confusion. Some lenses produce a uniformly illuminated disc. Others produce a disc that has a bright edge and a dark center, producing a "doughnut" effect, which is the worst from a bokeh standpoint. Lenses that generate a bright center that fades to a darker edge are favored, because their bokeh allows the circle of confusion to blend more smoothly with the surroundings. The bokeh characteristics of a lens are most important when you are using selective focus (say, when shooting a portrait) to deemphasize the background, or when shallow depth-of-field is a given because you're working with a macro lens, long telephoto, or with a wide-open aperture.

Figure 5.22 Lateral chromatic aberration shifts some colors to the sides. In this extreme enlargement, you can see that magenta tones have been shifted to the left, and cyan fringes to the right.

Figure 5.23 Perspective distortion can cause buildings or structures to appear to be falling backwards.

Figure 5.24 "Bad" bokeh (top) is intrusive, while "good" bokeh helps the background to blend together.

Creating a Photo

here's a big difference between taking a photo and making a photo. Today's technology makes it fairly easy to point a camera at something, press the shutter release, and end up with a decent picture. Going beyond that to get a really *great* photograph requires some work and planning.

That doesn't mean you need to spend hours plotting out exactly how you will photograph your next subject, of course. There's no real need to scout a location weeks in advance, decide on the perfect moment when the planets conjoin, and then devote hours to setting up the camera and framing the absolute perfect image. All you really need to do is understand the principles set out in this chapter, and then keep them in mind as you prepare to take your next photograph. You might need to consciously consider each of these guidelines at first, but eventually they'll become second nature to you and become a regular part of your shooting repertoire. This chapter provides a summary of the key components of a well-thought-out image, and shows you what rules to follow and what rules to break.

Choosing a Theme and Purpose

Every picture tells a story, and you should decide on that story before you shoot. The story can be lighthearted and heartwarming; perhaps you want to show a new puppy getting acquainted with a young child. The tale you want to tell might be "here's what we did on our vacation" and concentrate on documenting interesting activities and sites. Or, you might have shifted into photojournalist mode and plan to tell a story about how a local woodlands has been devastated by human carelessness. Some of the themes you'll use for your photos are determined when you set out on your shooting expedition.

Other times, a picture's story is determined on the spur of the moment. You're out shooting landscape photos of a majestic mountain, and encounter a family of deer. You're exploring a winding street in a picturesque European town when suddenly the narrow way fills with an impromptu parade of teenagers,

their faces painted in support of their local soccer team. You spy an elderly man proudly escorting his wife on their daily constitutional—both of them dressed to the nines (see Figure 6.1). All these have happened to me, prompting a storytelling photo right on the spot. While it's possible to take photos of interesting subjects in random ways, your results will be better if you have a theme and purpose in mind when you shoot.

Here are some things to think about:

◆ What's the story here? A single subject can be portrayed in many different ways. A sports photo can show a local hero in a solo moment of glory or concentrate on that same individual's confrontation with an opponent. You might want to show two teammates working together, concentrate on the crowd's reaction, or show the coach agonizing over a crucial decision. The officials and team mascots have their own stories, too. You need only choose which story you want to tell.

Figure 6.1 Some photographs make you think about things, such as how many decades must have passed since this couple first began taking their daily walks.

♦ How will your photo be used? Will this image appear on a webpage, or is it destined for display as a framed print on your wall? Will it be printed in a newspaper or magazine (see Figure 6.2), perhaps, or, more likely, reproduced in your club's newsletter? Perhaps you'll make a few small prints to pass around, or you will be viewing your final shots only as slideshows on your computer screen. Believe it or not, the intended purpose of an image can affect how you shoot it. Photos intended for display require tight

composition so you won't waste any pixels when you enlarge the image, and excellent exposure so details are present in both the highlights and shadows. Pictures that will be printed in publications call for a tonal range suitable for the kind of reproduction you have in mind: Photos that will be printed in slick magazines need different qualities from those that will be printed in a low-budget company newsletter. It you understand the purpose of your final shot, you can make the appropriate adjustments when you create the image.

♦ Who is your audience? You'll probably know in advance who will be viewing your images. Perhaps your travel pictures will be seen only by family and friends, in which case you'll want to include yourself and your traveling companions in at least a few shots (see Figure 6.3). You'll also want to make sure all the traditional subjects are included: the Great Pyramid in Egypt, the Taj Mahal in India, or the Great Wall of China in China. Photos taken on the same travels that will be presented to

strangers (perhaps you're preparing a travelogue) may have an entirely different focus. If you accompanied your CEO on a trip to the same countries, you'll want to show the boss doing something CEO-ish, with, perhaps, one of your company's products worked into the photo if appropriate. If you try to put yourself in your viewers' shoes when you take a picture, you can better imagine what they expect and want to see in your photos, and provide that viewpoint.

Figure 6.2 Photographs that will be reproduced in books and magazines need to be composed tightly and have a good tonal range.

Figure 6.3 This photo is intended only for viewing by friends and family, so it's okay to mug for the camera in front of a tourist landmark.

Selecting a Center of Interest

Good photographs capture the eye with a strong main subject, usually called the center of interest, which is a person, a group of people, or some other subject that embodies the theme of the image. The center of interest can be a cluster of animals, a mountain, a building, or other obvious focus of the photograph. I say obvious because the viewer shouldn't have to search through an image, trying to find some place for the eye to alight. A good picture shouldn't be a "Where's Waldo?" puzzle, cluttered with so many interesting things that it's difficult to decide what the photograph is about.

It's possible to include secondary objects of interest, which add depth and richness to an image, but the other subject matter clearly should be subordinate to the center of interest. One of the worst things you can say about a photograph is to call it "busy." In creating your composition, you'll want to identify the center of

interest, and then eliminate or minimize the importance of other portions of the photo that compete for attention. Crop the image to exclude distracting subject matter, or change your angle so it no longer appears in the field of view. If the offending subject is a person, ask him or her to come stand by your side to help

take the picture, or send the person on an errand (small bribes sometimes work). It's also possible to take several photographs of the same scene, each featuring a different person vying to be the center of interest, as you lavish the most effort on the one who is your secret goal.

Here are some things to keep in mind when establishing a center of interest in your photos:

◆ One main subject. Be sure that your image has one, and only one, center of interest. That center can be more than one object, as in Figure 6.4, but all the components of your main subject should be in close proximity. For example, you can photograph a set of twins

Figure 6.4 The center of interest can consist of more than one subject, as in this sports shot in which the umpire, first baseman, and base runner are all the focus of the image.

together, as long as you avoid having one of them on one side of the picture and the other on the opposite side. While the twins don't have to be dressed identically and posed exactly alike, there should be no outlandish difference between them—unless one or the other is the true center of interest and the additional twin is a secondary subject. A child playing with a puppy is an image with a single center of interest. If there are other puppies elsewhere in the frame behaving in a distracting way, you have a potential for conflicting focus.

- Don't always center your center of interest. Your most important subject should usually be located a little to one side and toward the top or bottom of the frame, in order to keep the photo from becoming too static. There are exceptions to this rule, as you can see in Figure 6.5, but it's a good idea not to take the "center" concept literally. Avoid having any subordinate and secondary subject matter smack in the middle of the photo, too: Anything you place in the center is likely to become the center of interest whether you want it to or not.
- ◆ Prominence. Your center of interest should be the largest subject or otherwise the most prominent part of the picture. If you want to feature your Uncle Charlie, make sure that an elephant, space alien, any Ferrari automobile, or Brad Pitt isn't also in the picture. Any of these are likely to seize the focus of attention in your photograph, rendering Uncle Charlie as a mere onlooker.
- ◆ Color and brightness. The center of attention doesn't have to be very bright or colored in a gaudy way, but you must at least be sure that other brighter, more colorful objects don't overpower the real subject of your photograph. Exclude such objects from your image by cropping, moving them behind something, or changing the light that illuminates them (if possible). In a pinch, plan on reducing the power of distracting objects in your image editor.

Figure 6.5 The most prominent object in your image should be the center of interest, with the other objects subordinate to it. It's okay to center your main subject if the composition calls for it.

Figure 6.6 By placing one bright crayon in the midst of a group of pastel crayons, the most colorful crayon automatically becomes the center of interest. In a black-and-white version of this shot, however, nothing would stand out.

Orientation

Another important compositional element that you must decide on is the orientation of the photo whether you shoot the image "wide," in a landscape arrangement, or "tall," in a vertical configuration. The orientation of an image can have a powerful effect on how the viewer visualizes the photo. Landscape orientation tends to produce a feeling of width and sprawl, and it can lend the feeling of a panorama even in compositions that don't depart from the common dSLR 3:2 aspect ratio. Our eyes tend to explore a photo that is wider than it is tall from left to right or right to left, unless there are strong vertical lines within the composition (which may mean the orientation for the picture was incorrect).

Because digital SLRs are built using a horizontal orientation as the default, that's the way many beginning photographers instinctively frame all their photos until they learn better. Good horizontal subjects include many landscapes, sports that include

horizontal movement (such as football or soccer), and many animals (see Figure 6.7).

Vertical (or "portrait") orientation (see Figure 6.8) provides expectations of height and vertical movement, and our eyes tend to examine such a picture from the bottom to the top. Vertical orientation tends to be more exciting if used with appropriate subjects, and more frustrating if the orientation was chosen incorrectly, because our eyes will yearn to see what's off to either side of the subject. Typical subjects that lend themselves to vertical compositions are buildings, sports with a vertical component (such as basket-ball), people, and upright animals.

There is a third possibility, of course: the square composition (see Figure 6.9), which can only be achieved by trimming the edges of a digital photograph composed in one of the other two ways. Circular subjects lend themselves to square compositions, and they often are centered within the image. A subject that

Figure 6.7 Horizontal orientations work well with subjects that are moving from one side of the frame to the other.

Figure 6.8 Some subjects just naturally seem to fit best in a vertical orientation.

contains both vertical and horizontal components, such as a sprawling farmhouse and barn next to a silo, can look good in a square format.

Sometimes the overall orientation of the photo might be dictated by your intended application. Images destined for a projected presentation or display on the computer screen may need to be

oriented in a horizontal direction in order to fill up the width of the screen as completely as possible. You may still be able to use a vertical shot, but you will need to mask off the sides of the image and then settle for a photo that is no taller than the short dimension (height) of the screen and which appears to be much smaller than the horizontally composed images in the same presentation.

Figure 6.9 Although square layouts tend to look static, if the subject itself is dynamic, a square image can work well. In this case, the musicians on either side of this drummer were distracting to the composition, so they were cropped out.

Angles and Distance

Once you've decided whether your image will look best in a vertical or horizontal orientation, you'll need to figure out where to stand. The distance and angle you select can have a powerful effect on your photograph. Choosing your spot is not something you do once and forget about if your goal is to provide thorough coverage of your subject. As you shoot, explore different angles and positions to look for new perspectives and new ways to improve your composition. With a digital SLR, your choice of lens or zoom setting has much the same effect as changing the relative distance between you and your subject, too. Here are some guidelines.

Fill the frame with interest. To be sure, you don't necessarily have to fill the frame with your main subject matter. But everything in the photo should contribute to the composition. If you include extraneous information that you'll only crop out later, you're wasting pixels.

- Move in close to emphasize a person or object or to create a feeling of intimacy. A close-up view shows details and texture, so when you want to highlight a person, a group of people, or some specific object, move in close or use a telephoto zoom setting (see Figure 6.10).
- Step back to create a feeling of distance, space, or depth.

 Move a few steps back or use a wide-angle zoom setting to emphasize the foreground area, cause the details in the background to retreat, or create a feeling of space (see Figure 6.11). Outdoors, this will allow more of the sky to show in your images, enhancing the feeling of depth.

Figure 6.10 Fill the frame with your center of interest to avoid wasting pixels, and to emphasize texture or details.

- ◆ Don't minimize your main subject. Your wide-angle lens or steps backward can reduce the size of your main subject so much that it becomes subordinate to its surroundings. Unless that's the feeling you're going for, avoid distant views that reduce the apparent size of your main subject too much.
- Use high angles to emphasize the immediate surroundings of your subject, and low angles to create a feeling of tallness. Shooting down on your subject will emphasize those parts of your subject that are higher off the ground, while de-emphasizing parts that are lower (see Figure 6.12). Low angles do the reverse. For example, shooting a basketball player dunking the ball from above the rim will make the rim, basketball, and the player's arms dominate the photo. The same shot taken from near the floor will emphasize the player's legs and height.

Figure 6.11 A wide-angle lens emphasizes the foreground, as in this shot of a rural trail.

The Rule of Thirds and Other Guidelines

The Rule of Thirds is something to keep in mind even when you're ignoring it. Briefly stated, this rule says that your main subjects of interest should be located roughly one-third of the way from the top, bottom, or either side of the image. You can visualize this layout by imagining a line located one-third of the way down from

the top of the frame, and another line one-third of the way up from the bottom, dividing a landscape-oriented image into three horizontal strips. Then, imagine two vertical lines trisecting the image, as shown in Figure 6.13. Using the Rule of Thirds, the "best" location for your subjects will be at the intersections of these lines.

Figure 6.13 Picture imaginary lines dividing your frame into thirds, and place the center of interest at one of the intersections.

In practice, the Rule of Thirds works quite well. In landscape photos, the horizon shouldn't be placed in the center of the frame. Moving it up to coincide with the horizontal one-third divider creates a more interesting composition that emphasizes the foreground. Placing the horizon at the lower one-third point is also interesting, but changes the emphasis to the sky (see Figure 6.14).

Locating other subject matter at the intersections of the dividers also produces pleasing compositions, because such placement keeps important objects from straying too close to the edges, and also ensures that there will be a portion of the frame for your center of interest to "look into" or which can intercept the viewer's gaze and lead the eye to the

main subject (see Figure 6.15). Here are some of the ways you can apply these basic compositional guidelines:

- ◆ To locate large subjects. If your subject is so large that locating it at one of the one-third intersections clips it off at the top, bottom, or side, move it within your composition so the entire object is included comfortably.
- ◆ To shoot close-ups and portraits. By convention, we often expect to see the subjects of close-up pictures and portraits centered in the frame. A photograph you take of a flower, or a picture destined for your passport, might look odd if composed using the Rule of Thirds as a guideline. That's not to say you can't include more space around your close-up photos and people pictures, but these kinds of images often are cropped very tightly with the subject matter centered.

WHEN TO BREAK THE RULE OF THIRDS

This rule is only a guideline. There are many times when you'll want to ignore it.

Figure 6.14 Putting the horizon at the upper third of the frame emphasizes the foreground; placing it at the lower third emphasizes the sky.

- ◆ To convey a concept. If you want your subject to appear static, penned in, or surrounded, you might find that centering the center of interest is an effective tool. Putting the subject at one of the intersection points implies motion or direction. When you mean to imply the opposite, ignore the Rule of Thirds.
- ◆ To show symmetry. A centered subject that's more or less bilaterally or radially symmetrical, located in a symmetrical background, can form a pleasing, geometric pattern. Flowers in close-ups are a good example of this. The composition may appear to be a bit static, but that might be what you're looking for in addition to geometric harmony.

Figure 6.15 Large objects and portrait subjects can be centered in the frame effectively.

Backgrounds

The background is an important element in most photos, even if it's a featureless expanse of a single color or tone. A flash photo taken at night might have a deadblack background; an exposure on an Arctic snowfield might show nothing in the background but a bright glare. In both cases, these backgrounds still manage to tell you something about your subject's surroundings. More commonly, a background will include more relevant details that you can use to your advantage, or minimize to bring the focus of attention on the subject in front. Here are some considerations to deal with when incorporating backgrounds in your images.

Avoid making the background the focus of the picture. The background should not be gaudy, be filled with distracting detail, be significantly brighter, or contain anything more interesting than the subject itself (see Figure 6.16). If that's the case, it's time to think of ways to minimize the background.

- Use a plain background for portraits. A blank, featureless background can work for portraits, as long as it isn't totally bland. Notice how professional photographers who pose subjects against a seamless background still use lights to create an interesting gradient or series of shadows in the background.
- Use natural objects such as trees, grass, and skies.
 We see these backgrounds as natural accompaniments to outdoor photos, so they are interesting without dominating the photo (see
- Be alert for strong lines or shapes that distract from your subject. Such elements are great when they add to a composition, but they are not good if they distract from the main subject.

Figure 6.17).

Figure 6.16 This shot would be much better if the background weren't so gaudy and filled with distracting objects, including some sort of creature approaching a feeding bowl at lower center.

Creating a Photo

♦ Use selective focus to minimize a distracting background. Lack of depth-of-field can be your friend, when selective focus is used to blur the area behind the subject (see Figure 6.18). You can also make the

background darker, or less cluttered. You want the background to appear in such a way that it provides sufficient separation between the subject and itself. (They both shouldn't be the same tone, color, or pattern, for example.)

Figure 6.17 The cloud-filled sky makes a perfect background because it has color and texture, but is not distracting.

Figure 6.18 Using selective focus to let the background blur is one way of minimizing a distracting background.

Using Straight Lines, Curves, and Balance

One of the things that makes a composition pleasing to the eye is the opportunity to discover something new or unexpected as the image is explored by the viewer. We like to see subjects arranged in interesting ways, and in ways that are unpredictable, while still maintaining a sense of order. While you can arrange all the objects in an image in a straight horizontal or vertical line, instead provide variety by arranging them in diagonal lines, or in converging pairs of lines, or in gentle curves. These lines can lead the eye towards the main subject in a subtle way, or more explicitly for a dramatic effect. Balance within an image is important, too, because you don't want your photo to appear to be lopsided, with all the interesting elements on one side or the other, and nothing of interest elsewhere in the picture. Here are some ideas to work with.

- Straight lines add drama. Fenceposts, shorelines, the lines of a modern building. Vertical and horizontal lines can provide dramatic compositions and patterns, but they require especially interesting subject matter to overcome the static nature of these shapes.
- Diagonal lines direct the eye to the center of interest. Like signposts or directional arrows, diagonal lines are more dynamic and interesting and lead the eye naturally through an image (see Figure 6.19).
- ♠ Repetitive lines create patterns. These can be multiple parallel or converging lines in a single object, such as the courses of bricks in a wall or the lines formed by converging objects, such as fences erected on opposite sides of a road. These lines can create a pleasing pattern that reinforces an image's basic composition (see Figure 6.20).

- ◆ Curved lines add graceful movement. Arcs and bends can help the eye explore an image in a gentle, less jarring way. Instead of being directed along a certain path forcibly, as is sometimes the case with strong diagonal lines, the eye can be motivated to explore an image naturally and smoothly with the use of curves.
- Shapes can shape emotions. Triangles can represent conflict and forcefulness, while squares can provide a more open feeling, and circles are even more open and
- calm. So, arranging your subjects in a triangular shape causes the eye to follow the lines of the triangle toward the three apexes, where the main components of your images can reside. Squares and rectangles provide a more general arrangement that embraces more of the image, and circles, which point to nowhere in particular, are the least forceful elements of all.
- Balance creates a sense of completeness. Avoid putting all the interesting components of an

image on one side or another, or only at the top or bottom of the photo, so that there is nothing to see in the rest of the picture. An imbalanced photo is like a seesaw with a large child at one end, and nothing at all on the other end. You don't need to place another large youngster at the other end of the seesaw, but there should be something. That something shouldn't conflict with the center of interest of your photo: You can have a person or mountain or other subject as the focus on one side of the picture,

while a less important object, such as a group of trees or a smaller mountain resides on the other half. The center of interest remains the same, but the composition is more balanced. Balance can be symmetrical, with the opposing objects of equal size, but with the main subject brighter or more colorful, in sharper focus, or otherwise more compelling to the viewer. Balance can be asymmetrical, too, with the objects of different size (see Figure 6.21).

Figure 6.20 The repetitive parallel curved lines of the neon tubes form an interesting pattern.

Figure 6.21 This image has good asymmetrical balance. While the center of interest is the trees and sun in the upper-left half, there are interesting things to look at in the lower half and right side of the photo.

Framing Your Subject

A frame defines an image's shape and concentrates the viewer's attention on the subject matter within it. The border of an image is more than the physical picture frame and its matte. A frame can also be components of a composition, used to provide

an informal border around the main subject matter of the photo. Here are some things to think about:

Foreground frames are best. Doorways, windows, arches, and other elements of your picturetaking environment that are a natural part of the foreground make the best frames, because they blend in smoothly with the image behind them (see Figure 6.22). We naturally think of frames as being "in front of" the subject matter being framed, so the composition appears more natural. ◆ Frames add depth. Sometimes it's difficult to judge distances in a photo, but when a frame is used in the foreground, we instantly have a better idea of the scales involved. The foreground is "near" to us, and the scene behind it is "farther," so the image takes on a 3D realism that would not be there if it weren't for the frame (see Figure 6.23).

Figure 6.22 Tree branches are often used to create frames in the foreground for scenic and architectural shots.

Figure 6.23 Frames add depth, as you can see in this photo of a freight train seen through the frame of an old station house.

- Use telephoto lenses to compress this depth, and wideangle lenses to expand it. A tele will reduce the apparent distance between your foreground frame and the image in the background, while a wide angle will increase this separation (see Figure 6.24).
- Change positions constantly as you shoot. Look for new frames to wrap around your subjects by moving closer or farther away or by changing angles.

Figure 6.24 Wide-angle lenses expand the distance between the frame and its background. In this case, the railings form a frame-within-a-frame extending back many feet.

Great Themes

here are so many great subjects worthy of your photographic efforts that it's difficult to know where to start. Why not tackle one of the 20 great themes showcased in this chapter? Although each of these types of photography has been embraced and explored by photographers for aeons (or more accurately, sometime since the traditional beginning of the artform in 1839), there's always something new to discover.

Digital SLRs offer features that make them an even better choice than film or point-and-shoot digital cameras for these kinds of photos. You can review your pictures instantly and reshoot as necessary, which is a wonderful advantage for travel photography far away from home. Most dSLRs can crank out three to five frames per second, which is

great for fast-moving subjects like sports or children. Digital SLRs lend themselves to close-up photography, because you can better see the exact image you're taking with the SLR's optical viewfinder (compared to smaller LCD viewfinders on point-and-shoot digital cameras). Digital photos are easier to stitch together into panoramas and to enhance in an image editor to correct deficiencies in your original shots or to create new effects.

Read through the classic themes illustrated in this chapter, and then go out and show what you can do! Each of these topics is worth an entire chapter on its own, so my goal here is to provide a little taste of many different kinds of photography, offer some examples, and sprinkle in a few tips to get you started.

Action

Action photography requires a little technical expertise on several counts. First you'll usually want to stop fast-moving action in its tracks—unless you don't. That's because some of the time you'll want the highest shutter speed possible to freeze motion, and some of the time you'll prefer to use a slower shutter speed to let a bit of blur convey the feeling of movement. Knowing what shutter speed is best for the effect you want is half the battle. There's a summary of how shutter speeds affect different types of motion in Chapter 3, "Photography: The Basic Controls."

Action photography also often requires use of specialized lenses. You might need a telephoto lens to bring you close to the action and thus need a higher shutter speed and more careful focus to counter for the telephoto's characteristics. You must be skilled at selecting the right moment, too, to avoid capturing

that forgettable instant just before or just after the decisive moment.

Don't forget that any fast-moving subjects, whether birds in flight, you (or your brave friends) skydiving, or motoring all lend themselves to action photography. Figures 7.1 and 7.2 illustrate some of the basics of the sports variety of action photography, because many of the action pictures you take will be of spectator or participatory sports.

Both shots were taken with telephoto lenses from up in the stands, providing a good vantage point that minimizes distracting backgrounds like the dugout or other players in the field. Figure 7.1 shows a decisive moment, just after a game-winning homerun has been blasted. While it might have been nice to show the bat striking the ball, in this case it's interesting to see the batter following the arc of the ball as it heads over the fence.

Figure 7.1 The batter watches the ball sail over the fence in a decisive moment at a professional fast-pitch softball game.

Figure 7.2 shows how a little motion blur can enhance a photo. The pitcher is captured in mid-throw, just after the ball has left her hand with blinding speed,

which you can tell from the yellow orb's blur. Photos that are mostly sharp, but with blurring of the fastest-moving elements of the image can be the most effective.

Figure 7.2 Using a shutter speed just fast enough to freeze the motion of the pitcher, while allowing the ball to blur, produces a more exciting photo.

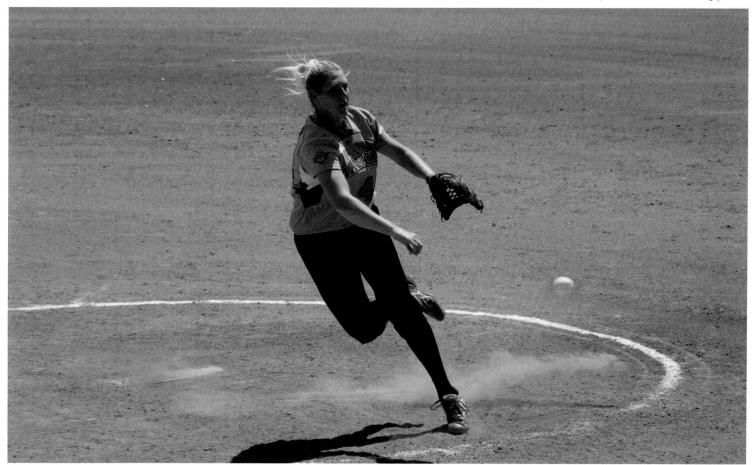

Animals

You'll find interesting animals to photograph everywhere you look. Family pets are a good place to start. They're comfortable with you, probably won't be frightened by the camera (even if you need to use flash), and are constantly available for re-shoots. At zoos, you'll find exotic animals you are unlikely to encounter anywhere else. The most challenging animal photography of all is out in the wild, where you not only need to figure out how to take creative photos of your quarry, you have to find them in the first place.

That's why it's often best to start with zoos. The trick there is to take photos that don't look like the animals are in cages.

Although zoos do their best to house their creatures in naturallooking environments—fences, fake rocks, moats, doorways that the animals can flee through to

escape for a quick nap indoors—all conspire to add a phony look to your images. Choose your angles carefully, crop tightly, and wait until the animal is doing something interesting to come away with the best pictures.

Here are some tips to keep in mind for zoo photography:

Visit early in the day. Some kinds of animals sleep 20 hours of the day. Even the most active creatures spend a lot of time doing nothing. They'll be at their best in the early morning when the first feeding takes place and the animals are busy planning their activities. Arrive at the zoo or animal park as soon as it opens and head directly for some of the most challenging beasts, such as the big cats (see Figure 7.3). You can find out from the zoo when the exact feeding times are, too. By high noon, you'll be ready for your own lunch or a visit to the indoor exhibits with the active smaller animals.

- Get as close as you can. That may mean using a longer lens, which, in turn, may call for using a monopod to steady your camera and avoid blur.
- Shoot at an angle. You can sometimes discover a more attractive background if you shoot at an angle that takes in foliage and ornamental shrubbery at the side of the compound. Angle shots will
- also allow you to avoid reflections as you shoot through glass or plastic that some zoos use to protect the animals from visitors
- Look for humorous views. A dolphin sticking out its tongue, a yawning lion, or some monkeys engaged in playful activities are more interesting than photos of the creature sitting there with a bored look on its face (see Figure 7.5).

Figure 7.3 Catching a lioness wide awake can be tricky. Visiting right after mealtime is your best bet.

Figure 7.4 Ostriches sleep with their necks stretched out on the ground (not stuck in a hole), but an upright, alert bird makes a more interesting shot.

Figure 7.5 This bovine's expression is priceless. Some of your best animal pictures will involve having the beast looking straight into the camera

Amusement Parks

Amusement parks, especially the bigger theme parks, have an endless array of fascinating subjects to shoot. Go early and stay late, because the opportunities for creative photography change throughout the day. Of course, you'll want to have fun on the rides, too, so make time for both kinds of activities. I'm fortunate enough to live near a major theme park and generally purchase season passes for my entire family. We visit the park to enjoy the rides during May and June, when the number of visitors is smaller and the lines are shorter. Then, in July and August, we wait until evenings for our return visits, because many folks are headed home by then. I'm usually able to fit in a couple trips to the park to do nothing but shoot pictures, too.

In the morning, when crowds are smallest, explore the park and

photograph any animal life that populates the place. Even parks that don't feature animals will usually have ducks, hungry pigeons, peacocks, rabbits, or other fauna wandering around. This is a good time to photograph flora, too. You'll find decorative flower plantings worthy of a floral exhibit scattered around many parks.

By mid-day you'll be ready to photograph some of the rides and structures in the park. Roller coasters, Ferris wheels, the various rides that go around and around in stomach-jerking ways all lend themselves to dramatic wide-angle shots (see Figures 7.6 and 7.8) or close-up telephoto pictures that reveal the stark terror on the faces of the riders.

Rides are also fun to photograph late in the day, when dramatic shadows provide interesting patterns, and after dark when the park is lit with bright bulbs and neon tubes. This is the time to experiment with longer exposures that can create interesting light trails (see Figure 7.7). I usually have no problem bringing a tripod into an amusement park, but you can also use clamps with a tripod screw that fasten to any

railing or other support. Don't forget the last moments of the day, when the park vendors are hawking those glow-in-the-dark tubes or offering specials on cotton candy. Weary but content park visitors, possibly wearing those silly hats they purchased on a whim, can make some great candid pictures.

Figure 7.6 This support structure for a roller coaster offered an interesting pattern that's bound to prompt a few "what's that?" queries.

Figure 7.7 A time exposure of several seconds with a tripod-mounted camera produces this interesting light trail of a rotating Ferris wheel.

Figure 7.8 The same Ferris wheel captured earlier in the day, using surrounding trees as a frame, produces another interesting pattern.

Architecture

Architectural photography can be a specialized art with complex rules and strict standards. That doesn't mean you can't have fun with it, too. You can picture interesting buildings and monuments as you travel, photograph architecturally important buildings in your own town, shoot interior photos of finely appointed rooms, or document the less finely decked-out rooms of your own home.

The keys to effective architectural photography include (usually) a good wide-angle lens that helps you capture your subject even when your back is to the wall or up against another building. Indoors, you might want some supplementary lighting to augment the available illumination. You'll want to use a small aperture to maximize depth-of-field, and because the light isn't always the best, a tripod can help steady your camera for a long exposure.

Another challenge to overcome is perspective distortion, which is

most often caused when you tilt your camera backwards to take in the top of a tall structure and end up with a "falling backward" look (see Figure 7.9). This effect is difficult to deal with in the field (sometimes you can find a higher place to shoot from, which can reduce the distortion), but can often be at least partially fixed in Photoshop or Photoshop Elements, using various perspective or lens distortion corrective tools.

One important aspect of architectural photography is the need to make what might be a staid old building look more interesting. You can do that by shooting from an unusual angle, perhaps even making use of perspective distortion to create strong diagonal lines in your composition.

Figure 7.9 The "falling back" type of perspective distortion in this shot was only partially corrected in Photoshop, making it not as obvious as it was in the original photo.

Great Themes

Another trick is to use surrounding buildings or trees to frame the structure (see Figure 7.10). As you learned in Chapter 6, a frame creates a 3D look that adds depth to the photo.

Indoors, you'll have to contend with one or more of the following lighting situations:

- Insufficient light. The illumination is so dim you're forced to make a long exposure with the camera mounted on a tripod.
- Uneven illumination. The light may be strong in one area of the interior and dim in another, making it difficult to evenly expose the entire image.
- Harsh illumination. Glaring lighting can give an image excessive contrast.
- ♠ Mixed illumination. You may have daylight streaming in the windows, mixing its blue light with the orangish incandescent illumination of the room, added to a green glow of a fluorescent tube.
- Off-color illumination. The light in the interior may be distributed evenly, diffuse, and pleasant—and entirely the wrong color, thanks to fluorescent lighting or, worse, colored illumination.

Your digital SLR's white-balance controls might or might not be able to correct for this problem.

Using a tripod, adding supplementary lights or reflectors, closing the blinds or curtains in an unevenly lit room, or turning off the room lights entirely to eliminate mixed light sources can all be used to fix these predicaments.

Figure 7.10 Use trees, plantings, or, in this case. arbors to frame your building and draw the eye to it.

Candid Photography

Candid photography is at once easy and difficult. It's easy because you'll find subjects for unposed photographs everywhere, and you generally won't need to do any "directing" to arrange your subjects. Having your victims simply be themselves can yield some great pictures. However, candid photography is also tricky, because you must avoid disrupting those very activities you want to capture. People can be on guard and not act naturally if they are nervous in a photographer's presence, so it's your job to blend in and become part of the activities, taking your candid photos in such a way that it's no big deal.

Another key to effective candid photography is knowing exactly when the best moment to take the picture is. You need to be prepared for the unexpected, as I was when a fellow dressed in a regal costume happened to walk across a public square, appar-

ently on his way to an acting job (see Figure 7.11). He wasn't part of a parade and no other actors were visible, and I found his incongruent presence interesting, so I snapped away.

I was more prepared to snap the photograph of a high school play (shown in Figure 7.12), as I'd seen the dress rehearsal the night before, and knew that this moment from "The Marriage of Figaro" when the title character suddenly discovers who his real mother is would be great. Although you can take as many photos in a candid setting as you want, you'll also want to be selective, both to get better pictures and to avoid turning an interesting situation into a "photo session."

Candid photography requires patience in finding just the right scene and moment, and a bit of luck. I set up my camera on a tripod, used a small f/stop and

slow (1/2 second) shutter speed to photograph city busses racing past. The bus was blurry (as I expected), and I had to take a few dozen different shots over the course of half an hour or so (as many busses passed) to get a picture with the passersby blurred a little, but not completely, as you can see in Figure 7.13.

You'll find candid photography is a great opportunity to catch people in unguarded moments doing interesting things.

Figure 7.11 This fellow popped up out of nowhere and, not being garbed like the rest of the crowd, added some humor to this candid photo.

Figure 7.12 Plays and presentations—although well rehearsed—still have an unposed look to them if you take your picture as the action unfolds.

Figure 7.13 Dozens of shots were required to get this candid photo of passersby with a blurry city bus behind them.

Child Photography

Kids are always good for some interesting photos. Some are painfully shy, but most will turn into natural hams if they know you. Children who are at the "I want to be at the center of attention" phase (which lasts until about age 24) love to be photographed. It's the photographer, not the camera, that may intimidate them. So, your job is to make them comfortable with you, which is no challenge at all if you happen to be a parent, a bit more of a task if you're a relative (especially one who doesn't see the kid regularly), and downright difficult if you're a stranger who wants to photograph somebody else's cute kids.

Here are some tips for successful child photography:

- Use props. A favored toy the child can hold as you're taking his or her photograph can put the child at ease, plus it gives you something to talk about as the kid explains to you what he likes about that particular toy.
- ◆ Shoot from the child's level.

 There's a tendency for adults to shoot children from a slightly elevated level. Getting down on the floor at the child's perspective can yield much more natural-looking photographs. Try out new poses, too, for a different look (see Figure 7.14).

Figure 7.14 Try new poses in addition to the standard ones. It never hurts to let the child suggest a few.

- ◆ Three's company. If the child is not your own, he or she will be more comfortable if Mom or Dad or a sibling is around. The trick is to make sure the child talks to you most of the time, rather than the other members of the family. You want the child to be at ease, but not busy looking away from the camera while chattering with another person.
- No new clothing. Avoid the temptation to dress the child in brand new clothing just for the photo shoot. Find something nice, clean, and well pressed so the kid will look good but not feel like he's dressed up in a "monkey suit" for the picture. Similarly, a recent hair-cut properly combed or brushed will look better than having every hair in place from that morning's trip to the stylist.
- ◆ Don't say cheese! Teenagers, in particular, may be self-conscious about their smiles, especially if they are wearing braces. If they prefer to smile rather than grin, don't force the issue (see Figure 7.15). Otherwise, your subject will end up being uncomfortable and that will show in your photos.

Figure 7.15 For an endearing photo of an older child, let your subject decide whether to smile, grin, or present a more serious mien.

Concerts—Live!

Nothing beats the enthusiasm and interaction of an audience with live music, and concerts are an opportunity to capture the visual excitement that doesn't begin to show up in audio recordings of even the most dynamic performance. Whether you're photographing an internationally known recording artist, or an up-and-coming act that may—or may not—make headlines some day, you'll find that concerts are a great way to take creative photographs.

There's one overriding challenge to this kind of photography: getting close enough to take pictures in which the performers are more than a rumor. Most of the time, stadium shows are a waste of time, even if you have primo seats, and in such venues you're likely to get jostled so much that your photography will suffer. Your best bet is at smaller theaters and clubs where getting up close is not a problem. For the five or six

concerts I photographed in the last year, I specifically tried for a second- or third-row aisle seat, because it was far enough to the side that I could get a good view of the performers and not so close that all the photographs were of the underside of their chins. To get those seats I had to order far in advance or, for general admission shows, arrive a couple hours early so I'd be first in line for the mad dash to the front. Here are some other things to watch out for:

- Microphones. It's odd, but you don't notice the microphones on stands much when you're watching a concert, but they intrude quite awkwardly when you take photos. At general admission shows I've actually switched seats so I could have a clear view of the performers, as you can see in Figure 7.16.
- Metering. You'll probably want to switch your dSLR from Matrix or Center-Weighted metering to Spot metering, and then lock in the correct exposure as you frame your pictures. It's often a good idea to

Figure 7.16 It's difficult to get a clear view of some performers. Getting up close can let you maneuver so the microphones and other paraphernalia aren't a major part of the photograph.

- use your camera's exposure meter to determine the correct exposure, but set it manually to avoid slight changes as your subject moves around in the frame.
- ◆ Changing light. It's very common for the light to change dramatically during the course of a show, from bright white spotlights to blue or red key lights to set a mood. Each individual performer may be lit differently, too, perhaps with a stronger light on a musician performing a solo, and lights at a lower level or of a different color on the other performers. Even if you're using automatic exposure, be prepared to adjust your settings as the evening goes on.
- Available light. If you have a sharp prime lens, like the 85mm f/1.8 lens used for Figure 7.17, don't be afraid to use it wide open. The large f/stop and shallow depth-of-field concentrates attention on the soloist (in this case the guitar player), while allowing the other musicians to be part of the composition even though they are softly blurred. As a bonus, the large f/stop may let you shoot at a fast enough shutter speed (1/160th second in this case) to provide a sharp image without the need to resort to a high, noiseinducing ISO setting.

Figure 7.17 Shooting wide open at f/1.8 puts all the emphasis on the guitarist, while the other players are in soft focus in the background.

eBay and Auction Photography

Online auctions like eBay are a areat way to sell your old photo gear so you can buy new stuff, or to free up some space in your garage by turning your unwanted trash into treasures that others will pay you to take off your hands. Some folks even make a living from these auctions, selling specialty items like the porcelain figurine shown in Figure 7.18. I've managed to fund my lens lust by selling several old film cameras and some lenses that aren't compatible with my dSLR. As sellers gain experience on eBay, they learn that a good photo goes a long way towards selling an item for the highest price. But, I'll bet you probably guessed that already.

But isn't a dSLR overkill for eBay photography, as most of the images will be no larger than about 600×400 pixels (in order to fit on the greatest number of browsers within a typical auction page format)? Not at all. If you shoot your auction pictures at a resolution higher than the final size, you can crop the picture freely before shrinking it down to its final size. A larger initial image will frequently have a longer tonal scale (the range of bright to dark tones) and better colors. Your dSLR's images will almost always look better at smaller sizes than one originally taken with a lowresolution camera.

Of course, larger images hold up to retouching and other manipulations better. You can adjust the brightness/contrast or balance the color of your auction pictures more thoroughly to arrive at a better-finished image. Here are some tips for creating smallformat images that look good on an auction page.

- ▶ Don't waste space. If your photo is going to end up no larger than 600 pixels wide, make sure that every one of those pixels is devoted to important image information. Arrange your picture setup carefully, choosing an angle that packs the most attractive view of your merchandise into a tightly composed shot. If necessary, crop your photo closely in your image editor to trim away the fat. Figures 7.19 and 7.20 show tightly cropped images that waste no space.
- Use a plain background. The example photos also use a plain white background that blends in with the auction page. A busy background distracts viewers from your product.
- Focus carefully. A sharply focused image taken at a small f/stop with plenty of depth-of-field makes the most of the available resolution in the final image. A

- sharp 600×400 image will look much better than a blurry or poorly focused 600×400 image, even though the resolution is identical.
- Use higher contrast effectively. Higher-contrast lighting or boosting the contrast in your image editor can make your image look brighter and sharper.
- ◆ Increase color richness. Digital SLR cameras and image editors have a color saturation or "vividness" setting you can use to make your image look more attractive. If the colors of the merchandise are important (clothing or dinnerware, for example) or extra bright colors can be misleading (old faded pulp magazines), use this adjustment sparingly.
- ◆ Show all sides of your item. In addition to the front and top views of the Olympus camera I sold on eBay, I also presented a back view, plus one of the inside of the camera showing the film channel. The more information your buyer has about your product, the more likely he or she is to bid the maximum amount.

Figure 7.19 This camera was shot on a plain white background, which is less distracting than the blue background used in the previous shot..

Figure 7.18 This porcelain figurine was lit with window light so that there were plenty of specular highlights to show its texture.

Events

By definition, events are happenings of limited duration, whether they are Olympic festivities, car shows, Civil War re-enactments, local celebrations, or even a wedding or two. They're great photo opportunities, because they often involve festivals, costumes, pageantry, and things you just don't see every day. That's why they are "events."

The important thing for shooting pictures at events is to plan ahead. You might want to scout parade routes in advance, see what kind of lighting might be in use, and understand any restrictions that will limit your access to the subjects that interest you most. I've been at events where no tripods were allowed, where finding a shooting position was subject to "first come, first served" mandates (there was no special shooting area for photographers), and where time limitations made getting a variety of pictures tricky.

You'll absolutely want a copy of the event schedule. Many events have their own website where you can peruse the schedule in advance, which can be helpful for multiday events like Renaissance Faires or Civil War re-enactments. You might want to attend only on a specific day, perhaps to catch a jousting tournament in full regalia, or to witness (and photograph) a climactic battle.

If you're going to be at an event for a full day or the duration, arrive early. Introduce yourself to the security staff (or write in advance) so they'll know you're not a wacko and will be more likely to tolerate your presence. Sometimes I show up while equipment is still being unloaded from trucks, mixing with the staff, but staying out of the way, so I become just another member of the crew. On one occasion, I even had to vouch for the local newspaper photographer, who arrived late, went to the wrong entrance, and forgot his credentials!

Figure 7.21 Hot air balloon lift-offs are often part of the festivities at many events. If staged in late afternoon, they can be thrilling and full of photo opportunities.

Figure 7.22 Car shows are great for photography, even if you're not a car buff, because there are always magnificently restored vehicles and some astounding customized automobiles to photograph.

Figure 7.23 Civil War re-enactments always have exciting battle scenes that make for an interesting trip back in time.

Fireworks and Aerial Pyrotechnics

Fireworks are fun to shoot, and it's easy to get spectacular results. They're not even as seasonal as they once were. You can expect to find fireworks and aerial pyrotechnics on the Fourth of July, of course, but many sports organizations, particularly baseball teams, offer fireworks nights after special games, as a promotion to get families to come out to the ballpark. Some amusement parks have fireworks shows as entertainment at the end of the park's day, in this case as an inducement to stay longer and buy more of those refreshments and souvenirs.

The biggest challenge when shooting fireworks is getting to actually see the fireworks yourself. The show is likely to be of limited duration—perhaps 10 or 15 minutes—so you'll be busy trying to take the maximum number of shots in the minimum amount of time. It's easy to become engrossed in the operation of

- your camera and miss the big show yourself. If you plan ahead and have your camera set up properly, you can usually relax and press the shutter release at appropriate times and actually view the show. Here are some tips for photographing fireworks.
- ◆ Take your tripod. Fireworks exposures usually require at least a second or two, and nobody can handhold a camera for that long. Set up the tripod and point the camera with your lens set at a normal or wide-angle focal length (depending on how much of the sky will be filled with pyrotechnics), and be ready to trip the shutter.
- ◆ Timing is everything. Watch as the skyrockets shoot up in the sky; you can usually time the start of the exposure for the moment just before they reach the top of their arc. With the camera set on time exposure, trip the shutter using a remove release (or a steady finger) and let the shutter remain open for all or part of the burst. Usually an exposure of one to four seconds works.

- ♠ Review and adjust. Look at your shots on your dSLR's LCD and, if necessary, adjust your f/stop so you don't overexpose the image. Washed-out fireworks are the pits. At ISO 100, you'll be working with an f/stop of about f/5.6 to f/11.
- Experiment with color filters. I held some color filters in front of the lens for part of the exposure shown in Figure 7.24, adding a purple tone to the white-tinted blasts.

Figure 7.24 Color filters held over the lens added this purple glow to the fireworks.

- ◆ Don't fret over noise. Even if you're using a relatively low ISO, you can end up with some noise because of the long exposures required. Fortunately, noise in fireworks really doesn't distract much from the picture. Don't use your camera's noise-reduction feature, either, as the extra processing time may cause you to miss the next display.
- ▶ Take a penlight. A handheld light source can help you check your camera settings and make manual adjustments, even if your dSLR has backlighting for the monochrome LCD status displays, and the back panel LCD is big and bright. You still might need some light for other tasks, such as mounting your camera on the tripod or changing digital memory cards.
- ◆ Use long exposures. Try leaving your shutter open for several sets of displays. Cover the lens with your hand between displays to capture several in one exposure, as shown in Figure 7.25.
- ◆ Use your image editor to combine displays. Figure 7.26 was assembled in Photoshop using bursts from several different images (note that the display in the lower-left corner is the same as the one at left in Figure 7.25). You can create a more exciting picture by filling up the sky with bursts.

Figure 7.25 Long exposures allow capturing more than one burst in a single photo.

Figure 7.26 Photoshop can be used to populate your fireworks photos with displays from several different images.

Lush Landscapes

You may love sports photography, be enamored of pictures of animals, and fairly fond of taking pictures at night, but it's the landscapes that you probably blow up to huge sizes and hang on your walls. With the exception of portraits of people (of all ages), and pictures of personal pets, perhaps no other type of photography gets printed up and proudly displayed. Your travel pictures of the Eiffel Tower or Statue of Liberty make it into albums, and you show your sports photos around to your friends, but you're probably proud enough of your landscape photos to hang them on the wall.

There are good reasons for that. Nothing beats Mother Nature for natural beauty. Most scenes have charm, unless humans have intruded to spoil the landscape. Scenic photos have a kind of neutrality to them, too. Unless you have extraordinarily cute children or a spouse who could be

employed as a model, most folks will enjoy your portraits of them in direct proportion to how well they know them. As much as you love your portrait subjects, unless the photography itself is extraordinary, viewers might actually find them boring.

Not so with landscape photos. There are fewer personal feelings about the subject matter to interfere with your viewer's response to your scenic pictures. Everybody loves the Grand Canyon, or purple mountain

majesties (see Figure 7.27), or a well-presented photo of trees dressed in their Fall colors (see Figure 7.28). If you shoot landscapes, you've got a ready audience for your work anywhere you go.

Figure 7.27 Photos of distant subjects can sometimes be improved by using a haze filter to cut through the blue haze seen here.

Any digital SLR can do a good job with landscape photography. It's not complicated. Just find yourself a suitable subject, use a lens or zoom setting suitable for capturing it (wide angles often work best), and choose an exposure that provides a good combination of f/stop for a healthy amount of depth-of-field (if foreground objects are to be included) and a shutter speed that will stop camera shakiness

You don't need a lot of gadgets or tools, but here are a few to think about, with most of them being filters of one sort or another:

from spoiling your shot.

- ◆ A tripod. Thankfully, you can shoot most landscape photos in daylight without a tripod, but, if you think your shot will be worth enlarging to jumbo size (say 20 × 24 or larger), you might want to use a tripod anyway to maximize sharpness.
- A polarizing filter. A filter of this type can remove reflections from any water in your landscape photos and deepen the color of the sky, providing an overall more satisfying image.

- ♠ A split-density filter. One problem with landscape photos is that it is difficult to get a good balance between the bright sky and darker foreground. There are special split neutral density filters that are dark on one half and clear on the other. You can orient the filter so the dark half covers the sky and reduces its intensity, while the lower, clear half lets the terrestrial part of your photo show through in all its glory.
- A neutral density filter. Snow or beach scenics can be excessively bright even when you use the

smallest f/stop and fastest shutter speed. If your digital SLR has a super-fast speed like 1/8000th second and a low sensitivity setting like ISO 50 or ISO 100, you probably won't have this problem. But, there are dSLRs with a 1/4000th second top speed and ISO 200 minimum sensitivity setting which, when used with a lens that has an f/stop no smaller than f/22, may limit your exposure choices. In addition, there are times when you don't want to use such a high shutter speed or small f/stop for techni-

- cal or creative reasons. A 2X or 4X neutral density filter will cut down on the light by one or two f/stops (respectively).
- ♠ A haze filter. Distant subjects force you to shoot through more layers of atmosphere, and the intervening haze might not be to your taste. A haze or skylight filter can be useful for cutting through the "fog" (in some cases it probably is fog) and restoring contrast to your image.

Figure 7.28 Set the Saturation control of your dSLR on "high" to brighten up the colors of your fall landscapes.

Macro Photography

Close-up or macro photography is a year-round activity that enthralls many photographers because of the unique opportunities it provides to explore new techniques and to find subjects even in commonplace objects. In spring, you can venture outside and shoot close-ups of flower buds as they emerge, or take macro pictures of insects and small animals as they build homes for the summer. Then, during the hot months, you can find whole worlds of tiny objects to shoot at the seashore or in your own backyard. When fall arrives, interesting photos can be captured in close-ups of leaves as they change color, tight shots of pumpkin carvings, or maybe in those decorated sugar skulls you or your kids prepared for Dia de los Muertos (Day of the Dead) festivities that have grown popular as schoolchildren of all backgrounds study Mexican culture.

And, of course, in the winter you can explore photography of your hobby collections or find interesting subjects in common household objects. Indoor macro photography is possible during the rest of the year, too, but those of us who live in chilly climates find it especially rewarding when the weather is cold.

If you own only basic dSLR equipment, you'll probably need a few gadgets to get the most out of this kind of photography. Here are some of the best accessories to consider:

◆ A close-up lens. The term can be applied, confusingly, to two different kinds of accessories. A traditional close-up lens is a filter-like attachment that screws onto a thread on the front of your lens, and allows it to focus even more closely—down to a few inches away. These can cost \$50 or less, and are available in several different magnifications that can be used singly or together. Another kind of close-up lens, more commonly called a *macro* lens, is an actual lens that replaces the one on your camera, and allows focusing more closely and without the loss of sharpness that the filter-type attachment can cause.

Figure 7.29 An extension tube and reversing ring allowed this extreme close-up of a dandelion.

- ◆ Extension tubes and reversing rings. These let you get really close, as you can see in Figure 7.29, which required both an extension tube (which moves the lens farther from the sensor so it can focus more closely) and a reversing ring, which makes it possible to point the lens mount end of your lens towards your subject. This provides even greater magnification and improved sharpness.
- ▶ Lighting equipment. To get the best results from your indoor macro photography, you'll want to use several lights that can be positioned to illuminate your close-up subjects in creative ways. The lighting equipment doesn't have to be complicated. For Figure 7.30, two high-intensity lamps were used to illuminate the rose. You can also use electronic flash, which might be your best choice outdoors when you need to fill the shadows or provide basic illumination for your close-ups.

A variety of backgrounds.

When you're shooting indoors, you may need to provide a plain background that doesn't clash or compete with your subjects, as in Figure 7.31, which used a piece of white posterboard as a background for the seashells. Outdoors, you can also use posterboard as a background if you like, but you may enjoy working with the natural surroundings instead.

Figure 7.30 Even simple high-intensity desk lamps can be used for lighting close-ups.

Figure 7.31 Even common objects can make good macro subjects. All you need is a handful of seashells and a piece of white posterboard as a background.

Moon Shots

If you want to impress your friends with the long reach of your telephoto lens, show them a few pictures of a subject located almost a quarter of a million miles away! I'm talking about our friend the moon, of course. which, in one sense hasn't really changed visibly in a few million years, but in another sense looks a bit different every night of the month. The challenge is to take photos of the moon using your own creativity to come up with a photo that's a little bit different from the millions of pictures that have already been taken of our orbital neighbor.

Shooting the moon is remarkably easy. Because it's illuminated by the same sun that brightens our landscape during daytime, the same "Sunny 16" exposure rule that photographers have relied on for dozens of years can be applied to an object which is,

after all, difficult to meter properly with your dSLR's exposure system. (Even if you use spot metering.) You can usually get good exposures of the moon with the Sunny 16 rule, using f/16 and the reciprocal of your ISO setting for starters. At ISO 400, you'd use 1/400th second at f/16. Of course, you'll be using a telephoto lens, which magnifies camera shake, so if you're not working with your camera on a tripod, you'd probably want to use an equivalent exposure with a higher shutter speed, such as 1/1600th second at f/8.

With the camera on a tripod, it would be a good idea to use a slightly slower shutter speed, such as 1/400th second, a slightly "better" lens opening (if you're using a zoom or telephoto with, say, an f/5.6 maximum aperture), such as f11, and drop the ISO down to a less noise-prone setting, like ISO 200. It would

also be wise to bracket your exposures one stop more or less to account for differences in camera calibration and/or a bit of haze in the atmosphere.

Although the moon may seem huge to you near the horizon, most (but not all) of that perception is an optical illusion. In reality, it subtends about 0.5 degrees, or about 1/360th of the total celestial hemisphere we can see at one time. That means you need a fairly long lens to register the moon at any appreciable size. A 400mm lens has enough magnification to produce an appreciably sized disk on your sensor, but you'll still have to crop heavily and enlarge your image to have the moon appear sufficiently big in your photos. (Your camera's crop factor has no effect on the size of the moon's disk on your sensor, but the larger your crop factor, the more excess pixels are trimmed from around it.)

One thing you might find annoying is that you won't see any stars surrounding the moon in your photos. The moon itself requires an exposure measured in fractions of a second, while the stars require several seconds or even minutes to register on your sensor. One solution is to shoot two photos: one, a traditional moon shot, plus a second, a longer time exposure of the star field. You'll want to boost the ISO setting of your camera and use a wide-open aperture to minimize the length of your star photo exposure, because the stars (as well as the moon) are moving across the sky as the Earth rotates on its axis. Exposures of heavenly bodies of any appreciable length of time (measured in seconds) produces a blurring effect, unless a tracking device called a clock drive is used to maintain the lens in sync with the movement.

You might actually want these star trails in your photos. You could even point your camera at the North Star to center the trails around it. Or you could just take a star photo using the shortest exposure time you can get away with and combine that picture with your moon photo. There are also techniques for simulating stars in Photoshop without any stellar objects involved at all. I'll leave you to guess exactly which method was used for Figure 7.32.

Moon pictures can also be taken in full daylight, of course, as in Figure 7.33. The contrast between the moon and the sky is lower, but can be quite interesting.

Figure 7.32 A double exposure, combining the moon and a background of "stars" produces a familiar look, even though it's actually impossible to photograph by ordinary means.

Figure 7.33 You can shoot the moon in full daylight, too, producing an interesting blue background.

Night Photography

Photography at night is challenging because there's so little light to work with. Subjects that look familiar in the daytime become dark and mysterious at night. You can photograph these subjects using the light that is there, or supplement that with electronic flash, extra lamps, or even a flashlight. You might need high ISO settings to capture an image at all, or you might require a tripod so you can use longer exposures. Night photographs can look moody and foreboding or include streaks of light that give them a Las Vegas or Great White Way excitement.

There are lots of different techniques you can use to shoot at night. Figure 7.34 relied on nothing more than the existing light and a long exposure with a tripod. This can be an interesting way to go on several counts.

One by-product of long exposures like this is that pedestrians walking through your photo won't

remain in one place long enough to even register in the image. There actually were people passing in front of this cathedral when I took the picture—you just can't see them.

Add some vehicles with headlights and taillights into the mix, and you end up with photos like those in Figure 7.35 and 7.36. These are two more tripod shots, but the automobiles in each photo left a trail of streaks behind. For Figure 7.35 I mounted the camera on a tripod on a hill overlooking a city center. You can see every streetlight, the streaks of light from the cars, and even an illuminated fountain at lower-right center. For Figure 7.36, I set up my camera on a tripod in the center of the bustling

Figure 7.34 A long exposure at night yielded this photo of a Medieval cathedral, illuminated only by the spotlights on the structure itself.

metropolis (pop 10,000) closest to my home. I probably could have set up in the middle of the street without being in any danger. The exposure was several minutes—if you look you can see the stop light has all the colors except for yellow (in one direction) showing.

Another technique is to "paint" with light. The tripod-mounted camera and long exposure is the same, but during the exposure you, or an assistant, race around with an electronic flash (popping it off manually) or a broad-beam flashlight, illuminating your subject as if painting. If the painter keeps moving and keeps his or her back between the light source and the camera, only the results of the painting will show up; the artist will be invisible.

Figure 7.35 When vehicles are visible in a scene, their headlights and taillights will cause streaks during a long exposure.

Figure 7.36 If your town is as quiet as this one, you may need an exposure of several minutes to get any taillight streaks.

Nature Photography

There's a lot of overlap among the categories discussed in this chapter. Under the heading of nature photography you can include macro photography, if you're shooting a spider; animal photography, should capturing deer strike your fancy; and you can include scenics under this umbrella. It's all nature. I included this catchall category because I wanted to show you a few more things that can be done.

One popular subject for nature photography is water, particularly waterfalls like the one shown in Figure 7.37. Waterfalls are especially beautiful, because the sparkling water passing over slick, washed rocks into a bubbling pool below can be entrancing. You can shoot most waterfalls from various angles, and using a variety of techniques. The figure shows a technique that has almost become a cliché because it's been used so much, but still is worth trying

at least once and possibly dozens of times in search of a new variation.

Simply put, the camera is placed on a tripod and an exposure of several seconds made. The rocks and background around the waterfall remain tack sharp, but the water itself is blurred, almost taking on a laminar flow appearance. It's a great look, and not difficult to achieve. The most challenging aspect is getting a long enough exposure. If you're shooting deep in the woods and out of direct sunlight, you might, on cloudy days, be able to shoot a picture at f/22 and perhaps 1/3rd of a second at ISO 100. Often, that won't be long enough to allow the water to blur. The common solution is to mount a

> One of the most wonderful aspects of nature is the array of beautiful colors that are presented to us each fall

neutral density filter on the lens, which will allow you to take a picture of several seconds' duration. A very dark, 8X (three-stop) ND filter is best. If you have several, you can stack them to reduce the light even more.

Another kind of nature photography is close-ups of small creatures like the spider shown in Figure 7.38. You'll need to be careful not to disturb the spider (if she moves much the web will vibrate), so a close-focusing longer lens (105mm or more) is probably a good idea. Indeed, the biggest problem with macro photography of natural subjects outdoors (after scaring away the ones that have legs) is avoiding or damping vibration that can make accurate focus and sharp photos impossible. If you're shooting flowers and other subjects that won't be frightened by the activity, it's often a good idea to set up windshields to block gusts. They can be something as simple as a few pieces of cardboard and have the added benefit of reflecting additional light on your subject.

Figure 7.37 A tripod-mounted camera and a long exposure yield a waterfall with a blurry rivulet of liquid pouring over the slick rocks.

Figure 7.38 Getting a photo of this nervous spider can be tricky, as sudden movements (by you or her) can start the web shaking, ruining your close-up.

Panoramas

Panoramas are another wonderful effect that gives you widescreen views of your subjects. They're usually used for scenic photographs, but can be applied to any kind of picture. For example, you could shoot the interior of a room in your home, showing all four walls smoothly merged into a single picture. It's usually easiest to shoot panoramas of landscape scenes, because your subject will remain fixed in place while you fool around taking the photo.

Panoramas can simply be "wide" photos showing, say, 100 degrees of a scene in a narrow strip, or can include 180 degrees or even a full 360-degree view if you have the inclination and technical wherewithal to accomplish such a feat. They often involve

shooting several pictures and stitching them together to create one wide view. There are several technical challenges to shooting panoramas. One of them involves the changing perspective of a camera that shoots a wide view of a single subject from one position.

When shooting panoramas, most find it useful to mount the camera on a tripod so the camera can be

smoothly panned from one shot to the next overlapping picture. Strictly speaking, the pivot point for multiple shots should be under the center of the lens, rather than the usual tripod socket location on the digital camera, but you should still be able to stitch together your photos even if you don't take the picture series absolutely correctly from a technical standpoint.

Figure 7.39 This image was created by trimming the top and bottom from an ordinary wide-angle photo.

A second challenge is the varying levels of illumination between individual pictures. Not only can the light change, but it's very likely that even if the light doesn't change during your series of exposure, not all angles of view will be lit in the same way. In either case, you may have problems matching up the individual pictures.

There are several ways to shoot panoramas. The simplest way is to simply crop the top and bottom of an ordinary photo so you end up with a panoramic shot like the one extracted from the full-frame picture in Figure 7.39. You'll get even better results if you plan ahead and shoot your original image so that no important image information appears in the

upper and lower portions. By planning ahead of time, you can crop your image as shown in Figure 7.40, and get a more natural-looking panorama.

Another way to shoot a panorama is to stitch together several individual photos. You take the first picture and then pivot the camera to take the next,

overlapping frames so you can match them to each other in an image editor. Photoshop CS 2.0 and Photoshop Elements have a panorama-stitching feature, but you can accomplish the same thing with utilities like ACDSee (or an equivalent program for Macs), as well as some programs furnished with digital cameras.

Figure 7.40 If you plan your picture ahead of time, you can create a panorama in which no important information appears in the top and bottom of the frame.

Portraiture

Portraits are a way of documenting our lives as we change and arow, showing us as friendly, glamorous, adventuresome, hopeful, or even sinister, depending on our whims and those of the photographer. Photographing people is certainly challenging, because everybody's a critic. You as the photographer not only have to please yourself with your results, you have to please the person you've photographed as well as everybody who knows that person. The photograph can't show your subject as they really are, but rather as they see themselves.

There are dozens of different kinds of portraits and people pictures: formal or candid; individuals, couples, or groups; family portraits; and fashion photography. Portraits can be photographed in a studio or shot on location for "environmental" portraits. But all have one thing in common: The arrangement and lighting tell us that this is a portrait, a deliberate representation of one or more persons.

To shoot effective portraits with your dSLR, you need certain basics:

- ♦ Lots of megapixels. The higher the resolution of your dSLR, the larger you can make your prints and the more editing you can do on your photos. If you're hoping to make 20 × 30-inch prints to hang over the mantle, you'd better have an 8–12 megapixel camera, or better!
- ♠ A short to intermediate telephoto lens. Individual humans look their best when photographed with a moderate telephoto lens, in the 85mm to 100mm range (or the equivalent to that range on a full-frame camera if your dSLR has a crop factor, such as a 60mm to 85mm lens). If you're shooting a

Figure 7.41 Window light provided the main illumination for this casual portrait.

full-length portrait, or picturing several people in one shot, the shorter end of the range, or even a normal (50mm equivalent) focal length can be used. Anything wider can distort the features of your subjects, especially when used up close. Noses look larger compared to the ears, and faces may look too thin. Longer focal lengths can compress the features, causing a face to look wider.

A light source. Or two. Or three. Multiple light sources are often used in portraiture to provide shape and texture to the face. One "main" light will illuminate part of the face, with a "fill" light used to brighten shadows. Additional lights can add some sparkle to the hair or light up the background. Learning to use light sources effectively can be half the challenge of learning how to shoot portraits. While good portraits can also be taken using nothing more than the light that's present in the scene (see Figure 7.41) working with artificial lights—either flash or incandescent-provides a greater degree of control and the opportunity to use light itself as a creative tool.

A background. Portraits work best if the background isn't busy. cluttered, or distracting, as you can see in Figure 7.42. Outdoors, you can often find a background in nature, such as trees, the sky, or a cliff. Indoors, the background can be a blank wall, a shelf of books, or a special background designed especially for portraiture. You'll find that simply adjusting the amount and type of light that falls on your background can change its appearance. Make it lighter to provide separation between a dark-toned subject and his or her surroundings, or darker for a lighter subject. You can purchase backgrounds for use in a studio. buy rolls of seamless paper, or make a background yourself.

Figure 7.42 Three lights were used for this portrait: a main light off to the left, a fill light at the camera position, and a background light to brighten the backdrop.

Still Lifes

Still-life photography is a little like macro photography, but from farther away and, perhaps, with a bit of specialization towards bowls of fruit and the like. Artists love to create still-life paintings because they cherish the chance to paint infinitely patient threedimensional subjects that will challenge their skills and give them a chance to try out various techniques, without worrying that the "model" will get tired and leave. Georgia O'Keefe was a master of the still life, and even Andy Warhol's soup can paintings are based on the concept.

Photographers can use the same kind of subjects to demonstrate that they are masters of arrangement and light, and the other components of successful still-life imaging. Of course, your models aren't limited to bowls of fruit or flowers (see Figure 7.43). Any collection of objects can be used

Figure 7.43 A box of crayons, photographed from above and lit from one side, produced this pattern arrangement.

Great Themes

effectively in a still-life arrangement. You can grab a box of crayons and play with lighting and color and framing until you get the exact effect you want. Or, you can fill a cocktail glass with hot peppers (see Figure 7.44) and adjust them until the colors or curve of the stems provides a pleasing composition.

I placed the glass on a plain white posterboard background and lit it with electronic flash bounced off umbrellas. I tried various angles and lighting effects to arrive at this shot. Replace the peppers with a lemon or lime, change the lighting a little, and you have an entirely new still-life arrangement. These kinds of photos combine the intimate shooting distances of macro photography with the careful lighting and "posing" techniques of portraiture. Indeed, still-life photography is excellent training and practice for both.

Figure 7.44 Still lifes traditionally consist of flowers or fruit, often in a basket, but there's a whole cornucopia of possibilities to explore.

Sunrises and Sunsets

Sunsets and sunrises are beautiful, colorful, and often appear to have been carefully planned, even though that's not usually the case. Most of the time, we happen to be in a particular location at the right time of day, look over at the setting (or rising) sun, and realize that the view is stunning. We snap away, and end up with a dramatic photo that makes us look like better photographers than we really are. That's why some photographers actually specialize in them.

Sunrises and sunsets can look almost identical; although, depending on the weather conditions, they often are not. Sunrises, like the one shown in Figure 7.45, take place after the cool of the night, when the Earth and its creatures are just waking up and becoming active again. There's often a light fog or haze as the sun warms and evaporates the dew.

Sunsets, on the other hand, often occur after a hot day. The air can be warmer and dryer and the sky clearer. As a practical matter, sunsets are easier to prepare for, as you have at least a modicum of light to work with in setting your camera until the actual sunset takes place. Here are some tips for shooting sunrises and sunsets.

 Experiment with white balance and exposure.

Experiment to see what white balance you want to use and bracket your exposures. You'll want a warm tone that isn't neutralized by the white-balance control and an exposure that will let you take advantage of the backlighting provided by the sun. With sunset photos, you generally want a dark,

- silhouette effect punctuated by the bright orb of the sun.
- ◆ Don't stare at the sun, even through the viewfinder. I usually compose my sunset photos with the sun slightly out of the frame, then recompose just before taking the photo. Often, I'll set the camera on a tripod and just press the shutter release when I see a composition I like.

Figure 7.45 Photos at dawn have a special quality, often quite different from photos taken at dusk.

- Avoid splitting your photo in half with the horizon in the middle. Your picture will be more interesting if the horizon is about one-third up from the bottom (to emphasize the sky) or one-third down from the top (to emphasize the foreground) (see Figure 7.46). Remember the Rule of Thirds.
- Sunsets don't have to be composed horizontally!
 Vertically oriented shots can be interesting.
- Experiment with filters. Star filters, gradients, or other add-ons can enhance your sunset pictures. You don't even need a star filter if you use a small enough lens aperture. At tiny f/stops, bright light sources burst into star effects all by themselves.
- Shoot silhouettes. They're more dramatic (see Figure 7.47).
- Focus at infinity. Sunsets can fool the autofocus mechanisms of some cameras. Use manual focus if you can't get the autofocus to focus at infinity.
- Have your tripod handy. The closer you are to actual sunrise or sunset, the longer the exposure. If your camera is mounted on a tripod, you can still get a good shot when the sun is behind some trees or buildings or below the horizon.

Figure 7.46 Place the horizon about onthird down from the top of the frame to emphasize the foreground.

Figure 7.47 Sunrises and sunsets make it easy to produce dramatic silhouettes.

Travel Photography

Vacations are a great time to take pictures. You're relaxed, ready to have fun, and have brought your digital SLR along to document every moment of your trip. When you get home, after spending thousands of dollars, all you'll have left are some treasured memories, a pile of souvenirs, and hundreds of photographs you can share with others.

In some ways, travel photography is an interesting blend of other kinds of photography in this chapter. It has elements of landscape and architectural photography. If you include family members in your photos, you can exercise your candid and portrait skills. There's lots of nature's wonder to picture, and urban life to capture.

But given all those opportunities, you should resist the urge to take along every possible piece of equipment you own. If you get weighted down by a ton of gear, you'll spend more time fiddling with gadgets than actually taking

pictures. I've traveled to Europe with just two digital camera bodies, plus a 12mm–24mm wideangle zoom, a 28mm–200mm "walk around" lens that covered most of the focal lengths I really needed, and a 105mm macro lens that I really didn't use very much.

The telephoto lens makes it easy to shoot subjects you can't get

close to, or details of interesting things such as statues or carvings, as shown in Figure 7.48. A wide-angle lens will let you capture architecture and monuments in situations where you can't back up far enough, take in wide vistas (see Figure 7.49), plus shoot interiors of interesting buildings.

In addition to your cameras and lenses, here are some other things to take with you:

Lots of memory cards. You'll want to have enough memory cards for at least a day or two's shooting. Plan on shooting twice as many pictures as you expect to. Your digital SLR makes it easy to snap photos, review them on the LCD, and then take more pictures. You'll end up shooting more photos

Figure 7.48 Telephoto lenses are great for capturing details and close-up looks at interesting sites while you travel.

from more angles than you expected, and your memory cards will quickly fill up. In a pinch, you can switch to a higher JPEG compression ratio (Standard instead of Fine, or whatever terminology your camera uses) to stretch your cards farther. But the best solution is to have lots of memory cards and some way of offloading photos from the cards you have at intervals so they can be reused.

A portable storage device.
 Because you'll probably fill up y

Because you'll probably fill up your memory cards quickly, a lightweight, battery-operated standalone storage device might be easier to carry and more practical than a huge complement of expensive memory cards or a laptop computer. Your best choice might be a portable DVD/CD burner so you can create several copies of each photo, but hard-drive based portable storage devices can work, too. If you already own a 20GB to 60GB Apple iPod, you can buy a card reader that plugs right in. Of course, hard-drive storage devices can crash, too, so this solution isn't perfect.

> Figure 7.49 A wideangle lens is a must for capturing vistas, such as this quaint lighthouse.

◆ A listing of cybercafés along your route. It's difficult to find a city of any size that doesn't have a cybercafé nearby. If you know in advance where you can find one of these handy rent-a-computer sites, you can leave your own computer at home and log onto one at the café to read your e-mail (if you must) or upload your photos (if you're smart). Just remember to take along your camera's USB cable or a USB card reader so you can link your camera or memory card to the café's computer. There are a couple drawbacks to this option. Although cafés are everywhere, there is no guarantee you can find one when you absolutely must have one. It's a better idea to compile a list before you leave. Nor can you guarantee that the

establishment will have a fast, broadband connection. You might have a dial-up connection that's great for e-mail, but not so great for sending multi-megabyte picture files. Finally, these outlets generally charge by the minute or hour, so uploading all your photos might prove expensive.

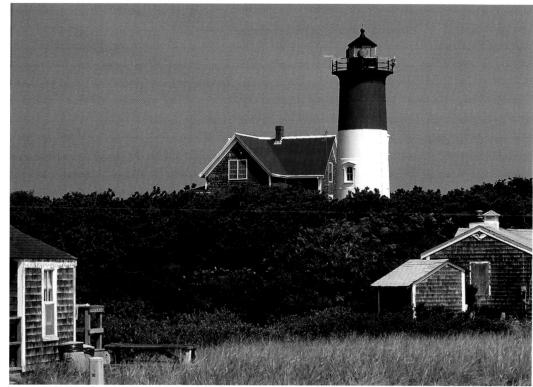

Glossary

additive primary colors The red, green, and blue hues which are used alone or in combinations to create all other colors you capture with a digital camera, view on a computer monitor, or work with in an image-editing program like Photoshop.

ambient lighting Diffuse nondirectional lighting that doesn't appear to come from a specific source but, rather, bounces off walls, ceilings, and other objects in the scene when a picture is taken.

analog/digital converter In digital imaging, the electronics built into a camera or scanner that convert the analog information captured by the sensor into digital bits that can be stored as an image bitmap.

angle of view The area of a scene that a lens can capture, determined by the focal length of

the lens. Lenses with a shorter focal length have a wider angle of view than lenses with a longer focal length.

aperture-priority A camera setting that allows you to specify the lens opening or f/stop that you want to use, with the camera selecting the required shutter speed automatically based on its light-meter reading. See also shutter-preferred.

aperture ring A control on the barrel of many SLR lenses that allows setting the f/stop manually. Some lenses have the aperture set by the camera only, and lack this ring.

autofocus A camera setting that allows the camera to choose the correct focus distance for you, usually based on the contrast of an image (the image will be at maximum contrast when in sharp focus) or a mechanism such as an infrared sensor that measures the actual distance to the subject.

Cameras can be set for *single* autofocus (the lens is not focused until the shutter release is partially depressed) or *continuous autofocus* (the lens refocuses constantly as you frame and reframe the image).

autofocus assist lamp A light source built into a digital camera that provides extra illumination that the autofocus system can use to focus dimly lit subjects.

Averaging meter A lightmeasuring device that calculates exposure based on the overall brightness of the entire image area. Averaging tends to produce the best exposure when a scene is evenly lit or contains equal amounts of bright and dark areas that contain detail. Most digital cameras use much more sophisticated exposure measuring systems based in center-weighting, spot-reading, or calculating exposure from a matrix of many different picture areas. See also Spot meter and Current-Weighted meter.

B (bulb) A camera setting for making long exposures. Press down the shutter button and the shutter remains open until the shutter button is released. Bulb exposures can also be made using a camera's electronic remote control, or a cable release cord that fits to the camera. See also *T* (*Time*).

back lighting A lighting effect produced when the main light source is located behind the subject. Back lighting can be used to create a silhouette effect, or to illuminate translucent objects. See also front lighting, fill lighting, and ambient lighting. Back lighting is also a technology for illuminating an LCD display from the rear, making it easier to view under high ambient lighting conditions.

ball head A type of tripod camera mount with a ball-and-socket mechanism that allows greater freedom of movement than simple pan and tilt heads.

barrel distortion A defect found in some wide-angle prime and zoom lenses that causes straight lines at the top or side edges of an image to bow outward into a barrel shape. See also pincushion distortion.

blooming An image distortion caused when a photosite in an image sensor has absorbed all the photons it can handle, so that additional photons reaching that pixel overflow to affect surrounding pixels, producing unwanted brightness and overexposure around the edges of objects.

blur In photography, to soften an image or part of an image by throwing it out of focus, or by allowing it to become soft due to subject or camera motion. In image editing, blurring is the softening of an area by reducing the contrast between pixels that form the edges.

bokeh A buzzword used to describe the aesthetic qualities of the out-of-focus parts of an image, with some lenses producing "good" bokeh and others offering "bad" bokeh. *Boke* is a Japanese word for "blur," and the h was added to keep English speakers from rhyming it with broke.

Out-of-focus points of light become disks, called the circle of confusion. Some lenses produce a uniformly illuminated disc. Others, most notably mirror or catadioptic lenses, produce a disk that has a bright edge and a dark center, producing a "doughnut" effect, which is the worst from a bokeh standpoint. Lenses that generate a bright center that fades to a darker edge are favored, because their bokeh allows the circle of confusion to blend more smoothly with the surroundings. The bokeh characteristics of a lens are most important when you are using selective focus (say, when shooting a portrait) to deemphasize the background, or when shallow

depth-of-field is a given because you're working with a macro lens, long telephoto, or with a wide-open aperture. See also mirror lens, circle of confusion.

bounce lighting Light bounced off a reflector, including ceiling and walls, to provide a soft, natural-looking light.

bracketing Taking a series of photographs of the same subject at different settings to help ensure that one setting will be the correct one. Many digital cameras will automatically snap off a series of bracketed exposures for you.

Other settings, such as color and white balance, can also be "bracketed" with some models.

Digital SLRs may even allow you to choose the order in which bracketed settings are applied.

brightness The amount of light and dark shades in an image, usually represented as a percentage from 0 percent (black) to 100 percent (white).

buffer A digital camera's internal memory which stores an image immediately after it is taken until the image can be written to the camera's non-volatile (semi-permanent) memory or a memory card.

burn A darkroom technique, mimicked in image editing, which involves exposing part of a print for a longer period, making it darker than it would be with a straight exposure.

burst mode The digital camera's equivalent of the film camera's "motor drive," used to take multiple shots within a short period of time.

calibration A process used to correct for the differences in the output of a printer or monitor when compared to the original image. Once you've calibrated your scanner, monitor, and/or your image editor, the images you see on the screen more closely represent what you'll get from your printer, even though calibration is never perfect.

camera shake Movement of the camera, aggravated by slower shutter speeds, which produces a blurred image. Some of the latest digital cameras have image stabilization features that correct for camera shake, while a few high-end interchangeable lenses have a similar vibration correction or reduction feature. See also image stabilization.

candid pictures Unposed photographs, often taken at a wedding or other event at which (often) formal, posed images are also taken.

cast An undesirable tinge of color in an image.

CCD Charge-Coupled Device. A type of solid-state sensor that captures the image, used in scanners and digital cameras. See also CMOS.

Center-Weighted meter

A light-measuring device that emphasizes the area in the middle of the frame when calculating the correct exposure for an image. See also averaging meter and spot meter. chroma Color or hue.

chromatic aberration An image defect, often seen as green or purple fringing around the edges of an object, caused by a lens failing to focus all colors of a light source at the same point. See also *fringing*.

circle of confusion A term applied to the fuzzy disks produced when a point of light is out of focus. The circle of confusion is not a fixed size. The viewing distance and amount of enlargement of the image determine whether we see a particular spot on the image as a point or as a disk.

close-up lens A lens add-on that allows you to take pictures at a distance that is less than the closest-focusing distance of the lens alone.

CMOS Complementary Metal-Oxide Semiconductor. A method for manufacturing a type of solid-state sensor that captures the image, used in scanners and digital cameras. See also CCD.

CMY(K) color model A way of defining all possible colors in percentages of cyan, magenta, yellow, and frequently, black. Black is added to improve rendition of shadow detail. CMYK is commonly used for printing (both on press and with your inkjet or laser color printer). Photoshop can work with images using the CMYK model, but converts any images in that mode back to RGB for display on your computer monitor.

color correction Changing the relative amounts of color in an image to produce a desired effect, typically a more accurate representation of those colors. Color correction can fix faulty color balance in the original image, or compensate for the deficiencies of the inks used to reproduce the image.

CompactFlash A type of memory card used in most digital single lens reflexes.

composition The arrangement of the main subject, other objects in a scene, and/or the foreground and background.

compression Reducing the size of a file by encoding using fewer bits of information to represent the original. Some compression schemes, such as JPEG, operate by discarding some image information, while others, such as TIF, preserve all the detail in the original, discarding only redundant data.

continuous autofocus An automatic focusing setting in which the camera constantly refocuses the image as you frame the picture. This setting is often the best choice for moving subjects. See also single autofocus.

continuous tone Images that contain tones from the darkest to the lightest, with a theoretically infinite range of variations in between

contrast The range between the lightest and darkest tones in an image. A high-contrast image is one in which the shades fall at the extremes of the range between white and black. In a low-contrast image, the tones are closer together.

crop To trim an image or page by adjusting its boundaries.

dedicated flash An electronic flash unit designed to work with the automatic exposure features of a specific camera.

density The ability of an object to stop or absorb light. The less light reflected or transmitted by an object, the higher its density.

depth-of-field A distance range in a photograph in which all included portions of an image are at least acceptably sharp. With many dSLRs, you can see the available depth-of-field at the taking aperture by pressing the depth-of-field preview button, or estimate the range by viewing the depth-of-field scale found on many lenses.

desaturate To reduce the purity or vividness of a color, making a color appear to be washed out or diluted.

diaphragm An adjustable component, similar to the iris in the human eye, which can open and close to provide specific sized lens openings, or f/stops. See also f/stop and iris.

diffraction The loss of sharpness due to light scattering as an image passes through smaller and smaller f/stop openings.

Diffraction is dependent only on the actual f/stop used, and the wavelength of the light.

diffuse lighting Soft, low-contrast lighting.

diffusion Softening of detail in an image by randomly distributing gray tones in an area of an image to produce a fuzzy effect. Diffusion can be added when the picture is taken, often through the use of diffusion filters, or in post-processing with an image editor. Diffusion can be beneficial to disguise defects in an image and is particularly useful for portraits of women.

diopter A value used to represent the magnification power of a lens, calculated as the reciprocal of a lens' focal length (in meters). Diopters are most often used to represent the optical correction used in a viewfinder to adjust for limitations of the photographer's eyesight, and to describe the magnification of a close-up lens attachment.

dodging A darkroom term for blocking part of an image as it is exposed, lightening its tones. Image editors can mimic this effect by lightening portions of an image using a brush-like tool. See also burn.

dots per inch (dpi) The resolution of a printed image, expressed in the number of printer dots in an inch. You'll often see dpi used to refer to monitor screen resolution, or the resolution of scanners. However, neither of these uses dots; the correct term for a monitor is pixels per inch (ppi), whereas a scanner captures a particular number of samples per inch (spi).

electronic viewfinder (EVF)

An LCD located inside a digital camera and used to provide a view of the subject based on the image generated by the camera's sensor.

EXIF Exchangeable Image File Format. Developed to standardize the exchange of image data between hardware devices and software. A variation on JPEG, EXIF is used by most digital cameras, and includes information such as the date and time a photo was taken, the camera settings, resolution, amount of compression, and other data.

existing light In photography, the illumination that is already present in a scene. Existing light can include daylight or the artificial lighting currently being used, but is not considered to be electronic flash or additional lamps set up by the photographer.

exposure The amount of light allowed to reach the film or sensor, determined by the intensity of the light, the amount admitted by the iris of the lens, and the length of time determined by the shutter speed.

exposure program An automatic setting in a digital camera that provides the optimum combination of shutter speed and f/stop at a given level of illumination. For example, a "sports" exposure program would use a faster, action-stopping shutter speed and larger lens opening instead of the smaller, depth-offield-enhancing lens opening and slower shutter speed that might be favored by a "close-up" program at exactly the same light level.

exposure values (EV) EV settings are a way of adding or decreasing exposure without the need to reference f/stops or shutter speeds. For example, if you tell your camera to add +1EV, it will provide twice as much exposure, either by using a larger f/stop, slower shutter speed, or both.

fill lighting In photography, lighting used to illuminate shadows. Reflectors or additional incandescent lighting or electronic flash can be used to brighten shadows. One common technique outdoors is to use the camera's flash as a fill.

filter In photography, a device that fits over the lens, changing the light in some way. In image editing, a feature that changes the pixels in an image to produce blurring, sharpening, and other special effects. Photoshop CS includes several new filter effects, including Lens Blur and Photo Filters.

FireWire (IEEE-1394) A fast serial interface used by scanners, digital cameras, printers, and other devices.

flash sync The timing mechanism that ensures that an internal or external electronic flash fires at the correct time during the exposure cycle. A dSLR's flash sync speed is the highest shutter speed that can be used with flash. See also front-curtain sync and rearcurtain sync.

flat An image with low contrast.

focal length The distance between the film and the optical center of the lens when the lens is focused on infinity, usually measured in millimeters.

focal plane An imaginary line, perpendicular to the optical access, which passes through the focal point, forming a plane of sharp focus when the lens is set at infinity.

focus To adjust the lens to produce a sharp image.

focus lock A camera feature that lets you freeze the automatic focus of the lens at a certain point, when the subject you want to capture is in sharp focus.

focus range The minimum and maximum distances within which a camera is able to produce a sharp image, such as two inches to infinity.

focus tracking The ability of the automatic focus feature of a camera to change focus as the distance between the subject and the camera changes. One type of focus tracking is *predictive*, in which the mechanism anticipates the motion of the object being focused on, and adjusts the focus to suit.

framing In photography, composing your image in the viewfinder. In composition, using elements of an image to form a sort of picture frame around an important subject.

frequency The number of lines per inch in a halftone screen.

fringing A chromatic aberration that produces fringes of color around the edges of subjects, caused by a lens' inability to focus the various wavelengths of light onto the same spot. *Purple fringing* is especially troublesome with backlit images.

(which follows at a distance

conclusion of the exposure).

determined by shutter speed to

conceal the film or sensor at the

For a flash picture to be taken, the entire sensor must be exposed at one time to the brief flash exposure, so the image is exposed after the front curtain has reached the other side of the focal plane, but before the rear curtain begins to move.

Front-curtain sync causes the flash to fire at the *beginning* of this period when the shutter is completely open, in the instant that the first curtain of the focal plane shutter finishes its movement across the film or sensor plane. With slow shutter speeds, this feature can create a blur effect from the ambient light, showing as patterns that follow a moving subject

with the subject shown sharply frozen at the beginning of the blur trail (think of an image of The Flash running backwards). See also *rear-curtain sync*.

front lighting Illumination that comes from the direction of the camera. See also back lighting and side lighting.

f/stop The relative size of the lens aperture, which helps determine both exposure and depth-offield. The larger the f/stop number, the smaller the f/stop itself. It helps to think of f/stops as denominators of fractions, so that f/2 is larger than f/4, which is larger than f/8, just as 1/2, 1/4, and 1/8 represent eversmaller fractions. In photography, a given f/stop number is multiplied by 1.4 to arrive at the next number that admits exactly half as much light. So, f/1.4 is twice as large as $f/2.0 (1.4 \times 1.4)$, which is twice as large as f/2.8 (2×1.4) , which is twice as large as f/4 (2.8 \times 1.4). The f/stops which follow are f/5.6, f/8, f/11, f/16, f/22, f/32, and so on. See also diaphragm.

full-color image An image that uses 24-bit color, 16.8 million possible hues. Images are sometimes captured in a scanner with more colors, but the colors are reduced to the best 16.8 million shades for manipulation in image editing.

gamma A numerical way of representing the contrast of an image. Devices such as monitors typically don't reproduce the tones in an image in straight-line fashion (all colors represented in exactly the same way as they appear in the original). Instead, some tones may be favored over others, and gamma provides a method of tonal correction that takes the human eye's perception of neighboring values into account. Gamma values range from 1.0 to about 2.5. The Macintosh has traditionally used a gamma of 1.8, which is relatively flat compared to television. Windows PCs use a 2.2 gamma value, which has more contrast and is more saturated.

gamma correction A method for changing the brightness, contrast, or color balance of an image by assigning new values to the gray or color tones of an image to more closely represent the original shades. Gamma correction can be either linear or nonlinear Linear correction applies the same amount of change to all the tones. Nonlinear correction varies the changes tone-by-tone, or in highlight, midtone, and shadow areas separately to produce a more accurate or improved appearance.

gamut The range of viewable and printable colors for a particular color model, such as RGB (used for monitors) or CMYK (used for printing).

Gaussian blur A method of diffusing an image using a bell-shaped curve to calculate the pixels which will be blurred, rather than blurring all pixels, producing a more random, less "processed" look.

graduated filter A lens attachment with variable density or color from one edge to another. A graduated neutral density filter, for example, can be oriented so the neutral density portion is concentrated at the top of the lens' view with the less dense or clear portion at the bottom, thus reducing the amount of light from a very bright sky while not interfering with the exposure of the landscape in the forearound. Graduated filters can also be split into several color sections to provide a color gradient between portions of the image.

grain The metallic silver in film which forms the photographic image. The term is often applied to the seemingly random noise in an image (both conventional and digital) that provides an overall texture.

gray card A piece of cardboard or other material with a standardized 18-percent reflectance. Gray cards can be used as a reference for determining correct exposure. grayscale image An image represented using 256 shades of gray. Scanners often capture grayscale images with 1,024 or more tones, but reduce them to 256 grays for manipulation by Photoshop.

highlights The brightest parts of an image containing detail.

histogram A kind of chart showing the relationship of tones in an image using a series of 256 vertical "bars," one for each brightness level. A histogram chart typically looks like a curve with one or more slopes and peaks, depending on how many highlight, midtone, and shadow tones are present in the image.

hot shoe A mount on top of a camera used to hold an electronic flash, while providing an electrical connection between the flash and the camera.

hyperfocal distance A point of focus where everything from half that distance to infinity appears to be acceptably sharp. For example, if your lens has a hyperfocal distance of four feet,

everything from two feet to infinity would be sharp. The hyperfocal distance varies by the lens and the aperture in use. If you know you'll be making a "grab" shot without warning, sometimes it is useful to turn off your camera's automatic focus and set the lens to infinity, or, better yet, the hyperfocal distance. Then, you can snap off a quick picture without having to wait for the lag that occurs with most digital cameras as their autofocus locks in.

image rotation A feature found in some digital cameras, which senses whether a picture was taken in horizontal or vertical orientation. That information is embedded in the picture file so that the camera and compatible software applications can automatically display the image in the correct orientation.

image stabilization A technology, also called vibration reduction and anti-shake, that compensates for camera shake, usually by adjusting the position of the camera sensor or lens elements in response to movements of the camera.

incident light Light falling on a surface.

infinity A distance so great that any object at that distance will be reproduced sharply if the lens is focused at the infinity position.

infrared illumination The non-visible part of the electromagnetic spectrum with wavelengths above 700 nanometers.

interchangeable lens Lens designed to be readily attached to and detached from a camera; a feature found in more sophisticated digital cameras.

International Organization for Standardization (ISO) A governing body that provides standards such as those used to represent film speed, or the equivalent sensitivity of a digital camera's sensor. Digital camera sensitivity is expressed in ISO settings.

interpolation A technique digital cameras, scanners, and image editors use to create new pixels required whenever you resize or change the resolution of an image based on the values of surrounding pixels. Devices such as scanners and digital cameras can also use interpolation to create pixels in addition to those actually captured, thereby increasing the apparent resolution or color information in an image.

invert In image editing, to change an image into its negative; black becomes white, white becomes black, dark gray becomes light gray, and so forth. Colors are also changed to the complementary color; green becomes magenta, blue turns to yellow, and red is changed to cyan.

iris A set of thin overlapping metal leaves in a camera lens, also called a diaphragm, that pivot outwards to form a circular opening of variable size to control the amount of light that can pass through a lens.

jaggies Staircasing effect of lines that are not perfectly horizontal or vertical, caused by pixels that are too large to represent the line accurately.

JPEG (Joint Photographic Experts Group) A file format that supports 24-bit color and reduces file sizes by selectively discarding image data. Digital cameras generally use JPEG compression to pack more images onto memory cards. You can select how much compression is used (and therefore how much information is thrown away) by selecting from among the Standard, Fine, Super Fine, or other quality settings offered by your camera. See also TIFF.

Kelvin (K) A unit of measurement based on the absolute temperature scale in which absolute zero is zero; used to describe the color of continuous spectrum light sources, such as tungsten illumination (3200 to 3400K) and daylight (5500 to 6000K).

lagtime The interval between when the shutter is pressed and when the picture is actually taken. During that span, the camera may be automatically focusing and calculating exposure. With digital SLRs, lagtime is generally very short; with non-dSLRs, the elapsed time easily can be one second or more.

landscape The orientation of a page in which the longest dimension is horizontal, also called wide orientation.

latitude The range of camera exposures that produces acceptable images with a particular digital sensor or film.

lens One or more elements of optical glass or similar material designed to collect and focus rays of light to form a sharp image on the film, paper, sensor, or a screen.

lens aperture The lens opening, or iris, that admits light to the film or sensor. The size of the lens aperture is usually measured in f/stops. See also f/stop and iris.

lens flare A feature of conventional photography that is both a bane and a creative outlet. It is an effect produced by the reflection of light internally among elements of an optical lens. Bright light sources within or just outside the field of view cause lens flare. Flare can be reduced by the use of coatings on the lens elements or with the use of lens hoods. Photographers sometimes use the effect as a creative technique, and Photoshop includes a filter that lets you add lens flare at your whim.

lens hood A device that shades the lens, protecting it from extraneous light outside the actual picture area which can reduce the contrast of the image, or allow lens flare.

lighting ratio The proportional relationship between the amount of light falling on the subject from the main light and other lights, expressed in a ratio, such as 3:1.

lossless compression An image-compression scheme, such as TIFF, that preserves all image detail. When the image is decompressed, it is identical to the original version.

lossy compression An imagecompression scheme, such as JPEG, that creates smaller files by discarding image information, which can affect image quality.

luminance The brightness or intensity of an image, determined by the amount of gray in a hue.

macro lens A lens that provides continuous focusing from infinity to extreme close-ups, often to a reproduction ratio of 1:2 (half life-size) or 1:1 (life-size).

magnification ratio A relationship that represents the amount of enlargement provided by the macro setting of the zoom lens, macro lens, or with other close-up devices.

matrix metering A system of exposure calculation that looks at many different segments of an image to determine the brightest and darkest portions.

maximum aperture The largest lens opening or f/stop available with a particular lens, or with a zoom lens at a particular magnification.

microdrive A tiny hard disk drive in the CompactFlash form factor, which can be used in most digital cameras that take CompactFlash memory.

midtones Parts of an image with tones of an intermediate value, usually in the 25 to 75 percent range. Many image-editing features allow you to manipulate midtones independently from the highlights and shadows.

mirror lens A type of lens, more accurately called a catadioptric lens, which contains both lens elements and mirrors to "fold" the optical path to produce a shorter, lighter telephoto lens. Because of their compact size and relatively low price, these lenses are popular, even though they have several drawbacks, including having reduced contrast and fixed apertures, and producing doughnut-shaped out-of-focus points of light (because

one of the mirrors is mounted on the front of the lens).

mirror lock-up The ability to retract the SLR's mirror to reduce vibration prior to taking the photo, or to allow access to the sensor for cleaning.

moiré An objectionable pattern caused by the interference of halftone screens, frequently generated by rescanning an image that has already been halftoned. An image editor can frequently minimize these effects by blurring the patterns.

monochrome Having a single color, plus white. Grayscale images are monochrome (shades of gray and white only).

infrared illumination The non-visible part of the electromagnetic spectrum with wavelengths between 700 and 1,200 nanometers, which can be used for infrared photography when the lens is filtered to remove visible light. See also infrared.

neutral density filter A gray camera filter reduces the amount of light entering the camera without affecting the colors.

noise In an image, pixels with randomly distributed color values. Noise in digital photographs tends to be the product of low-light conditions and long exposures, particularly when you have set your camera to a higher ISO rating than normal.

noise reduction A technology used to cut down on the amount of random information in a digital picture, usually caused by long exposures at increased sensitivity ratings. Noise reduction involves the camera automatically taking a second blank/dark exposure at the same settings that contain only noise, and then using the blank photo's information to cancel out the noise in the original picture. With most cameras, the process is very quick, but does double the amount of time required to take the photo. Noise reduction can also be performed within image editors and stand-alone noise reduction applications.

normal lens A lens that makes the image in a photograph appear in a perspective that is like that of the original scene, typically with a field of view of roughly 45 degrees. A quick way to calculate the focal length of a normal lens is to measure the diagonal of the sensor or film frame used to capture the image, usually ranging from around 7mm to 45mm.

overexposure A condition in which too much light reaches the film or sensor, producing a dense negative or a very bright/light print, slide, or digital image.

pan-and-tilt head A tripod head allowing camera to be tilted up or down or rotated 360 degrees.

panning Moving the camera so that the image of a moving object remains in the same relative position in the viewfinder as you take a picture. The eventual effect creates a strong sense of movement.

panorama A broad view, usually scenic. Photoshop's new Photomerge feature helps you create panoramas from several photos. Many digital cameras have a panorama assist mode that makes it easier to shoot several photos that can be stitched together later.

parallax compensation An adjustment made by the camera or photographer to account for the difference in views between the taking lens and the external viewfinder.

PC/X terminal A connector for attaching standard electronic flash cords, named after the Prontor-Compur shutter companies which developed this connection.

perspective The rendition of apparent space in a photograph, such as how far the foreground and background appear to be separated from each other. Perspective is determined by the distance of the camera to the subject. Objects that are close appear large, while distant objects appear to be far away.

perspective control lens A special lens, most often used for architectural photography, that allows correcting distortion resulting from a high or low camera angle.

Photo CD A special type of CD-ROM developed by Eastman Kodak Company that can store high-quality photographic images in a special space-saving format, along with music and other data.

pincushion distortion A type of distortion, most often seen in telephoto prime lenses and zooms, in which lines at the top and side edges of an image are bent inward, producing an effect that looks like a pincushion.

pixel The smallest element of a screen display that can be assigned a color. The term is a contraction of "picture element."

pixels per inch (ppi) The number of pixels that can be displayed per inch, usually used to refer to pixel resolution from a scanned image or on a monitor.

polarizing filter A filter that forces light, which normally vibrates in all directions, to vibrate only in a single plane, reducing or removing the specular reflections from the surface of objects and emphasizing the blue of skies in color images.

portrait The orientation of a page in which the longest dimension is vertical, also called tall orientation. In photography, a formal picture of an individual or, sometimes, a group.

positive The opposite of a negative, an image with the same tonal relationships as those in the original scenes—for example, a finished print or a slide.

prime A camera lens with a single fixed focal length, as opposed to a zoom lens.

process color The four color pigments used in color printing: cyan, magenta, yellow, and black (CMYK).

RAW An image file format offered by many digital cameras that includes all the unprocessed information captured by the camera. RAW files are very large, and must be processed by a special program supplied by camera makers, image editors, or third parties, after being downloaded from the camera.

rear-curtain sync An optional kind of electronic flash synchronization technique, originally associated with focal plane shutters, which consist of a traveling set of curtains, including a front curtain (which opens to reveal the film or sensor) and a rear curtain (which follows at a distance determined by shutter speed to conceal the film or sensor at the conclusion of the exposure).

For a flash picture to be taken, the entire sensor must be exposed at one time to the brief flash exposure, so the image is exposed after the front curtain has reached the other side of the focal plane, but before the rear curtain begins to move.

Rear-curtain sync causes the flash to fire at the *end* of the exposure, an instant before the second or rear curtain of the focal plane shutter begins to move. With slow shutter speeds, this feature can create a blur effect from the ambient light, showing as patterns that follow a moving subject with subject shown sharply frozen at the end of the blur trail. If you were shooting a photo of The Flash, the superhero would appear sharp, with a ghostly trail behind him.

red eye An effect from flash photography that appears to make a person's eyes glow red, or an animal's yellow or green. It's caused by light bouncing from the retina of the eye, and is most pronounced in dim illumination (when the irises are wide open) and when the electronic flash is close to the lens and therefore prone to reflect directly back. Image editors can fix red eye through cloning other pixels over the offending red or orange ones.

red-eye reduction A way of reducing or eliminating the red-eye phenomenon. Some cameras offer a red-eye reduction mode that uses a preflash that causes the irises of the subjects' eyes to close down just prior to a second, stronger flash used to take the picture.

reflector Any device used to reflect light onto a subject to improve balance of exposure (contrast). Another way is to use fill-in flash.

reproduction ratio Used in macrophotography to indicate the magnification of a subject.

resample To change the size or resolution of an image. Resampling down discards pixel information in an image; resampling up adds pixel information through interpolation.

resolution In image editing, the number of pixels per inch used to determine the size of the image when printed. That is, an 8×10 -inch image that is saved with 300 pixels per inch resolution will print in an 8×10 -inch

size on a 300 dpi printer, or 4×5 -inches on a 600 dpi printer. In digital photography, resolution is the number of pixels a camera or scanner can capture.

retouch To edit an image, most often to remove flaws or to create a new effect.

RGB color mode A color mode that represents the three colors—red, green, and blue—used by devices such as scanners or monitors to reproduce color. Photoshop works in RGB mode by default, and even displays CMYK images by converting them to RGB.

saturation The purity of color; the amount by which a pure color is diluted with white or gray.

scale To change the size of all or part of an image.

SecureDigital memory card Another flash memory card format that is gaining acceptance for use in digital cameras and

other applications.

selective focus Choosing a lens opening that produces a shallow depth-of-field. Usually this is used to isolate a subject by causing most other elements in the scene to be blurred.

self-timer Mechanism delaying the opening of the shutter for some seconds after the release has been operated. Also known as delayed action.

sensitivity A measure of the degree of response of a film or sensor to light.

sensor array The grid-like arrangement of the red-, green-, and blue-sensitive elements of a digital camera's solid-state capture device. Sony offers a sensor array that captures a fourth color, termed *emerald*.

shadow The darkest part of an image, represented on a digital image by pixels with low numeric values or on a halftone by the smallest or absence of dots.

sharpening Increasing the apparent sharpness of an image by boosting the contrast between adjacent pixels that form an edge.

shutter In a conventional film camera, the shutter is a mechanism consisting of blades, a curtain, plate, or some other movable cover that controls the time during which light reaches the film. Digital cameras can use actual shutters, or simulate the action of a shutter electronically. Quite a few use a combination, employing a mechanical shutter for slow speeds and an electronic version for higher speeds.

shutter lag The tendency of a camera to hesitate after the shutter release is depressed prior to making the actual exposure. Point-and-shoot digital cameras often have shutter lag times of up to 2 seconds, primarily because of slow autofocus systems. Digital SLRs typically have much less shutter lag, typically 0.2 seconds or less.

shutter-preferred An exposure mode in which you set the shutter speed and the camera determines the appropriate f/stop. See also *aperture-priority*.

side lighting Light striking the subject from the side relative to the position of the camera; produces shadows and highlights to create modeling on the subject.

single lens reflex (SLR)
camera A type of camera
that allows you to see through
the camera's lens as you look in
the camera's viewfinder. Other
camera functions, such as light
metering and flash control, also
operate through the camera's
lens.

slave unit An accessory flash unit that supplements the main flash, usually triggered electronically when the slave senses the light output by the main unit, or through radio waves.

slow sync An electronic flash synchronizing method that uses a slow shutter speed so that ambient light is recorded by the camera in addition to the electronic flash illumination, so that the background receives more exposure for a more realistic effect.

soft focus An effect produced by use of a special lens or filter that creates soft outlines.

soft lighting Lighting that is low or moderate in contrast, such as on an overcast day.

specular highlight Bright spots in an image caused by reflection of light sources.

spot color Ink used in a print job in addition to black or process colors.

Spot meter An exposure system that concentrates on a small area in the image. See also *Averaging meter*.

subtractive primary colors

Cyan, magenta, and yellow, which are the printing inks that theoretically absorb all color and produce black. In practice, however, they generate a muddy brown, so black is added to preserve detail (especially in shadows). The combination of the three colors and black is referred to as CMYK. (K represents black, to differentiate it from blue in the RGB model.)

T (time) A shutter setting in which the shutter opens when the shutter button is pressed, and remains open until the button is pressed a second time. See also *B (bulb)*.

telephoto A lens or lens setting that magnifies an image.

threshold A predefined level used by a device to determine whether a pixel will be represented as black or white.

TIFF (Tagged Image File

Format) A standard graphics file format that can be used to store grayscale and color images plus selection masks. See also *JPEG*.

time exposure A picture taken by leaving the shutter open for a long period, usually more than one second. The camera is generally locked down with a tripod to prevent blur during the long exposure. See also B (bulb).

time lapse A process by which a tripod-mounted camera takes sequential pictures at intervals, allowing the viewing of events that take place over a long period of time, such as a sunrise or flower opening. Many digital cameras have time-lapse capability built in. Others require you to attach the camera to your computer through a USB cable, and let software in the computer trigger the individual photos.

tint A color with white added to it. In graphic arts, often refers to the percentage of one color added to another.

tolerance The range of color or tonal values that will be selected with a tool like Photoshop's Magic Wand, or filled with paint when using a tool like the Paint Bucket.

transparency A positive photographic image on film, viewed or projected by light shining through film.

transparency scanner A type of scanner that captures color slides or negatives.

tripod A three-legged supporting stand used to hold the camera steady. Especially useful when using slow shutter speeds and/or telephoto lenses.

of providing viewing through the actual lens taking the picture (as with a camera with an electronic viewfinder, LCD display, or single lens reflex viewing), or calculation of exposure, flash exposure, or focus based on the view through the lens.

tungsten light Usually warm light from ordinary room lamps and ceiling fixtures, as opposed to fluorescent illumination.

underexposure A condition in which too little light reaches the film or sensor, producing a thin negative, dark slide, muddy-looking print, or dark digital image.

unipod A one-legged support, or monopod, used to steady the camera. See also *tripod*.

unsharp masking The process for increasing the contrast between adjacent pixels in an image, increasing sharpness, especially around edges.

USB A high-speed serial communication method commonly used to connect digital cameras and other devices to a computer.

viewfinder The device in a camera used to frame the image. With an SLR camera, the viewfinder is also used to focus the image if focusing manually. You can also focus an image with the LCD display of a digital camera, which is a type of viewfinder.

vignetting Dark corners of an image, often produced by using a lens hood that is too small for the field of view, or generated artificially using image-editing techniques.

white The color formed by combining all the colors of light (in the additive color model) or by removing all colors (in the subtractive model).

white balance The adjustment of a digital camera to the color temperature of the light source. Interior illumination is relatively red; outdoor light is relatively blue. Digital cameras often set correct white balance automatically, or let you do it through menus. Image editors can often do some color correction of images that were exposed using the wrong white-balance setting.

wide-angle lens A lens that has a shorter focal length and a wider field of view than a normal lens for a particular film or digital image format.

xD card A very small type of memory card, used chiefly in Olympus and Fuji digital cameras.

zoom In image editing, to enlarge or reduce the size of an image on your monitor. In photography, to enlarge or reduce the size of an image using the magnification settings of a lens.

zoom ring A control on the barrel of a lens that allows changing the magnification, or zoom, of the lens by rotating it.

Index

A	
A	
A	
A	

A (Automatic) flash, 84 PC/X connector for, 86

AA (Auto Aperture) exposure, 84
AA batteries, 16
aberration, chromatic, 109
AC adapters, 16
accuracy, manual focus for, 65
ACDSee, 163
achromats, 104
action photography, 132–133
Adams, Ansel, 50
Adobe Camera RAW, 47
Adobe Photoshop

chromatic aberration, correcting, 109 fireworks photography, editing, 151 Lens Correction filter, 108 noise, cutting, 47 panoramo-stitching feature, 163 stars, simulating, 157

AE-L lock button, 56
aerial pyrotechnics, photographing,
150–151
always flash setting, 10

ambient light
fill light and, 78

shutter speeds and, 37
amusement parks, photography at,
136–137

angles, 120–121

in architectural photography, 138 for child photography, 142 in concert photography, 145 framing subject and, 129 with wide-angle lenses, 94 in zoo photography, 134

animal photography, 134–135 aperture lock for macro lenses, 103 aperture priority, 48–49

with programmed exposure mode, 53 aperture ring for macro lenses, 103 apertures, 4. See also f/stops

constant aperture lenses, 45 and depth-of-field (DOF), 45 intensity of light and, 71 with macro lenses, 103 setting, 12 vignetting and, 109

Apple iPods, 171 arches as frames, 128 architectural photography, 138–139 auctions, photography for, 146–147

audience for photograph, 115 auto flash setting, 10 auto mode, 48

with programmed exposure modes, 52–53

autoaperture functions, extension tubes for, 104 autoexposure, 5, 40

extension tubes for, 104

autofocus, 2

assist lamps, 61 Automatic Autofocus mode, 73 basics of, 60–61 checking setting, 28–29 Continuous Autofocus mode, 62–63 extension tubes for, 104 focus priority, 63 locking in, 60 modes, 62–63 overriding, 61 priority of focus zones, 60 release priority, 63 Single Autofocus mode, 62 teleconverters and, 106 zoom lenses with, 90

Automatic Autofocus mode, 73 Automatic/Manual focus switch, 6 automobiles

car shows, 148–149 in night photography, 158–159 autorotation, **31**

AV port, 4 axial chromatic aberration, 109

back panel controls, 4-5 backgrounds, 124-125

for auction photographs, 146–147 light, 79 for macro photography, 155 for portraits, 165 for still-life photography, 167

backlighting, 68

with wide-angle lenses, 94

bad sectors, 20

balance, 127. See also white balance

for auction photographs, 146 for sunrise and sunset photography, 168

balanced TTL, 84 barrel distortion, 108

with wide-angle lenses, 94, 108

batteries, 16-19

additional batteries, holding, 18 charging, 16 clock battery, 16–17 compartment, 8 monochrome status LCD for, 6 no review mode and, 30 preserving life of, 17–19 remaining power, checking, 16–17

Battery Information screen, 17 beach/snow mode, 53 beeps, setting, 36 bellows attachments, 104–105 Bibble Pro, 47 black and white filters, 34 blooming effect, 40 blur

> in action photography, 132–133 bokeh, 110–111 in concert photography, 145 intensity of light and, 71 shutter speeds and, 42

bokeh, 110–111 books, photographs for, 115

bracketing, 4

customizing options, 37 exposure bracketing, 56-57

brightness

for auction photographs, 146 and center of interest, 117 histograms showing, 58 texture of light and, 70

broad lighting, 77 building photography, 138-139 built-in flash. See flash burst/sequence shooting, 81

cable, hot shoe, 86 camera shake, 42 candid photography, 140-141 Canon cameras, 1

> batteries for, 19 crop factor with, 93 flash with, 80 teleconverters, 106

capacity of memory card, 8 cars. See automobiles center of interest, selecting, 116-117

center-weighted metering, 29, 54-55

child photography, 142-143 children mode, 48 chromatic aberration, 109 circle of confusion, 110 circular subjects, 118-119 Civil War reenactments, 148-149 clock battery, 16-17 close-up lenses, 104, 154-155

close-ups, 131. See also macro

lenses

built-in flash and, 80 intensity of light and, 71 locking range, 61 manual focus for, 64-65 in nature photography, 161 Rule of Thirds for, 122

in zoo photography, 134 clothing for child photographs, 143 Cloudy Light setting, 72 clusters, 22-23

colors. See also filters; tonal range

and center of interest, 117 hue, adjusting, 32 temperature, 72

CompactFlash (CF) cards, 8, 23 compression, 24-25

with telephoto lenses, 98 computer display, orientation for, 119

concepts, conveying, 123 concert photography, 144-145 constant aperture lenses, 45 Continuous Autofocus mode, 62-63 continuous lighting, 67 continuous/sequence shooting button, 4

contrast for auction photographs, 146

controls

back panel controls, 4-5 front panel controls, 2-3 functions, 36-37 top panel controls, 6-7 crop factors, 92-93

cropping

cybercafés, 171

for auction photographs, 146-147 for brightness, 117 for center of interest, 116 moon shots, 156 curved lines, 127 custom settings, 36-37 cyanotype filters, 34

Dark Frame Subtraction process, 47 Daylight/Direct Sunlight setting, 72 DC port, 4 deleting photos, 21 Depth-of-Field button, 2

depth-of-field (DOF), 2, 12

in architectural photography, 138 bokeh and, 110 in concert photography, 145 and crop factor, 92 exposure and, 41 f/stops and, 12, 45 imaginary DOF, 95 intensity of light and, 71 ISO and, 47 with macro lenses, 102-103 with telephoto lenses, 96-97 with wide-angle lenses, 94-95

depth of light, 81 diagonal lines, 126 diaphraam, 12 diffraction, f/stops and, 45 diopters, 104

correct feature, 5 directionality of light, 68-69 Display Info button, 4

distance, 120-121

framing subject and, 128-129 speed and, 43

distortion, 108-111. See also barrel distortion; perspective distortion

chromatic aberration, 109 pincushion distortion, 108-109 with telephoto lenses, 98 with wide-angle lenses, 94

distraction, backgrounds as, 124 doorways as frames, 128 doughnut effect, 110 DVD/CD burners, 171 dynamic range of sensors, 40

e-mailing travel photos, 171 eBay, photography for, 146-147 electronic flash. See flash electronic flash tube, 10 electronic viewfinders (EVFs), 1 emotions, shapes and, 127 **EV** settings

adjusting, 34 button, 6-7 changing display, 30 exposure settings with, 56 flash EV settings, 10, 56, 85 and histograms, 58 increment settings, 36

evaluation mode

exposure evaluation mode, 41 metering, 54-55

events, photographing, 148-149 exchangeable media, 8 exposure lock, 56 exposure measurement time, 41

Quick Snap Guide to Digital SLR Photography

exposure mode, 41

checking setting, 28–29 monochrome status LCD for, 6 programmed modes, 52–53

exposures. See also TTL exposure

AA (Auto Aperture) exposure, 84 in amusement park photography, 136-137 in architectural photography, 138 bracketing, 56-57 controls, 40-41 for fireworks photography, 151 flash exposure, 84–85 histograms and, 58-59 manual exposure, 50-51 mechanical shutter for, 13 memory card capacity, 8 metering, 54-55 for moon shots, 156-157 for night photography, 158-159 noise and, 32, 46 overriding camera settings, 56-57 scene modes, 6

zone/method selector, 7 extension tubes, 104–105, 155 external flash, 50

168

for sunrise and sunset photography,

connecting, 86–87 PC/X connector, 10 slave triggers, 87 wireless triggers for, 87

f/stops, 4, 12

in aperture priority, 48–49 for auction photographs, 146 for candid photography, 140

checking setting, 28-29 choosing, 44-45 in concert photography, 145 and depth-of-field (DOF), 12, 45 diffraction and, 45 exposure and, 41 fill light and, 79 for fireworks photography, 150 for lush landscape photography, 153 monochrome status LCD for, 6 for moon shots, 156 with programmed exposure mode, 52 sharpness and, 44 in shutter priority, 49 teleconverters and, 106 variable f/stops, 45 waterfalls, photographing, 160-161 with zoom lenses, 91

fast lenses, 44

FAT (File Allocation Table)
allocations, 22–23
field of view with wide-angle
lenses, 94–95

files

hidden or protected files, 20 numbers, assigning, 34

fill flash setting, 10 fill light, 78-79 filter thread, 6 filters, 34

for fireworks photography, 150 for lush landscape photography, 152–153 for sunrise and sunset photography, 168

fireworks, photographing, 150–151 fixed focal length lenses, 91, 102

vianettina and, 109

flash, 80–81. See also external flash; hot shoe; TTL exposure

AA (Auto Aperture) exposure, 84

combination modes, 83 common settings, 10 customizing modes, 37 depth of light, 81 EV settings for, 10, 56, 85 exposure, 84-85 front sync flash setting, 10, 82 ahost images with, 82-83 Guide Numbers, 84 intensity of light and, 71 manual settings, 50, 80, 84-85 modeling lamp feature, 37 for night photography, 159 for portraits, 165 pre-flash, 3 rear sync with, 10, 82-83 recharging, 81 setting, Electronic Flash, 72 for still-life photography, 167 sync modes, 82-83 with telephoto lenses, 98 with wide-angle lenses, 94 working with, 10-11

flash compensation button, 10 flip-up flash. See external flash flip-up mirror, 12 fluorescent lighting, 72–73 focal length, 91, 102, 103 focus. See also autofocus

for auction photographs, 146 backgrounds, selective focus and, 125 for macro lenses, 103 manual focus, 64–65 monochrome status LCD for, 6 in sunrise and sunset photography, 169

with telephoto lenses, 96

focus assist lamp, 3 focus lock, 5

with autofocus, 60

focus priority, 63 focus ring, 6

for macro lenses, 103

focus scale, 6

for macro lenses, 103

focus screen, 12 focus zone display information, 31 folders, assigning, 34 foreground frames, 128 Format command, 20

formatting media, 20–23
bad sectors, 20
FAT (File Allocation Table) allocations,
22–23

4GB memory cards, 23 frames, 128-129

in architectural photography, 139 depth and, 128–129

freezing motion, 42-43, 132-133 flash and, 81

front curtain, 80 front panel controls, 2–3 front sync flash setting, 10, 82 function button, 2, 37

G

ghost images with flash, 81–83 grain. See Noise grids in viewfinder, 36 Guide Numbers, 84

H

hair light, 79 hand grip, 2, 8 handheld meters, 50-51 handkerchiefs with flash, 80 haze filters, 152-153 Help button, 5 hidden files, 20 high-angle views, 120-121 high speed crop mode, 26 histograms, 58-59 Hitachi Microdrives, 8 horizontal orientation, 118 hot shoe, 2, 6

cable, 86 external flash, connecting, 86-87 hue, adjusting, 32

> in candid photography, 140-141 in zoo photography, 134

humor

idling cameras, 19 illumination. See light image optimization, 32-33 image stabilization, 89 Incandescent Light setting, 72 increment settings, 36 information displays, 30-31 intelligent batteries, 17 intensity of light, 70-71 International Organization for Standardization. See ISO settings intimacy, creating, 120-121 inverse square law, 80 IR receiver, 3

ISO settings, 4

AA (Auto Aperture) exposure and, 84 adjusting, 46-47 checking setting, 28 in concert photography, 145 display information, 30 exposure adjustments and, 41 for fireworks photography, 150 Guide Numbers, 84 increment settings, 36 intensity of light and, 71 for lush landscape photography, 153 main command dial for, 5 metering mode for, 5 minimum settings, 47 monochrome status LCD for, 6 for moon shots, 156 for night photography, 158 noise reduction and, 32-33 with normal lenses, 101 teleconverters and, 106 waterfalls, photographing, 160-161

JPEG format, 25

levels of compression, 25 lossy compression with, 24 low resolution and, 26 with RAW format, 25 for travel photography, 171 white balance and, 28-29

Kelvin degrees, 72 Kenko teleconverters, 106

Kodak cameras, 1 Konica Minolta cameras, 1

crop factor with, 93 special feature button, 4

L

landscapes, 48, 53

lush landscapes, photographing, 152-153 orientation of photos, 118 and purpose of photograph, 114 Rule of Thirds for, 122 scene modes, 29

lateral chromatic aberration, 109 LCD screen

autorotation display, 31 brightness, changing, 30 monochrome status LCD, 6 review/menu LCD, 4

LED autofocus assist lamps, 61 lens hood

bayonet, 6 electronic flash tube and, 10 lens mount release, 2

lens multiplier, 92 lens thread for macro lenses, 103 lenses, 12, 89-111. See also distortion; macro lenses;

telephoto lenses; TL exposure; wide-angle lenses; zoom lenses

for action photography, 132 bokeh characteristics of, 110 close-up lenses, 104, 154-155 constant aperture lenses, 45 crop factors, 92-93 elements of, 12 manual focus lenses, 64 normal lenses, 100-101

older lenses, 50 sharpness and, 44 teleconverters, 106-107 top panel controls, 6

light, 67. See also flash; white **balance**

in architectural photography, 139 background light, 79 in concert photography, 145 continuous lighting, 67 directionality of, 68-69 fill light, 78-79 fluorescent lighting, 72-73 hair light, 79 intensity of, 70-71 for macro photography, 155 main light, working with, 77 multiple lights, working with, 76-79 for panoramas, 163 for portraits, 164-165 quality of, 68-71 rim light, 79 shadows, 68 for still-life photography, 167 telephoto lenses and, 96 texture of, 69-70

light meters, 51 limit switch for macro lenses, 103 lines. See also straight lines

in backgrounds, 124 curved lines, 127 diagonal lines, 126 repetitive lines, 126-127

lithium ion (Li-Ion) batteries, 16 live performances

concerts, photography at, 144-145 events, photographing, 148-149 plays, photography at, 140-141

Quick Snap Guide to Digital SLR Photography

locking. See also focus lock

autofocus range, 61 exposure settings, 56

longitudinal chromatic aberration, 109

lossless compression, 24 lossy compression, 24–25 low-light lenses, 44 lush landscapes, photographing, 152–153

M

M (Manual) mode, 48 macro lenses, 89, 102–103, 154–155

> accessories for, 104–105 parts of, 103 steadying camera for, 102

macro photography, 53, 154-155 of natural subjects, 161

magazines, photographs for, 115 magnification

with macro lenses, 102–103 with teleconverters, 106–107

main command dial, 5
main light, working with, 77
main subject of photograph,
116–117

116-117

manual settings

for exposure, 48, 50–51 for flash, 50, 80, 84–85 for focus, 64–65 with programmed exposure mode, 53 for white balance, 72–73

MASP (Manual, Aperture Priority, Shutter Priority, and Programmed), 48 matrix metering, 54–55 maximum sync speed, 81
mechanical shutter, 13
mechanical vignetting, 109
media. See memory cards
media slot cover, 8
medium resolution, 26
megapixels, 26. See also resolution

for portraits, 164 sensors determining, 13

memory cards, 8

bad sectors, 20
capacity parameters, 8
exchangeable media, 8
FAT (File Allocation Table) allocations, 22–23
formatting, 20–23
low resolution and, 26
no cards, shooting with, 36
play mode, 36
speed parameters, 8
for travel photography, 170–171
white balance presets, small cards for, 74
wrong formatting problems, 20

menu, 4 metering, 29, 54-55

center-weighted metering, 29, 54–55 for concert photographs, 144–145 matrix metering, 54–55 Spot metering, 54–55

microphones, shooting around, 144 mirrors

flip-up mirror, 12 pentamirror, 12

mode dial, 2, 6
modeling lamp feature, 37
monochrome status LCD, 6
monument photography, 138–139
moon shots, 156–157

motion. See also freezing motion

autofocus and, 60
Continuous Autofocus mode, 62–63
distance and, 43
manual focus and, 65
shutter speed and, 41–42

multi-selector pad, 5 multiple lights, working with, 76–79 Multipoint metering, 54–55

museum scene modes, 29

N

nature photography, 160–161. See also landscapes

animal photography, 134–135 backgrounds for, 124–125 lush landscapes, photographing, 152–153 portraits, outdoor, 165 sunrises and sunsets, 168–169

travel photography and, 170-171

neutral density filters, 153 nickel metal hydride (NiMH) batteries, 16 night photography, 158–159

> moon shots, 156–157 portrait mode, 53 scene modes, 29, 48, 53

Nikon cameras, 1

Automatic Autofocus mode, 73 batteries for, 19 crop factor with, 93 flash with, 80 teleconverters, 106

noise

Dark Frame Subtraction process, 47 in fireworks photography, 151

ISO settings and, 46 reduction, 32–33, 47

Noise Ninja, 47 normal lenses, 100

0

O'Keefe, Georgia, 166
older lenses, 50
Olympus cameras, crop factor with, 93
optical defects with wide-angle lenses, 94
orientation of photos, 118–119
overriding
autofocus, 61

P

Panasonic cameras, crop factor with, 93 panning, 43 panoramas, 162–163 PC/X connectors, 2, 86–87 substitute PC/X connectors, 87 penlight for fireworks

exposure settings, 56-57

photography, 151 pentamirror, 12 pentaprism, 12

Pentax cameras, 1

crop factor with, 93

perspective. See also perspective distortion

with wide-angle lenses, 94–95

perspective distortion, 109-110

in architectural photography, 138

Photoshop. See Adobe Photoshop picture review, 4-5

histograms, 58–59
noise and, 46
play mode, 36
playback, menu for, 4
plays, photography at, 140–141
polarizing filters, 153
porroprisms, 12
portability of normal lenses, 101
portable storage devices, 171
portraits, 6, 29, 48, 53, 164–165
backgrounds for, 124
child photography, 143
fill light for, 78
Rule of Thirds for, 122
with telephoto lenses, 96
vertical orientation, 118–119
power switch, 2, 7
pre-flash, 3
predictive focus, 60, 65
presets for white balance, 74
price for normal lenses, 100
prime lenses, 91
macro lenses, 102
priority. See also aperture priority;
shutter priority focus priority, 63
release priority, 63
programmed exposure modes,
52-53
prominence of center of interest,
117
proprietary connectors for flash, 86
props for child photography, 142
Protect/Lock button, 5
protected files, 20
purpose of photograph, 114–115

pincushion distortion, 108-109

blooming effect, 40

resolution

pixels, 26. See also megapixels;

Q
quality
of light, 68–71
metering mode for, 5
resolution and, 26
resolution and, 20
D
R
RAW format
compressed, 24
JPEG format with, 25
noise reduction with, 47
tonal information, 41
uncompressed, 24
white balance and, 28–29, 74–75
read only files, 20
rear curtain, 80
rear sync flash setting, 10, 82–83
recharging batteries, 16
Record button, 5
red-eye, 10
front sync with, 83
release priority, 63
removable media, 8
repetitive lines, 126–127
resolution, 26-27
low resolution, 26
sensors determining, 13
retouching auction photographs,
146
reversing rings, 104–105, 155
review/menu LCD, 4
review modes, 30
rides, photographing, 136–137
rim light, 79
Rule of Thirds, 122–123

S
Sai
sat
sav sce
services ser
sep sho Sho sho sho
sho sho

```
shutter release, 2, 7
                                            for fireworks photography, 150
nDisk FAT (File Allocation Table)
                                            locking exposure settings with, 56
cards, 23
                                       shutter speeds. See also freezing
turation
                                          motion
adjusting settings, 34-35
                                            checking setting, 28-29
display information, 30
                                            choosing, 42-43
ving white balance presets, 74
                                            exposure adjustments and, 41
ne modes, 6, 29, 48
                                            flash modes and, 37
with programmed exposure mode, 53
                                            ISO settings and, 46
olling options, 37
                                            monochrome status LCD for, 6
condary objects of interest, 116
                                            with programmed exposure modes.
cureDigital (SD) cards, 8, 23
                                              52-53
ective focus and backgrounds,
                                            with telephoto lenses, 96
125
                                       shutters, 13
ling objects, photography for,
                                            main command dial for, 5
146-147
                                            sounds of, 36
sitivity. See ISO settings
                                       Sigma cameras, 1
nsors, 13. See also autofocus;
                                       silent mode settings, 36
SO settings
                                       silhouettes
dynamic range of, 40
                                            directionality of light and, 68
oia filters, 34
                                            with manual exposure, 50
adows, 68
                                            in sunrise and sunset photography,
ady Light setting, 72
                                              168
aky cameras, 42
                                       simplicity of normal lenses, 101
apes, using, 127
                                       Single Autofocus mode, 62
arpness
                                       size
in action photography, 133
                                            with wide-angle lenses, 94
adjusting, 32
                                           of zoom lenses, 90
in concert photography, 145
                                       slanted movement, 43
f/stop selection and, 44
                                       slash mode, 10
with normal lenses, 101
                                       slave triggers, 87
teleconverters and, 106
                                       slow sync with flash, 83
of zoom lenses, 90
                                       Sony cameras, crop factor with, 93
ooting mode menu, 4
                                       sounds, setting, 36
ort lighting, 77
                                       special effects with manual
tter priority, 48-49
                                          exposure, 50
with programmed exposure mode, 53
                                       special feature button, 4
```

Quick Snap Guide to Digital SLR Photography

speed. See also shutter speeds	
low resolution and, 26	
of memory card, 8	
with normal lenses, 100	
of zoom lenses, 90	
split-density filters, 153	
sports photography, 6, 53	te
shutter priority in, 49	t
story in, 114	3
telephoto lenses and, 96, 99	t
vertical orientation for, 118	
spot metering, 29, 54–55	T
square layouts, 118–119	ti
stars, photography, 157–158	t
status LCD backlight button, 6	
still-life photography, 166–167	
stopping action. See freezing	
motion	t
storage devices, portable, 171	t
story of photograph, 114–115	t
straight lines, 126	
with wide-angle lenses, 94	T
sub-command dial, 2	t
substitute PC/X connectors, 87	t
sunrises and sunsets,	
photographing, 6, 168–169	
symmetry	
and balance, 127	
showing, 123	
synchronization mode for flash, 37,	
82-83	
Fryng	

T

Tamron teleconverters, 106 teleconverters, 106–107 telephoto lenses, 89, 96–99. See also zoom lenses

for action photography, 132–133 chromatic aberration with, 109

crop factor with, 92 distance and, 129 for intimacy, 120-121 for moon shots, 156 for portraits, 164-165 in travel photography, 170 exture of light, 69–70 heme for photograph, 114–115 3D realism, 128 through the lens exposure. See TTL exposure TIFF format, 24 ime exposures, 51 tonal range, 41 for auction photographs, 146 book or magazine photography, 115

for histograms, 58
top panel controls, 6–7
tourist photographs, 115
transverse chromatic aberration,

Trash key, 4 travel photography, 115, 170–171 tripods

109

in architectural photography, 138–139 for candid photography, 140 for fireworks photography, 150 for lush landscape photography, 153 for moon shots, 156 for night photography, 159 for panoramas, 162

in amusement park photography, 136

for sunrise and sunset photography, 169

waterfalls, photographing, 160-161

TTL exposure, 54, 84 balanced TTL, 84

metering, 54

2:1 lighting ratio, 78

U

underexposure, 50 USB port, 4 use for photograph, 115

V

vacation photography, 115, 170–171 variable f/stops, 45 vertical orientation, 118 viewfinder

exposure information, 50 grids in, 36 in noise reduction process, 47 window, 5

viewing systems, 12 vignetting, 109 vividness for auction photographs, 146

Warhol, Andy, 166
water and waterfalls,
photographing, 160–161
white balance, 4, 72–75

checking setting, 28–29
display information, 30
increment settings, 36
manually setting, 72–73
measuring, 74
metering mode for, 5
presets for, 74
RAW format and, 28–29, 74–75
for sunrise and sunset photography,
168

wide-angle lenses, 89, 94-95

in architectural photography, 138 barrel distortion with, 108 crop factor, 92 for distance, 120–121 frame subject and, 129 in travel photography, 170

windows as frames, 128 windshields in macro nature photography, 161 wireless triggers for flash, 10, 87

X

xD cards, 8, 23

7

Zone System (Ansel Adams), 50 zoo photography, 134–135 zoom creep, 90 zoom lenses, 90–91. *See also* telephoto lenses

> crop factors, 92 local length setting, 30 for lush landscape photography, 153 for moon shots, 156 prime lenses, 91 teleconverters, 106–107

zoom ring, 6 zooming, 5. See also magnification; telephoto lenses; zoom lenses

locking exposure settings with, 56 with macro lenses, 102 main command dial for, 5

THOMSON

COURSE TECHNOLOGY

Professional ■ Technical ■ Reference

On the Road with Your Digital Camera ISBN: 1-59200-497-0 **\$24.99**

Digital Night and Low-Light Photography ISBN: 1-59200-649-3 **\$29.99**

Mastering Digital Printing, Second Edition

Digital Abstract & Macro Photography ISBN: 1-59200-613-2 = \$34.99

When you see the perfect shot, will you be ready?

Mastering Digital SLR Photography ISBN: 1-59200-605-1 = \$39.99

Digital SLR Pro Secrets

ISBN: 1-59863-019-9 **■ \$39.99**

THOMSON

COURSE TECHNOLOGY

Professional ■ Technical ■ Reference

Call 1.800.354.9706 to order Order online at www.courseptr.com